Secrets of Figure Creation
with Poser 5

Secrets of Figure Creation with Poser 5

B L Render

Focal Press

AMSTERDAM BOSTON HEIDELBERG LONDON NEW YORK OXFORD
PARIS SAN DIEGO SAN FRANCISCO SINGAPORE SYDNEY TOKYO

Focal Press
An imprint of Elsevier
Linacre House, Jordan Hill, Oxford OX2 8DP
200 Wheeler Road, Burlington, MA 01803

First published 2003

British Library Cataloguing in Publication Data
A catalogue record for this book is available from the British Library

Library of Congress Cataloguing in Publication Data
A catalogue record for this book is available from the Library of Congress

ISBN 0 240 51929 9

For information on all Focal Press publications visit our website at:
www.focalpress.com

Typeset by Keyword Typesetting Services Ltd
Printed and bound in Italy

Contents

Preface **xi**

Introduction **1**
A brief history of Poser 1
The basic steps 1
 Creating the mesh 2
 Slicing or splitting the mesh 2
 Defining the hierarchy 2
 Setting joint parameters 2
 Creating morphs 3
 UVMapping and texturing 3
 Putting it all together 3
Character creation vs figure creation 4
Pitfalls to avoid 4
How to use this book 5
P3 vs P4 vs PPP vs P5 7

1 Morphing **9**
Morphing: Theory 9
 Morph types 12
 Morph categories 13
 To limit, or not to limit …? 14
 Cross-talk 14
Morphing: Practice 17
 Preserving morphs 20
Magnets: Theory 21
 Editing the falloff graph 24
The Grouping Tool: Theory 26

Contents

The Grouping Tool: Practice 26
 Saving Magnets 29
Magnets: Practice 29
Building for morphs 29

2 Joint parameters 30
Joint parameters: Theory 30
 Children affect their parents 30
 The Joint Parameters Window 30
 Joint controls 31
Joint parameters: Practice 36
Building for joints 37

3 Poser library files 38
CR2: Theory 38
 CR2 sections (top level) 38
 FigureResFile pointers 39
 The Version section (one level) 40
 The Geometry section (one level) 41
 The Controls section: level 1 – basic body part controls 42
 The Controls section: level 2 – channels 48
 Channels 52
 The Figure section: level 1 – everything 60
 The Figure section: level 2 – P3/P4 materials 63
 The Figure section: level 3 – P5 Shader Tree 66
 The Figure section: level 4 – P5 material node inputs 67
 Other Poser library files 68
 Other Poser library files: Alternate Pose files 75
CR2: Practice 79
 Plugging in a new OBJ file 79
 Removing embedded geometry (geomCustom) 80
 Dial operations 81
 Scaling 84
 Welding 88
 Affectors 89
 Changing rotation orders 91
 Changing rotation types 94
 Grafting on body parts 94
 Chopping (deleting body parts) 99
 Conforming 101
 Extended Remote Control (ERC) 101
 Easy Pose 103
 Geometry Swapping 109

4 Figure creation 114
Figure creation: Theory 114
 Basic mesh structure 114

Intermediate mesh design 117
UVMapping 125
Advanced figure design 125
Clothing design 139
Prop design 150
Figure creation: Practice 151
Poser 3 PHI method 151
Poser 4 hierarchy method 151
Poser Pro Pack/5 Setup Room method 152
Finalization 153
Poser 5 materials 153
P3/4/PP materials 155
Rotation names and limits 159
Morph limits 159
Initial pose, IK favoring, memorizing 159

5 Poser 5 extras **161**
Dynamic hair 161
Basic hair operations 161
Hair materials 166
Dynamic cloth 169
Conforming vs dynamic clothing 170
Dynamic cloth principles 171
Designing and creating dynamic cloth props 175
Setting up the dynamic cloth prop 179
Shader Tree materials 180
The base "Poser Surface" node 180
Simply slapping on a texture map 183
Plugging in Old BUM bump maps 183
Bump vs Displacement 184
Noise vs Granite vs Spots 185
Skin (human) 185
Scales 185
Iridescence and random colors 187
Fur 188
Hair 190

6 Trouble-shooting **191**
Morphs and morphing 191
Wrong number of vertices 191
Exploding morphs 192
"But I'm using the *exact same mesh* . . . they used to work, but now they
 explode . . ." 193
Dud morphs 193
Morphs that work, but fly off 194
Morphs that work, but shrink/expand 195
Telescoping morphs 195

Contents

Morph speed	196
Full Body and Partial Body morphing	196
FBM has no effect	196
FBM affects things it is not supposed to affect	197
Partial Body Morph does not affect other parts	198
Magnets	199
The Magnet is not having any effect	199
Morph targets spawned from Magnets do not look the same	200
Magnet effects appear doubled	200
Joint parameters	201
Backwards joints	201
Sibling rivalry	201
Children Affect Their Parents – too much!	202
No body part selected	203
Parts that bend when they are not supposed to	203
Missing JP controls	204
Greyed out JP options	205
Dropping JPs and MatSpheres	205
CR2 problems	206
Torn seams	206
Flying vertices	207
IK tears off the foot	207
A "grafted on" body part does not bend correctly	207
Geom Swapper with wrong starting geometry	208
Incorrect morphs for swapped geometry	209
Other Poser files	210
Smart props turn dumb	210
"My prop is smart, but it does not bend"	210
"My beard makes me bald!"	211
MOR Poses change the figure's pose	211
MAT Pose does not change prop materials	212
MAT Poses add weird materials to the figure	212
Figure problems	213
"Where's my figure?"	213
"My figure is invisible!"	214
"My figure is a ghost!"	215
Invisible parts	215
Poser can't find OBJ – "Out of Memory"	216
Recorrupting RSRs	216
AbNormals – "My figure is inside out!"	217
Most of the figure is fine, but some bits are inside out	217
"There are holes in my figure!"	218
Feet moving when you use the Face Cam	220
Model won't texture	221
Poser can't find a file and won't say what it is	221
Fixes to the object don't take	222

"When I import my OBJ into PHI Builder, I get a 'Level Skipped' error;
 but I haven't started editing yet!" 222
Conforming clothing 223
 "My conformer . . . doesn't" 223
 Bits of skin stick out through the clothing 224
 Conformer gets in a twist 225
Dynamic hair 225
 Radioactive hair 225
 Hair turns white 225
 Can't select Guide Hairs 226
 Offset hair 226
Dynamic cloth 227
 Constrained groups aren't 227
 Cloth sucks up under the figure 227
 Different dynamic groups have the same properties 228
 Cloth falling through 228
 Things poking through 229
 The cloth slices through itself 230
 Magnets and morph strength are doubled 230
 Simulation stalls 231
Shader Tree material 231
 Radioactive hair 231
 Can't see the texture 232
 Black triangles all over 232

Showcase **235**

Appendix: GetStringRes lookup tables **255**

Glossary **263**

Index **273**

Preface

When I first started out with Poser 2 I was a clueless newcomer. I had the vague notion that I could model some gargoyle arms and legs, and use "Replace body part with prop" on a human, but that wouldn't really give me the proper proportions or digitigrade legs, and nothing would be welded together. It might be good to paint on top of in Photoshop.

Then came Poser 3 with – so exciting! – non-human figures. I stumbled onto the Poser Forum Online and spent several weeks exclaiming: "You can do *that*!? How? How did you do that!?" There was hair and clothing of all kinds for these mostly bald, naked people. And the clothing even moved with them (mind-blowing to me), not to mention these totally *new*, non-human characters that people built from scratch – dragons and aliens and little cartoon critters.

So I gave it a try and totally, utterly, miserably failed. Joint Parameters: not helping. Morphs: exploding. Seams: falling apart. Head: squishing. Yet here I am today, writing a book on how to create Poser figures, which just goes to show you that *any*body can learn to do this.

I owe it all to the great Poser pioneers who came before me, the generous artists of the online communities who shared their combined knowledge and helped me reach my level of expertise today.

I want to thank all the Poser Techs and give a special mention ("Hey! Your name's in the book!") to PhilC, JeffH, ClintH, ScottA, Nerd, RobWhiz, Akisiel, Lemurtek, Lesbentley, and _Dodger.

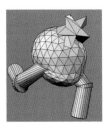

Introduction

A brief history of Poser

Poser initially was not designed as a 3D application. It used 3D models, but its purpose was to create proportion, foreshortening, and lighting studies for drawing and painting (real or digital). The "human" models were barely more than mannequins. In Poser 2, they took on more features, such as actual faces with eyes, nose, mouth, and ears, hands with fingers, and some musculature. Poser 3 is where things started really happening.

With Poser 3 came the addition of animal and robot figures. Poser wasn't just for humans any more! Also at that time, the "Advanced Techniques PDF" document was released. This arcane scroll outlined how to create your own custom Poser figures.

This capability, plus the new and improved human figures by Zygote, allowed Poser to evolve into a real 3D application. Subsequent versions added various features to help with building custom figures, but the procedure is basically the same.

The basic steps

At its heart, Poser figure creation is a simple process. The workflow follows these steps:

- Creating the mesh
- Splitting the mesh into body part groups
- Defining the hierarchy
- Setting joint parameters
- Creating morphs
- UVMapping and texturing

Creating the mesh

Poser uses polygonal meshes, in the Wavefront OBJ format. It is not in and of itself a modeling program, so you will need another application to create your models. It does not matter what program you use, as long as you can end up with an OBJ model at the end of the day. If your program does not import/export OBJ files, there are file conversion utilities that will translate between most 3D formats.

It is beyond the scope of this book to teach actual mesh modeling, but in Chapter 4 you will find basic design principles you should follow in creating your figure.

Slicing or splitting the mesh

This is a misnomer; there is no need to actually cut or slice the mesh. What this means is the OBJ file needs to have group information for each body part. In some applications (such as Ray Dream or Carrara) this may entail physically dividing parts of the mesh from the rest. In other programs (such as Lightwave) assigning polygons to groups does not change the structure of the mesh.

If you have Poser 4 or above, you can assign groups to polygons with the Grouping tool. This is not an optimal solution, but it can be done if you are very patient. You could also download the free UVMapper, which will allow you to assign groups and materials to OBJ meshes.

Chapter 4 will cover group naming conventions for Poser.

Defining the hierarchy

The body parts are arranged in a hierarchy that defines their relationship. The hip is usually the base body part. Wherever the hip goes, the rest of the body goes with it. Then from the hip, the torso and legs branch off. Thighs are children of the hip, shins are children of the thighs, and so on down to the feet and toes. Whenever you bend the thigh, the shins, feet, and toes go with it – they are all connected. Thus the entire figure can be defined in a tree-like structure of the body parts. Building a hierarchy is discussed in Chapter 4.

In Poser 3, this step is done outside of Poser, but in version 4 and above, the hierarchy can be constructed within the program.

Setting joint parameters

The joint parameters are controls that define how the body parts move: the point at which they bend, how much of the joint stretches and deforms as the limb moves, how much it twists, etc. Adjusting these controls is important in getting the figure to move in a natural manner. These are covered in Chapter 2.

All joint parameter editing is done inside Poser.

Creating morphs

Morphs change the shape of the mesh in a prescribed manner, without affecting how the figure poses and moves. Examples of common morphs are the smiling and blinking morphs for the human figure heads. Morphs are defined by changes in location for various vertices on the model.

Poser 4 and above have Magnet and Wave deformers, which allow you to create morphs within the program. However, there are some types of morphs that are best done in another 3D application. Morphs are explained in detail in Chapter 1.

UVMapping and texturing

UVMapping defines texture regions for your model in 2D space, so that "skins" can be painted for it. This can actually occur at any stage of the process. You can create a UV map for your model as you build it, or create mapping for it after everything else is done. If your modeler does not have UVMapping capabilities, you can use a UVMapping tool. The Grouping tool in Poser 4 and up will do some UVMapping, but it is limited in its control.

Details on UVMapping styles and procedures are located on the CD. Painting textures themselves is a two-dimensional art, and beyond the scope of this work.

Putting it all together

Each step of this process is interdependent on other steps. How the mesh is built will have a direct impact on how well the morphs will work: if you want your eye to blink, you will have to build an eyelid. How you split the mesh will also impact morphs: if you split your leg in the center of the knee, and want to create a "knobby knees" morph, you will end up having to do the morph across two body parts, which is awkward.

The mesh construction and splitting also affect the joint parameters. As you bend the figure, you may find you do not have enough polygons to stretch and create a smooth bend, or you may find the body parts too close together where they crash into each other as they try to bend. Splitting the mesh and building the hierarchy are also closely linked. The hierarchy has a rule that a body part can only touch one parent and its own children. If there is an area where several limbs or body parts come together, with no common parent, this could be a problem.

How can you know in the early stages how the joints and morphs are going to work in the later stages? After you have been up and down the workflow, going back and forth with a figure, you start to see the process as a whole, and you can begin designing the mesh with these future steps in mind. But, hopefully, reading this book will give you a head start and you won't have to struggle through several projects to get going. Because the latter figure creation steps have impact on previous steps, I have decided to go through the processes backwards in this book – which is actually a natural learning progression; you get into figure dabbling by creating morphs for existing figures, then work up to messing with the joints and CR2, and finally create your own figure.

Character creation vs figure creation

A "character" is built from a pre-existing figure, using one or more of the following: textures, morphs, scaling, and various accessories such as hair, clothing, and other props. If the figure you want to create is a human, there is no need to start modeling one from scratch. You can use an existing human figure. For example, Jon Malis of PoserGamers has several historic and fantasy characters built upon the Poser humans, such as Roman gladiators and dwarven warriors. My Antelope Expansion Pack is a set of characters for the DAZ buck, consisting of new mapping, textures, props, and morphs. You may create your own textures, morphs, and props, or use existing ones. Either way, this is considered character creation.

Figure creation involves building a new model for "Poserizing." Then there is a gray area in between, where part of a model is newly built, and part uses an existing figure, such as the various mermaids and the DAZ hippocampus. There is also the art of recombining existing meshes, such as Lemurtek's Second Nature series, where he has merged animal heads and legs with the human figures. In these cases, "figure creation" and "character creation" are used interchangeably.

If you are interested only in character creation, the Morphing and Library File chapters will have the information most relevant to you. You can also work with tweaking joint parameters, and check out the information on UVMapping.

Pitfalls to avoid

You may have already tried some forays into figure creation, trying to "Poserize" existing meshes, or perhaps throwing together a simple figure to try your hand at setting joint parameters. If you ended up with a weird figure with a warped head, torn seams, broken legs, and pieces bulging out or collapsing everywhere, you are not alone. And, it's *not your fault*.

Let me tell you a story about Stumpy. I put Stumpy together in Ray Dream; he had a sphere for a body, two cylinders for thighs and two for shins, and an extruded star shape for his head. All I wanted to do was test this new, arcane (at the time) figure creation process. I built the mesh, got the body parts and the hierarchy, but it all went wrong at the joint parameters. The thighs squashed the sphere torso into the most awful shapes, the shins were hopeless, they sheared this way and that, and the knee would *not* bend smoothly. And the head . . . that thing expanded and contracted from side to side, distorting the torso even worse than the thighs; it twisted all out of shape. The whole project was hopeless! (See Figure I.1.) If you play with Stumpy II on the CD, you will see what I mean.

But the reason was not that joint parameters were beyond me; it was the mesh. The legs could not possibly work, because the lengths were undivided polygons from top to bottom. Poser needs polygons to stretch and contract with joint movement, and they did not exist. The body distortion problems could have been addressed by using spherical falloff zones on the joints, and the head could have had its bend turned off.

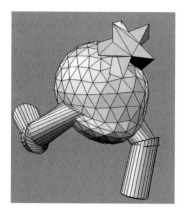

Figure I.1 Stumpy lives! Distorted body, deformed head, broken legs – what a mess!

Stumpy II has even more problems. See if you can find him after hitting <Shift–Ctrl–F> (Edit: Restore: Figure). Try scaling the BODY to 2000%, and hit <Ctrl–D> to "drop to floor." You can now see why a hastily built test figure can scare anybody away from even attempting to create Poser figures. By the way, Stumpy II's sphere is named "body," which is why you can tear off his limbs (try it!) and why he turns upside down when you drop to the floor. Dropping to the floor moves the root body part (usually the hip), not the BODY (the whole figure). Since Stumpy II's "hip" is his "body," Poser is confused as to whether that is a body part or the whole BODY. And the moral of that story is, never name any part of your figure "body!"

Using pre-built static meshes has its own dangers. Static meshes are usually built in a posed position, with limbs bent, which makes the default joint parameter angles do weird things with them (especially the twist). The mesh may not be dense enough to bend smoothly, and if you also do not know where and how to use the spherical falloff zones, things could get messy very quickly. There is a reason that Poser figures are built with straight limbs. If you want to practice on pre-built figures, try out the BBN figure that is included on the CD. The BBN is available in several stages, so you can practice slicing up the undivided mesh, or doing joint parameters on the unedited CR2, or doing morphs on the final figure.

Building a well-designed mesh, organizing a proper hierarchy, and setting joint parameters is not rocket science. Anyone can learn these skills with the proper guidance, and that's what this book is here for.

How to use this book

This book covers figure creation for Poser version 3, 4, Pro Pack, and 5. There are three different ways to "Poserize" your figure: the P3 PHI file method, the P4 Hierarchy Window method, and the Pro Pack/P5 Setup Room method. All three methods will be covered in this book, and each version of Poser supports previous methods, so you can choose which method suits you best. Other than the figure Poserizing, everything works the same no matter which version you have – joint parameters, morphs, etc. Some of the tools and features are not available in all versions of Poser (see the P3 vs P4 vs PPP vs P5 comparison in Table I.1 below).

Table 1.1 Comparison of features offered by Poser 3, 4, Pro Pack, and 5

Poser 3	Poser 4	Poser Pro Pack	Poser 5
Multiple figures in the document	More animals	Setup room	Dynamic hair
Some animal and robot figures	Transparency in materials	Rotation orders in JP window	Dynamic cloth
	Reflections in materials (reflection mapping)	Python scripting	Wind deformer
	Textures optionally apply to only single materials		Collision detection
	Full body morphs		Multiple Runtime directories
	Magnets and wave deformers		New materials using Shader Tree
	More than 99 morphs on a body part possible (with the patch)		Ray tracing engine, including real reflections
	Grouping Tool		Displacement mapping
	Conforming clothing		Parameter dial groups
	Hierarchy Editor		View magnification
			Morph putty
			Direct manipulation tool

Each chapter has main sections on theory and practice. Theory sections will go through the technical explanations of why things work the way they do, while Practice will show you how to put the theories to actual use. Then the Trouble-shooting chapter will address every bug, every problem, and every weird Poser occurrence I have come across so far. If something goes wrong, chances are the answer is here. If you don't find your problem addressed in the area you expect it, try the other Trouble-shooting sections. A morph problem may actually be a CR2 problem, a joint parameter problem might be a figure problem – so explore what's there.

If you are new to Poser figure creation, you can follow through the chapters and exercises of this book, in order. If you are intermediate, you can jump to any section where you want more in-depth information, or use your own figures for the exercises. Advanced users can use this book as a handy reference tool. Perhaps you need the lines for slave code, or a procedure for Geometry Swapping. Or have you got a figure design that you are not sure how to joint? It's all here at your fingertips.

If you would like to go from start to finish on a test figure, use the BBN0.OBJ on the CD. You should start in the *Figure Creation: Theory* section in Chapter 4 to learn how to split the mesh, then go to *Figure Creation: Practice* on the CD to Poserize it. Also on the CD, you can then work through the *Joint Parameters* section that deals with the Norn, and the *Morphing* section.

The CR2 chapter (Chapter 3) contains advanced techniques such as Geometry Swapping, remote control, grafting things together, meddling with the joints, and all sorts of good stuff. Be forewarned that you were never meant to tinker with the Poser library files, and doing so may cause disastrous results. Meddle at your own risk!

Lastly, check out the appendices for more helpful information. There is a list of Poser utilities to help you in your work, online resources where you can get more help (and download the utilities), GetStringRes lookup tables, and a glossary, in case some of the terms I use, like smooxing and abNormals, sound like gibberish to you.

P3 vs P4 vs PPP vs P5

Some instructions, tricks, and code do not apply to all versions of Poser. Where there are vast differences in procedure, I have tried to clarify which version does what. If you have P3 or P4 and you cannot find a control, the chances are it doesn't exist in your version.

Table I.1 (page 6) offers a listing of the new features each version brings to the scene.

Morphing

Morphing: Theory

Morphing means to change shape. In Poser, morphs are used to change the shape of individual body parts, for example, to make the mouth smile, or to make a muscle bulge. The joint parameters (JPs) also change the shape of the body parts, where they stretch and compress as the parts are posed, but this is not considered a morph, *per se*, in Poser.

Morphs are created by moving the vertices of the object. If you want to turn your head into a perfect sphere, you cannot simply create a sphere and tell the head, "Okay, now go into that shape." You have to place each of the head's vertices into position on the surface of the sphere shape you want. As you can imagine, morphing can get complicated! Similarly, you cannot use an analogous mesh. You cannot tell Michael, "Okay, now smile like Vicky!" You have to use the exact same mesh, with the vertices in the exact same order.

Vertex order is important, because the computer cannot see the 3D model as a structure with shape and form. It just sees a row of numbers, which are coordinates for the vertices. When you move the vertices, you create new coordinate numbers, and the only way Poser knows which vertices move is by their order.

Here is a simple, 2D example of how morphing works. Pretend I say, "Get some graph paper, and draw a square 10 units on a side. Now, number each corner, and then move corner #3 three grid-lines to the right." What shape results? Well, it all depends on how you numbered your square corners, doesn't it? (See Figure 1.1.)

A complex 3D model is rather like those punch cards they had in the early days of computing. Instead of magnetic disks or even tape, computer programs were stored on a series of punch cards. To run the program, you had to feed the punch cards into the computer punch-card-reader one at a time. Apart from the holes in them that the computer could read, the cards were

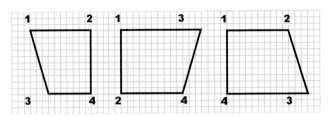

Figure 1.1 The results of various numbering schemes, where vertex number 3 is moved three units to the right.

all featureless and identical. If you were walking down the hall with your program cards in a box, and tripped, and they all went flying everywhere there would be no way to get them back into the proper order. If you then fed the cards into the computer in the wrong order, garbage would come out. Or the computer would explode! That's what happens with morphs that have vertices out of order: you get morphs that explode your head (or whatever you are morphing at the time). (See Figure 1.2.)

Figure 1.2 Right number of vertices, wrong order. Random vertices "explode" off the head (or any other object) when the vertices are out of order.

How do vertices get out of order? Well, the various programs might change the vertex order as they load, organize, and/or save the mesh. Amorphium, for example, always puts all the vertices in reverse order. Poser is not exempt from this, either. At times, Poser will export a mesh and change the vertex order. Usually this occurs if you are welding body parts, and Poser changes the vertices along the edges to match the order used on the other side of the weld – or that's my theory, anyway.

Normally, most programs will leave the vertex order intact and there is nothing to worry about. But if your head explodes, you'll know the reason why.

There is one solution to this problem. UVMapper Pro will reorder vertices for you, based on a target mesh. You will need to have the one group you are working on saved as an OBJ. You can export the single body part from Poser – turn off "Weld Body Part Seams" and turn on "As Morph Target." Then load the misbehaving morph OBJ into UVMapper Pro, and do Tools: Vertices: Reorder. Locate the base OBJ you just exported from Poser and, miraculously, your

vertices will be reordered. Save the OBJ. Note that you won't *see* any difference – the vertices still have the same UV coordinates – but the difference is vast, trust me. Also, if your body part is made up of *only* quads or triangles, UVMapper Pro may not be able to untangle the vertices properly. After all, one square looks pretty much like any other.

It may also happen that your morph works exactly as you wanted, but it drags your entire body part off into space. Your head may shoot forward on a long giraffe neck, for example. Or drop to the floor. This occurs when the base you have used for the morph target is not in the correct absolute position when you start your morph.

OBJ space is its own little universe, and it has an absolute coordinate system. The head of your Poser figure is in a specific location in this universe. If you export the head from Poser when the figure is in its default pose, or when it is lying down, or looking to the left, etc., then you will generate a new OBJ with different coordinates. (Except when using "Export as Morph Target.") If you load a figure into Poser, then import the figure's geometry, you can see that the default pose is not the same as the base object. The limbs are slightly bent, and the whole figure is moved forward (human figures, at least). Thus, if you export the head from where it is on a "live" figure, and apply it as a morph target to the base head, the head will move forward. Basically, you have changed all the vertex coordinates so they are moved forward in absolute space, and thus, the computer believes that's what the morph is meant to do.

A similar problem occurs with sizing. Poser uses a tiny speck of the OBJ Absolute Universe. Compared to other programs, Poser figures are only a few millimeters tall. In some programs, the figures are so small you cannot even see them, even at the highest zoom! If you increase the scale to see what you are doing, all the vertex coordinates change. It may be possible to un-scale the OBJ after you do the morph, but most programs will not do this accurately. Many programs size things from the center. If your morph has extended a part of the mesh beyond its previous bounding box, the center may have moved, and the scaling will put the object back in a different place. If you need to scale objects to work on them, Compose by John Wind will do this, and un-do this on morphs, accurately. ObjAction Scaler by Maz was also designed with this in mind.

So, the rules go like this:

- Use the original OBJ mesh, rather than exporting bits from Poser.
- Do *not* add or remove vertices.
- Do *not* move the mesh.*
- Do *not* scale the mesh.*

*Unless you know what you are doing, and how to undo it.

Remember, anything you do to change any vertex coordinates will translate into a motion of the morph.

Now, the good news is, it *is* possible for different figures to use the same morph targets, if the particular body part uses the same mesh, with the vertices in the same order. For example, there is a version of the Businessman that uses the same head mesh as the P4 Nude Male, so all the head morphs will transfer between characters. The Poser 3 and Poser 4 nude figures also share

mostly the same geometry, except for the chests and forearms. The UVMapping is the main thing that changed between the P3 and P4 figures.

It is also possible to create "geometry families" that share morphs, although the meshes may not be exactly the same. For example, Stephanie by DAZ 3D was built from Michael's mesh. Her head is a different shape and size (and in a different absolute location) than Michael's, but they can share morphs. How is that possible? Well, if you take a head morph OBJ made for Michael and load it onto Stephanie, her head will fly up and expand, as you would expect. But, if you use Morph Manager or a CR2 editor to transfer the morphs, they will work fine.

The reason for this is because the vertex information in a morph is not stored as absolute coordinates, but as relative vectors. These are calculated from the spatial differences between the base vertices and the morph object vertices. Which is fortunate, because when vertices don't move, the information is not stored in the morph (if it were, morphs would take up even more space than they already do!).

For example, if you have a nose-lengthening morph, most of the head will stay still, but the nose vertices will move forward; that is, they will have a positive Z axis vector. So once you load the long-nosed OBJ onto Michael, the morph will contain +Z vector information for the nose vertices. If you take those +Z vectors and apply them to Stephanie, they will move her nose vertices forward on the Z axis, just as they are meant to. If you put the morph on Victoria, there is no telling what will happen. The morph may not work at all if the indexes do not match. If it does work, the tagged vertices will begin to move forward, but most likely they are not the vertices that make up Victoria's nose. They could be anywhere on her head.

Morph types

There are three types of morphs: Construction, Expression, and Fixes.

Construction, or Sculptural, morphs change the structure of the base mesh. These change the shape/size of the nose, lips, beak, ears, claws, or what have you. Normally, these are used to create a character, which is a variant of the base figure, and they do not change once they are "sculpted." An example would be nose length. Unless you're Pinocchio, your nose doesn't tend to change length as you move or speak.

Expression, or Motion, morphs are malleable properties of the figure. No matter how long your nose is, you can wrinkle it, or twitch it, flare your nostrils, etc. These are mainly used on the head to create expressions. Phoneme morphs would also fall into this category. Other types of Expressions/Motions would be a morph to retract and extend claws, or to turn flight feathers on a wing, or spread the feathers of a bird tail, raise the crest of a lizard, flex a muscle, etc. These morphs are variable, and can end up being animated, etc.

Fix morphs are designed to fix flaws in the model, particularly when it is bending. My swan has some fixes on the head for when it is bent at an angle to the neck (the curve parameters of the neck do not particularly like to be attached to an end-part that is not curved). Victoria and

Michael, versions 2, have morphs that fix various areas of the body (elbows, knees, shoulders) that bend and distort.

Morph categories

There are three basic categories of morphs, as well: Stand-Alone, Full Body Morphs, and Partial Body Morphs.

The Stand-Alone morph is standard, of course. You turn the dial, the morph morphs. Every morph works this way. In addition, the morph can be part of a Full Body Morph (FBM), or a Partial Body Morph (PBM). A Full Body Morph is created in Poser by setting the various morph dials on any/all body parts, and spawning an FBM. This creates a master dial under the BODY, which basically turns all the morphs on all the body parts for you, all at once.

A Partial Body Morph is basically the same thing, but instead of affecting the entire body, it will affect only a certain group of body parts, like the right arm. When located in the BODY of the figure, these morphs are still called FBMs. However, it is possible to place these master dials on another body part. Controls for the right arm can go on the right shoulder. In actual practice, it is more sensible to slave the morphs to another morph dial, rather than a regular master dial. In other words, the Popeye-Arm morphs for the fingers, hand, and forearm will be slaved to the Popeye-Arm morph of the shoulder. Thus, when you morph the shoulder, you morph them all. For more information on slaving dials, see *CR2 Practice: Extended Remote Control* in Chapter 3.

When you are creating Full Body Morphs, there are a few things to keep in mind. First, once you create an FBM, do *not* delete the individual morph dials that made it up. The FBM is not a morph dial, it is really only an empty master dial. It really does turn the various dials for you, and if those dials are deleted . . . it just won't work.

The FBMs do not use limits, so there is no sense setting them. Instead, the FBM will use the limits of its constituent morph dials. So if you want/need to limit an FBM, note down its furthest limits, and punch them into each of the individual morph dials. You can tell if you've missed any by winging the FBM dial up and down. The body part that continues morphing after all its fellows have quit at a reasonable time has the limits set incorrectly. Unless you meant to do that. (There's always that possibility!)

Finally, and perhaps most importantly, make *sure* that no *other* morphs have any values set when you go to create your FBM. When creating your own figure, have the default state un-morphed, so you can hit < Shift–Ctrl–F > and zero all your morph targets before you begin constructing an FBM. If you are working on another figure, check the default morph settings. I believe Victoria has a hip morph set to some value by default, for example. If you create several FBMs, and turn them all on, and her hips grow . . . well, it wasn't too many fattening meals causing that!

If you do end up with a stray morph (maybe it was set to .179 and the dial *said* 0) in your FBM, don't trash everything, it can be fixed with some simple CR2 editing. You can just delete the slave controls from that particular dial. (More information is in *CR2 Practice: Extended Remote Control* in Chapter 3.)

To limit, or not to limit...?

Some people believe morph limits should be set, and some don't find this necessary. I like to set limits on mine, as it prevents the dial from getting out of control and flinging bits to all corners of the universe. However, keep in mind that morph targets by default use a "forceLimits" value of 4, which means to use the limits no matter what. If you constrict the morph limit range too much, users will run into the problem of not being able to turn the dial as much as they wish, unless they go in and change the limits themselves.

In addition, when setting morph limits, one usually applies them one at a time. This does not take into account what may happen when multiple morphs are used at once. For example, your Nose Width morph may squish your nostrils onto opposite sides of the face at −2, which is useless (unless you're making a zombie or something). However, there may also be a Nostril Flare morph. When this is used, the −2 on the Nose Width morph might not go far enough. For Construction/Sculpting morphs, it is best to leave a lot of leeway, or you can leave them limitless. Expression morphs have a narrower range of usefulness, but still, if the head is morphed into an odd construction, Expression morphs may need to be applied more strongly for the correct effect.

The industry standard is not to set morph limits. The industry standard is taken from the Poser default figures, and those created by DAZ 3D.

Cross-talk

Put very simply, cross-talk is what happens when you put two figures in a P4/PPP scene and the latter figure obeys the Full Body Morphs (or other master dials) of the first figure, rather than their own. So if you put in your hulking super-hero figure, and then add your skinny rubber-chicken villain figure, the skinny guy will suddenly become all buff and be able to take on your hero. Or in a romantic scene between Michael and Victoria, making Victoria's nails long and elegant will make Michael's long and elegant, as well.

The technical explanation goes like this: When body-typing and proportioning was phased out between Poser 2 and Poser 3, there was no longer a way to affect the entire body at once. Even if they had kept the body-types, they were no longer as effective on the new, more detailed figures. (Body-typing was a set of body scaling that made the Poser 2 figures over or underweight. Only the body parts were scaled, any surface musculature was still in place, which is why it didn't work so well for the newer nude figures, although for clothed figures, it was fine.) If you wanted a hugely muscled figure, you would have to make musculature morphs for each body part, and then set them all to the same value. So the programmers came up with Full Body Morphs. These are simply new dials that change the value of other dials.

The coding is fairly simple. The master dial is basically an empty dial with a name. The slave dial points to the master dial, which is identified by figure name, body part, channel name. And the slave adds a proportional delta to the master dial, to handle Full Body Morphs that have some constituent morphs turned to 1, while other morphs are more or less than 1.

This worked fine, but it did not take into consideration what happens when multiple figures are loaded into Poser. Poser changes the loaded figure names and numbers on the fly, so the P4NM may be saved in the CR2 as Figure 1, but if you load him fourth in the scene, his name is now Figure 4. Sadly, this old part of the Poser code was not changed to accommodate slave channels, and thus they keep pointing to Figure 1, even when their own figure name/number is changed.

Sometimes, this is not a problem. If you load a frog and a human, the human's FBMs will work fine, even though technically the slave dials are trying to point to the master dials in the frog's BODY. Since the frog's BODY does not contain these controllers, the slave dials apparently wander through the rest of the scene looking for them, and manage to find them on Figure 2. No one is sure exactly how this works. In fact, nobody is quite sure how the slave dials "know" that the master dials are being turned in the first place; it is a remarkable piece of coding.

If you load a human and some conforming clothing for the human, and the clothing has matching Full Body Morphs, then cross-talk is good. For example, Capsces created a suite of morphs for Michael, named Boris. These were done with magnets, which were saved and then applied to different Michael clothing, such as the Changing Fantasy Suit from DAZ. When you load Boris and the CFS, and you crank Boris' FBM dials, the Suit changes with his body. Very convenient!

In all other circumstances, cross-talk is a major headache. Even worse, the cross-talk behavior changes after saving and loading a Poser scene. The frog and human example might work when you load them into Poser, but when you save the PZ3 and re-open the scene...suddenly, the human's body will no longer respond to his FBMs. It is not clear why, but perhaps saving the file locks in the slave dial pointers so they cannot go roaming around looking for their master dials in other figures, if they do not find them in the first one.

Cross-talk has been effectively eliminated in Poser 5. However, people may still be using your figures in Poser 4 (or even 3), so you should still be aware of how to fix it. There is only one tried-and-true, unbreakable, 100%-reliable method, and that is to use a custom Null Loader figure. The first "EMC Fixer" was developed by Charles Taylor, then Robert Whisenant did exhaustive tests and came up with this method, which you can read about on his web page.

First, you need to create a Null Loader for your particular figure. The null figure is basically your figure's CR2, gutted of the channels section and empty of any actual actors. Rob's Millennium Null, for using with Michael/Victoria/Stephanie, is on the CD if you want to study it. There are no figureResFile pointers, only a list of the body part actors, and the addChild statements of the figure section.

Once you create the Null, you have to follow a set procedure for using it and loading figures into your scene. Start with an empty scene and load the Null Loader as the first figure. Make sure

you select its BODY. Note that being an empty figure, Poser will list the BODY as "No Actor;" this is normal. With the "No Actor" BODY selected, load your first real figure.

Then, you must load a second Null Loader figure, and select *its* BODY while you load your second real figure into the scene. You must load a Null and figure, in exactly this manner, each time you add a figure to the scene. If you only load the first Null, or if you do not select the BODY of each null as you load the new figures, everything may work correctly while you are in that Poser session. But if you save the file and open it later, the FBMs will become confused.

Why does this work? Well, the first Null takes up the appellation of Figure 1, and clearly does not have the master dials that the slave dials would be searching for in "Figure 1." Therefore, they fall back on the next figure and find the dials there. The other null figures, according to Rob, act as buffers between figures to keep the cross-talk from crossing. Again, it is not clear exactly why or how, but it works.

There are two other not-so-100%-reliable methods of curtailing cross-talk.

My method is almost exactly the same as the Millennium Null, but I have created a "Universal Null." When I was working with Dragon Factory, I noticed that I never had cross-talk problems between the front and hind legs, although both figures had exactly the same morph sets. That is, I never had a problem, as long as a body figure was loaded first; a figure that had absolutely no body part or morph names in common with the subsequent figures.

So the Universal Null (available at 3D Menagerie) contains one empty body part with a name that no other figure uses. When used as described in the Null Loader voodoo, above, it works pretty much the same way, but it works with any figures, not just the humans. The only thing it does not do is work with cascading ERC. That is, if one morph dial is slaved to another, which is slaved to an FBM dial, the Universal Null will not work. This happens in Victoria 2, so the Universal Null is no good for her. Rob's Millennium Null *will* work with her. Also, Ajax's Easy Pose (EP) dials use cascading controls, and the Universal Null will not work with them. (Rob's Millennium Null won't either, the whips and chains need their own custom null loader.)

The other method is to simply change the names of the FMB dials for your figure. If each figure has unique morph names, the dials cannot become confused as to which figure's dials they are supposed to be looking at. Ajax uses this with his Easy Pose items. When he creates the Easy Pose controls, the master dials have internal names with unique prefixes. So if you have an EP-whip and an EP-chain in a scene (for purely non-kinky purposes, I'm sure!), and you turn the TwistAll dial on one, the slave controls cannot be confused as to which TwistAll they are obeying, because internally, the whip's is "QT1EPWATwistAll" and the chain's is "QT1CA11TwistAll."

Stephanie, as well, has internal cross-talk deferrers. All her FBMs, which are otherwise identical to Michael's, have an "a" on the end in the internal names. Therefore, Michael's slave dials will point to "Tone" and Stephanie's will point to "Tone a," etc.

These work fine for keeping different figures from clashing, however, you still get the same cross-talk problem when you load two Stephanies into a scene (or two whips or two chains, etc.). They'll all have "Tone a" or whatever, and all be trying to point to that.

So the renaming of the FMBs will prevent your figure/character from cross-talking with other similarly-constructed figures, but it will not prevent them from cross-talking with multiple instances of themselves. Note that in the above examples, only the internal names were changed. The user names are the same, so the user only sees "TwistAll" dials or "Tone" dials. If you are converting a figure that has already been done, you can just do a search and replace to change the dial names (both internal and external).

Poser 5 "fixed" all this, so you don't have to do anything to any dials. Unfortunately, it also fixed cross-talk that people didn't want fixed (such as with the clothing morphs being slaved to the base figure FBM dials).

This fix occurs when loading figures into the scene. It does not fix PZ3 files from previous versions, so if you have a scene with clothing slaved to the main figure, you can open these files, manipulate them, and save them in P5 and retain the cross-talk. Conversely, if you have a PZ3 scene ruined by cross-talk, you cannot fix it by just loading it into P5.

Lastly, cross-talk is famous for one more thing: the discovery/invention of Extended Remote Control. While playing around in the Poser files, studying cross-talk, we discovered the coding parameters for master and slave dials. Charles Taylor and Robert Whisenant developed other applications for this code, starting with the slaving of morph dials to rotation dials, which was named Extended Morph Control, at the time. With this concept, a bicep-bulge morph could be slaved to the forearm Bend dial, to cause naturalistic muscle contraction as the arm bends.

Extended Morph Control evolved into Enhanced Remote Control, as more people found more applications for the slaving of dials. Ajax created Easy Pose by slaving rotation dials to master dials. Morphs can be linked to other morphs for Partial Body Morphs, rotation dials can be linked for complex actions, scale dials, geometry swapping dials, translation dials, even other master dials can be slaved to almost anything.

See *Extended Remote Control* under *CR2: Practice* in Chapter 3 for instructions on harnessing this power.

Morphing: Practice

In practice, morphing is one of the last stages. It must be done after the mesh is completed and finalized, and the body part divisions are made. It can be done before UVMapping, however, as creating the UVs will not disturb the vertex order. It can be done after setting joint parameters, but JP tweaking can go on while the morphing is going on.

Now we will look at figure design and how it affects morphing. Start Poser and load the Poser Horse. Zoom in the left (or right if you prefer) camera so you can see the head. Turn on a

shaded wireframe mode (flat or smooth) so you can see the mesh construction. You can also open the horse mesh in your modeler, to take a look at it, and try to create some of these morphs. The horse isn't too bad; you can see the construction lines follow the head contours very nicely. (See Figure 1.3.)

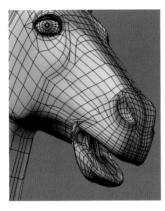

Figure 1.3 This is the horse's head, showing the mesh construction, and the OpenMouth morph I have created for it, available for download at 3D Menagerie.

Let's say we want the horse to open its mouth, which is of course something horses do, although this horse was never designed to. Fortunately, there *is* a slight gap between the upper and lower lips. As a static model, this might have been built with just an indentation along the mouth line, and the lips could have been continuous from top to bottom. As it is, to get the mouth open, the flat area inside the lips has to be pulled back into the mouth, and when the mouth is open, there is not much to see inside. There is no mesh here to create an inner lip edge or anything. There is certainly nothing in here resembling gums, teeth, or tongue.

The horse might like to roll its eyes. That would be easy enough to accomplish, as they are not-quite-complete spheres within the head. In most programs, you could grab a few eye vertices or polygons, select connected, and have the eye ready to be moved around.

Closing or opening the eye is yet another story. The horse does have an eyelid – one upper eyelid, which is not connected to the head mesh. This makes it easy to select, but doesn't leave much to pull down over the eye. A lower lid might be faked out of the skin around the eye socket.

Also look at the ear area. Many attempts have been made to get the ears to turn and/or lay back, without much success. To turn back, the ears have to twist around 180 degrees, and there is not enough mesh around the ear bases to do this without a lot of distortion. Additionally, the ear flows right into the head, without a base area.

Another bad example is the head of my free swan figure, built in Ray Dream 5. (See Figure 1.4.) The bill has been smoothed, *a lot*, which causes lots of sub-dividing triangles. Yes, there's plenty to work with, but imagine trying to select something specific! The knob is a deformed sphere, and is not even attached to the mask, which has NO construction lines whatsoever. No eyelids for closing the eye, no contour lines on the head. Truly a mess!

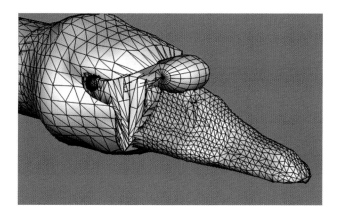

Figure 1.4 Here is a morphing nightmare: my Deluxe Multi-Species Swan. Too many triangles, lines that don't follow contours, and no facial detail whatsoever.

Meta-balls are fantastic, and quick, for organic modeling. But morphing things after you create them? Big problems. The vertices and lines follow no contours, no logical construction, they're not even symmetrical. They're sparse here, concentrated there. You can shove the vertices around into broad shapes, but for detailed morphing, it is a mess. (See Figure 1.5.)

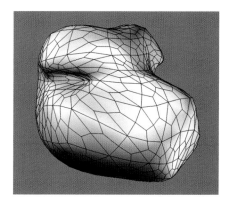

Figure 1.5 This is a meta-balled head. Forget triangles, they're all grouped into hexagonal shapes with no rhyme or reason.

Take a look at the P4 Male head versus Michael's head. (See Figure 1.6.) Aside from having a higher density of mesh, Michael's construction lines more accurately follow the facial muscles. Suppose you wanted to create a morph that wrinkles the forehead. If you attempt this on the P4 Male, you can dent his head at every other line, which won't do much except make him look as if he were in a head-on collision with a grate. Michael is designed with this morph in mind, and he has several construction lines around each brow wrinkle to facilitate them. He also has similar construction areas around the eyes for bags and crow's feet, the chin and cheeks for dimples, etc.

We will learn more about head construction and morphing in the Magnets section. Because there are so many different programs that can be used to create morph targets for Poser, we cannot go over them in detail. Aside from the general rules of what not to do, it is best to try to

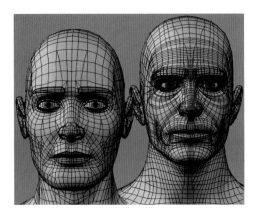

Figure 1.6 Here's an example of mesh construction and density, as it affects morphability. On the left is the P4 Nude Male, and on the right is DAZ's Michael.

avoid moving the edge points of the body part in the morph – unless you are working on a Full Body (or Partial Body) Morph. And if you are doing so, be careful that the pairs of edge seam points do not become separated as you work with them. This will cause your model to rip at the seams.

When the morphs are completed, it is a good idea to organize them, using a CR2 Editing program, especially if you have a lot of them. It is standard practice to divide the head into regions from top to bottom, and gather the morphs in groups. Or you can alphabetize them. Or both. When I create head morphs, I use a two-letter abbreviation for the section, and a short name. This is followed by an L or R, depending on whether it is an asymmetrical morph. So a Worried Brow morph would be named Br-Worry-L, etc. You can create your own standard, of course. In fact, this might be preferable – if you create a morph package for the Millennium figures, people may wish to add them to the already available morphs. If the new and old morphs share the same name, this would be a serious problem!

See *Telescoping morphs* under *Trouble-shooting: Morphs and morphing* in Chapter 6 if you need help with same-named morph dials.

Preserving morphs

You may wish to enhance an existing figure (or one you have built), or transfer a body part from one figure to another – to put a cat head on a woman, for example. It would be best if you could keep the morphs that are already in place. There are a few things you can try.

The simplest, and most tedious method is exporting all the morphs. You can try this if you want to change the mesh density or construction. Perhaps you want to subdivide the cat head so there are more vertices to work with for future morphs. You can set each morph dial, in turn, to 1, and export the head as a morph target. If you subdivide the head and each of these morph targets in the same manner, you might end up with the extra vertices all in the correct order (or you can fix them with UVMapper Pro). You could then load the subdivided OBJ files back in as new morph targets.

Or, if you have enlarged the cat head and stuck it on your woman's neck, you could export the head from this new position, and all its morph targets as well, so those will work with the new head location on your combined figure.

An easier method, if you are not changing the mesh, just its location/size, is to copy the morph channels from the old CR2 to the new. Because the morph channels hold the relative vector information instead of absolute coordinate information, these will work fine.

Another situation that may occur is if you want to split a body part into two (or more) parts. For example, you may want to try to make the P3 horse's ears, eyes, and jaw posable. If you cut the head into these various parts, none of the head morphs will work any more. But what you could do, instead of cutting the current mesh, is to use "Poser Bones" or "Body Handles."

After creating several new morphs for the P4 Lion head, I then decided I wanted to make the jaw posable. Instead of cutting the jaw off the head, I inserted a row of polygons as a jaw bone. (See Figure 1.7.) The JPs of this bone allow the jaw to be posed, while leaving the head mesh intact so it could keep its morphs. (See *Joint parameters: Practice: Norn* on the CD to see how a jaw bone works.)

Figure 1.7 This is the Poser Lion, with a simple jawbone inserted (highlighted in red).

Magnets: Theory

Poser 4 Magnets are a powerful morphing tool, although some people find them overly arcane. They aren't that bad, and if you can master them, the time you spend morphing will be dramatically decreased. Aside from being fast and direct, magnets allow you to see how the morph looks as you bend and move the figure. This is invaluable, especially when you need morphs to fix messed up joints. You can also see how the morphs will work with others, how they will look at different values, including negative values, etc. You can adjust the morph so that it works optimally under live conditions.

The first thing to remember about Magnets is, they are not magnets. That is, they are not magnetically attracting the vertices like a magnet attracts iron filings. Instead, the Magnet is

a symbolic proxy for the vertices. Whatever you do to the Magnet, will be done to the vertices. So if you Y-scale the Magnet 150%, the vertices will be Y-scaled 150%. If you rotate the Magnet 60 degrees, the vertices get rotated 60 degrees. If you drag the Magnet out into left field . . . well, you get the idea.

The Magnet is only one part of Poser magnetism. Next is the Mag Base. The positioning of this only matters in scaling and rotating, in which case, it defines the center point for those actions. The scale and rotation of the Mag Base itself has no effect on the morph. For doing rotation morphs, it is best to align the Base with the object to be morphed. If your eyelid is facing 45 degrees out from your head, you should align the Base to it. Then a simple X-rotate of your Magnet will roll the eyelid up or down on its axis. Similarly, if you want to change the height or length of your jaw, which is angled down, you should align the Base with it, and then the Magnet axis scales will scale the jaw along its length and breadth.

The final part of the Magnet group is the Mag Zone, and this is the most important. It defines which vertices will be affected by the Magnet, and how much they will be affected. Vertices in the center of the Zone are affected 100% while vertices near the edges are affected less. Vertices outside the Zone do not move, of course. If you install TargoMagnet from MorphWorld (included with the CD), the spherical Mag Zone will have cross hairs and an inner zone marker, to make positioning and visualization of the Mag Zone easier.

The Zone can be scaled on any/all axes to encompass the vertices you wish to work on, but it can never be a shape other than a spheroid. Experiments have been done using different prop meshes as the Mag Zone (Cube, Pyramid, even the Steps), but these have no effect on the Zone's actual sphere of influence.

The Mag Zone has two other properties to enhance its function. The first is the falloff graph. This is a graphical representation of the Zone's influence from the center of the sphere to the edge. The center is represented by the left side of the graph, and the edge by the right. To visualize the graph curve in 3D space inside the sphere, imagine that you are going to lathe the graph line around the leftmost side. (See Figure 1.8.)

The default graph results in a bell shape, where the center of the Zone concentrates the effect of the Magnet, and it tapers off at the edges. This most often results in a smooth blend between your morphed zone and the rest of the object. It is possible to invert the graph, so the center of the Zone has no effect, and the edges react most strongly to the Magnet. In fact, almost any shape is possible with the graph. You cannot move the graph control points lower than the 0% line, or higher than the 100% line, but it is possible to get the graph to bend beyond the boundaries, by adding control points near the current points, and dragging them sharply up or down. This would cause some of the vertices to have the Magnet affect them more strongly (as if you had turned the Magnet Dial on the object up past 1), or to have the negative of the Magnet applied to them.

On a complex model, the results might be harder to read, especially when you get into rotating the Magnet and moving it around. Here is a real-life example. I am working with the DeEspona free seahorse model. I have made it into a prop, rather than trying to turn it into a figure. Because the model is so hi-res (it has more polygons than Vicky!), I have decided not to create

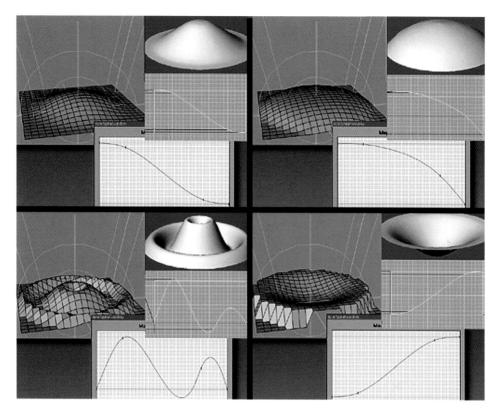

Figure 1.8 Here are some examples of using a Magnet on the Ground Plane in Poser, showing the results of different Zone falloff graphs. The Magnet is raised on the Y axis. On the flat Ground Plane, it is easy to see the effects of the Zone. The shape of the area of effect is exactly what occurs if you were to revolve the spline around its leftmost point, which I have done in Rhino. Notice how the ground plane takes on the shape of the rotated splines.

morph targets for it. Each morph target has the vertex information stored in the file, and five morph targets on this would be like loading several copies. So instead, I have decided to attach magnets to it: one for the head, one for the tail, and one for each fin. These magnets will allow me to pose the body parts without all that fiddling around with figure creation or morphs.

I want the tip/curled area of the tail to move the most, and the Magnet to stop affecting the mesh about where the tail meets the body. My Zone location and size defines these parameters. (See Figure 1.9.)

I want to bend the tail backwards, so the Magnet is X rotated. You can see with the default Mag Zone falloff, this turns out to be a mess (Figure 1.10). The tail begins to distort. Why is this? Well, look at the falloff graph. The points in the center of my zone are moving the most, and then there is a sharp dip downwards, so points just outside the center are moving less and less, until they come to a smooth decline in effect near the edges. The problem is, the center of the tail curl is moving along quite briskly, and is outpacing the other curl arcs around it, which are moving more sluggishly as you get further out from the tail tip.

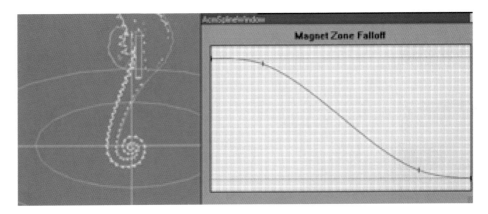

Figure 1.9 This is the tail Magnet and Zone. Notice that I am using TargoMagnet, so you can see where the center is.

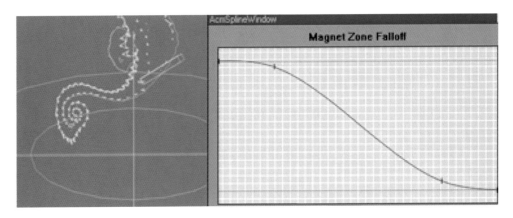

Figure 1.10 Rotating the Magnet may cause unwanted shape distortion when using the default falloff graph.

When the mesh distorts too much, it is best to use the "hill" style falloff zone. This is created simply by raising the low point on the right, until the S-curve of the graph is more of a rounded dome shape, and pushing the left high point to the top of the graph. (See Figure 1.11.)

Now the curly part is moving more in step with the tail tip, and the distortion is ironed out. Keep an eye on the edge of the Mag Zone, because this "hill" graph causes a rapid dropoff of the Magnet effect at the edges. This may cause your morph to have a sharp cutoff point, which is usually undesirable. For most cases, it works quite nicely however, and I end up using the "hill" style graph almost as much as the default S-curve.

Editing the falloff graph

This is fairly simple. Grab a tick and drag it up or down to bend the graph. There are four default ticks: the left and right endpoints, and the points just inside them, which I call the top point and the bottom point.

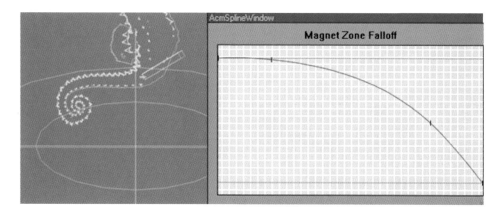

Figure 1.11 The hill-shaped falloff graph smoothes out the distortion.

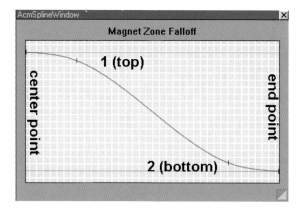

Figure 1.12 The default falloff graph has four control points and an S-curve shape (actually one half of a bell curve).

If you grab an empty section of the graph and drag up/down, a new tick will be created at that location for you to play around with. Sometimes this is not what you meant to do, which is okay, because you can click on an empty area and drag sideways to select a portion of the graph. Well, what you are really doing is selecting the ticks, and if you hit the Delete key, you can delete them.

You cannot move the ticks sideways, you have to make new ones (and delete the old ones, if necessary). You cannot save falloff graphs (by themselves; they do save with the Zone, see below), and they will not be pasted when you copy and paste the Mag Zone. Sorry, but it's not my fault.

The other important property of the Magnet Zone is the Group function. You can set the Zone to affect only certain groups, and ignore any others. The groups are created with the Grouping Tool – the one tool even more arcane than Magnets. You must create groups on your object before you can use the Mag Zone Group function.

The Grouping Tool: Theory

The Grouping Tool was designed so you can subdivide objects (body parts or props) into sub-groups. There are not a lot of good reasons for wanting to do this, but it does enable you to assign materials to groups. So if you import an OBJ or 3DS file with no material subdivisions, you could create them.

It can "Create Perspective UVs," which means you can select a bunch of facets with this tool, line the camera up to view them all, and "shoot" new planar UVs for them. When you create them, Poser plops them somewhat near the middle of the map, and they may overlap pieces that have already been mapped. You will need to untangle them with a UVMapping program, but people have used this to good effect to place tattoos across arm and leg seams. Or, if your prop has no UV coordinates, you can create them by shooting Perspective UVs on the whole object, or on each material.

It can reverse normals, so it is handy for fixing things with inverted normals. It works very well when you load your figure for the first time and find out the forearms and third digit of the ring finger have come out inverted.

And, of course, it can create groups for Magnets to affect. Although the Mag Zone can only ever be spherical, you can get it to affect a particular or irregular area by creating a group of the faces you want to move.

The Grouping Tool: Practice

In practice, the Grouping Tool is stubborn, obstinate, eccentric, and its accuracy is such that you could be forgiven for thinking it doesn't matter if you have your eyes open or closed while you're using it. (The Grouping Tool is much better behaved in Poser 5!)

The Grouping Tool operates in two modes: the single click select, and the marquee select. The latter is more reliable than the former, so try to use that wherever possible. When you click on a polygon to select, the Grouper may select it, and some/all of its neighbors, and possibly some polygons that are not visible, all the way over on the other side of the current body part. You can click (and/or drag) or <Shift> click/drag, to add polygons to your group. Select the subtraction button in P5 or use the <Ctrl> key to subtract from your group. Remember that your group is dynamic, it changes with each and every addition/subtraction, and does not become finalized until you stop using it, or create a new group. If you are trying to perform a very complex addition/subtraction from your group, it may behoove you to save the entire thing as one group, then create a new group and select the bits you want to add/subtract. You can then add/subtract the groups to get what you really want.

When you are working in close, and get your group finally the way you want it, be sure to zoom out, or use a different view, and use the wireframe document style to make sure there are no stray red polygons in your group. If you do not, you may end up with nostril polygons on the back of your head and on the edges of the ears (trust me, it happens). If you have assigned a

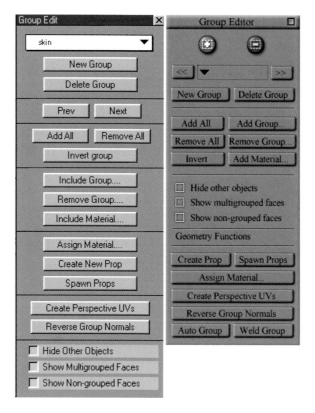

Figure 1.13 Poser 4 (left) and Poser 5 Grouping Tool.

material before you checked, you are in a lot of trouble. You will have to extract the stray polys and assign them back to the proper group/material.

The Grouping Tool is supposed to affect only polygons it can see, so the display mode has a lot to do with how it works. If you are in wireframe view, you can select polys on the near side of an object, on the far side . . . anything you can see (which is all of them). If you want to restrict the tool to select only polygons facing you, then use the flat-lined or smooth-lined shaded mode. Keep in mind this does not guarantee that polygons on the back sides of things will not be selected. *Always* check. Check from different views, so you can see where the red polygons really are.

Now, the Grouping Tool isn't all bad. If you can manage to use it without having to click on any polygons, it works really well. Let's run through the options it has.

New Group: This is what you press first. This creates the first group. When you create it, you give it a name, but there is nothing in it. Once you hit this button, remember that the CR2 generated when you save in Poser 4 is not distributable under most objects' copyright stipulations. For Pro Pack and Poser 5, a new OBJ file is created in the figure library; remember to keep track of it.

Delete Group: This removes the group information for the current group. It does not delete any polygons on your model or anything drastic like that.

Prev/Next: Cycles through the groups.

Add All/Remove All: They are speaking of polygons here. Add all the polygons of the object to the group, or take them all out. This is handy if you want a group of "Everything but the Teeth." You can create the group, Add All, then subtract a group that contains the teeth material (you have to create the group first, you can't subtract by material.)

Invert Group: If it's easier to select what you *don't* want, then you can use this to invert the selection and get what you do want.

Include Group: This adds a previously defined group to your current group. It does not change or eliminate the added group; it is still there and polygons can belong to more than one group.

Remove Group: This subtracts an existing group from your current selection. Don't confuse it with Delete Group.

Include Material: This adds polygons with a certain material to your group. If you want a group for teeth, then create it, and add the teeth material. Now that's easy isn't it?

Assign Material: If there is no teeth material, then you can painstakingly select the tooth polygons and assign them one.

Create New Prop: This copies the selected polygons as a new, free-floating object. You could, in theory, select around the eye area of your face and spawn a mask using this. (In practice, the polygons never make a smooth edge around the "mask" area, so they don't turn out that well.)

Spawn Props: This copies each group as a new prop. Basically, it explodes your object into its constituent groups. This is used in the Poser 4 Hierarchy method of Figure Creation.

Create Perspective UVs: As mentioned above, this "shoots" a planar mapping of your group, from the current camera's viewpoint.

Reverse Group Normals: Flips the polygon normals.

Hide Other Objects: This makes all the other body parts invisible while you work on one, or all of the other props, figures, stuff, etc.

Show Multi-Grouped Faces: This hides everything but the polys that are in more than one group. This sort of thing can cause headaches with the P4H method of figure creation.

Show Non-Grouped Faces: This shows only polys that have not been stuck in a group yet.

There is no "Show Only Current Group," option, sadly.

The handiest option is "Include Material," as this can give you good groups for morphing, or at least a good starting point for them.

If you have abNormals that do not encompass whole body parts, and do not have a 3D app that can fix them, the Grouping Tool can help you. There is a tutorial on this at my 3D Menagerie web site. For more detailed instructions, see *abNormals* under *Figure problems* in Chapter 6.

Saving Magnets

You can save Magnets in the Props library, just like any other prop. When you do so, be sure to use the Select Subset option and grab all three Magnet pieces. It is not fun to re-load your Magnet and find only a lonely Mag Zone imported into your scene, with no Mag Base or Magnet to use it.

Magnets: Practice

The tutorial for this section is located on the CD. The tutorial will teach you how to adjust the Mag Base and Mag Zone, work with groups (and the Grouping Tool), edit the Falloff Graph, test and optimize your Magnet morphs, and do symmetrical morphs with one and two Magnets. The tutorial features the Poser 3 Dog, which will also teach you some invaluable lessons in how *not* to build your mesh.

Building for morphs

When building your mesh, there are two main concerns you need to keep in mind. One is the division, jointing, and bending of your model, and the other is morphing. We will see more about this in Chapter 2 on *Joint parameters* and Chapter 4 on *Figure creation*. For morphability, remember these lessons:

- Try to keep your mesh following contour lines of your creature.
- If you want to morph wrinkles, also be sure to keep the mesh dense enough to create them.
- Unlike static models, interior structure counts in posable models: gums, teeth, inner lips.
- Remember to include mesh for expressive structures: eyes close better if there are eyelids, your cat may want to extend its claws once in a while, your horse might want to open its mouth and turn its ears.

2

Joint parameters

Joint parameters: Theory

Children affect their parents

The most important thing to remember about joint parameters is CATP ("Children Affect Their Parents"). When you set JPs for any body part, those JPs will affect portions of the parent's mesh that they come in contact with. The JPs do not affect the body part's children: keep this in mind as well – the children *always* move 100%.

In the *Theory* section of Chapter 4 on *Figure creation* we'll see how the construction of the child/parent relationships affect the JPs (or fail to) in more detail. But start internalizing this idea now.

The Joint Parameters Window

This is accessed from the Window: Joint Editor menu. It is an independent little window that you can throw anywhere in your workspace (preferably out of the way of anything important you need to see). There are several configurations of the JP Window, depending on what you are working on. When you first open it, it may simply say "No Body Part Selected." As you can no doubt figure out, this means a light or camera is selected. If you just want to open the JP Window for one second to access the "Zero Figure" button, this can be annoying.

In Poser 5 and the Pro Pack, the JP Window also has a drop-down list whereby you can change the rotation order of any joint. If you are using P3 or P4, see *Changing rotation orders* under *CR2: Practice* in Chapter 3.

Once the JP Window is open, you will see the joint controls.

Joint controls

The center and end point

In most body parts, only the center is visible, as a green cross-hair. The end point is visible on the base body part and those at the end of a limb; it is a red cross-hair. (See Figure 2.1.) The center defines the center of rotation for the limb, of course.

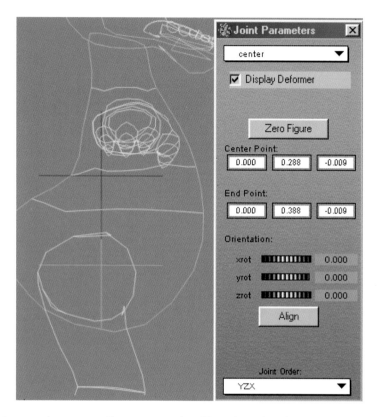

Figure 2.1 The joint center is represented by a green cross-hair. The red cross-hair (when visible) displays the end point. In the JP Window, under the "Zero Figure" button, are the coordinates of the center (and end) point.

The end point (when visible) can be moved to any location, usually to the end of the limb. Moving the end point will not change the angle of the limb's joints, only rotating the center will do that. You can rotate the center (and end point) with the dials in the JP Window. If you spin them, the center/end points will spin around like pinwheels. These are used to align the central axis of the joint with the mesh that makes up your limb. This is most notable with the Twist Bar, but if you rotate your centers, the Bend X controls are also affected. If you change the center alignment after setting the bending JPs, you will need to re-adjust the angles of the Bend X arms.

The "Align" button is a sort of auto-rotator. If you move the cross-hairs around so they are no longer lined up, you can press this button to have them point at each other. This control is also available on body parts without visible end points. When you press the "Align" button for

those, the center point will rotate to face the next body part's center. You can also type in specific angles, which may be the most accurate way of doing things.

When not visible, the end point is automatically placed at the next limb's center coordinates.

The Twist Bar

This looks like a white bar with one red end and one green end. Everything beyond the green end *does* move, everything beyond the red end does *not* move. Everything along the white bar between them is the blend zone. (See Figure 2.2.)

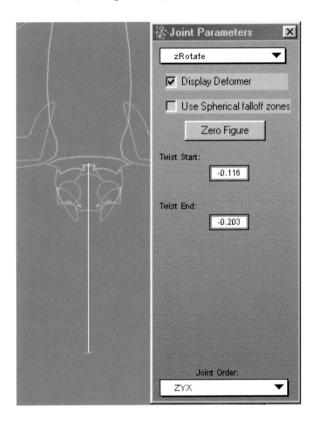

Figure 2.2 The Twist Bar JP and the JP Window controls for it.

Usually it works best if you stretch the Twist Bar along the entire length of your limb. This will cause a gradual twisting of the limb from the child (which turns fully) to the parent, which remains stationary. However, if your limb is supposed to be less malleable, it would be better to confine the blend zone to a small area at the parent–limb or limb–child border.

The Twist Bar is the only joint parameter seriously affected by the orientation of the JP center. The Twist Bar will follow the axis of the center point. (See Figure 2.3.)

Figure 2.3 If your limb is at an angle, and your Twist Bar is straight, the limb will wrap around as you twist it. If your center is off-center to your limb, it will cause a "wrapping" effect, or bobbling as the limb rotates around a center that is outside of it.

The other unique property of the Twist Bar is that it is the only JP that can include or exclude the body part 100%. The Twist Bar is confined to one axis along its length, but the ends can move anywhere along that axis, including totally outside the body part. This is useful whenever you want to rotate a body part 360 degrees or more, without it distorting. (See *Limb angles and rotation orders* under *Figure creation: Theory* in Chapter 4 for non-standard uses of the Twist Bar.)

There is not much to the twist controls in the JP Window. There is the option to use spherical falloff zones. (Display deformer simply turns on the JP visibility in the workspace. Since it's difficult to adjust things well if you can't see them, it isn't very useful.)

The Twist Start and Twist End have numerical entries here, although it is much easier to just grab the ends in the window and drag them around.

The Bend X

These JPs, used on the "side–side" and "bend" joints, look like Xs with two red arms and two green arms. Everything between the green arms *does* move. Everything between the red arms does *not*. Between the red and green arms is the blend zone.

If your limb's parent is to be rigid, the red arms of the X must move closer to the green. Be careful of how close the red and green arms come, and note how they interact as you bend the

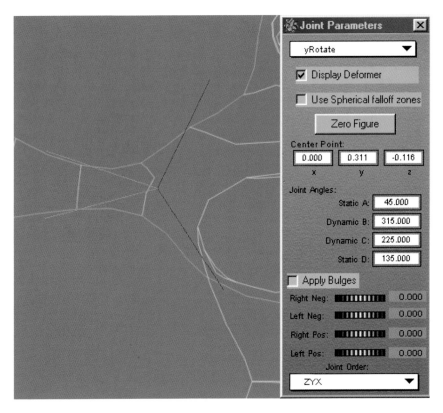

Figure 2.4 Bend X optimal spread: When editing the Bend X, the optimal spread is usually to have the green arms tangent to the corners of the part–child seam, and the red arms tangent to the parent–grandparent seam. This yields the largest blend zone for smooth bending, without distorting the seams between the body parts.

limb. When the green arm meets the red arm, crunching occurs. This happens when the moving polygons of the inclusion and blend zones hit the un-moving polygons in the exclusion zone. The moving portions continue, into and beyond the un-moving portions, causing the jagged joint seams.

When you are setting the JPs, remember that the delimiters go well beyond the spiky little sticks that you see as you are editing them. Those green and red sticks are infinitely long, so even if they do not appear to reach the end of the limb's child, their effect will. In addition, each "stick" is really an infinitely long rectangle, extending into space perpendicular to the joint's angle of effect. Keep this in mind when bits of the parent are far from the child. (See Figure 2.5.)

To limit these infinite projections, use spherical falloff zones for the joint.

Now the JP Window controls are getting fancy. Besides the usual controls, we also have the coordinates for the center point, again. Remember, if you move the Bend X control around, you are also moving the center point. Since it is easier to see what you are doing with the Bend X, this is the better way to fine-tune the center point location.

Figure 2.5 Here the Bend X arms of the index finger are shown as long sheets, so you can see how they cut through the hand along its entire length.

In the middle are the Joint Angles. The Static/Dynamic A-B-C-D refer to the arms of the X. The static ones are red, and the dynamic ones are green. But which letter corresponds to which arm? I don't know: I just drag them around in the window. But the Static/Dynamic numeric values are how they are represented in the CR2.

At the bottom is the "Apply Bulges" section. If your elbow polygons stretch and appear to deflate into the arm while your forearm bends, you can use this to bulge them out again. Or you can use an inverse bulge in areas where things are puffing out too far as you bend the limb. Basically, if you see any pinching or unwanted puffing at your joints, you can try this option to see if it can improve the situation.

We will see how to use the Apply Bulges option in the *JP Practice* section, on the Norn's foot. But basically, the bulge will affect the polygons between the red and green arms of the Bend X on one side or the other (the "Right" or "Left" side). The "Pos" and "Neg" refer to the value of the bend dial – whether it is a positive value or negative. With these controls, you can have one side bulge inward at negative values and outward at positive values. And the other side can do the same, or different, or have zero values.

MatSphere Zones

When using spherical falloff zones, the innerMatSphere and outerMatSphere are displayed. They are green and red, respectively. Everything inside the green sphere *does* move. Everything outside the red sphere does *not* move, *unless* it is also inside the green sphere. Between the spheres is the blend zone.

Normally, you will not need to use the MatSpheres, but there are two instances where you must use them. The first is when a limb has more than one child. Both children will affect their parent, and possibly cause distortion in the seam between the parent and their sibling. MatSpheres will

Figure 2.6 The innerMatSphere (green) and outerMatSphere (red). Spherical Falloff Zones can be used on any type of joint, whether Twist Bar or Bend X.

isolate the effect, and prevent this sibling rivalry. You may be able to get away without using MatSpheres, if the children are far enough apart, or the straight Bend X JPs isolate them easily enough.

The other instance will occur with odd-shaped parents. If part of the parent sticks out over or near the child, you may need MatSpheres to exclude bits of the parent that cannot be excluded with straight Bend X JPs. This typically occurs with a jaw, which needs to affect the lower part of the head, but not any muzzle or nose that sticks out over the jaw.

Joint parameters: Practice

On the CD you will find the walkthroughs for setting up joints on the Norn, which will cover regular joints, joints that use spherical falloff zones, and tricky joint setups such as a posable jaw, eyes, and eyelids. It will also tell you how to deal with that "Head is Not a Body Part" bug in pre-P5 Posers!

Also, there is the Mantabat tutorial, which discusses the modeling, development, and jointing of webbed wings, such as for a bat or dragon.

Building for joints

When building your figure, keep these joint concerns in mind:

- The limbs should be fairly straight, to avoid excess crunching as they try to bend, or too much stretching as they extend.
- Keep the mesh dense near bending joints. The more flexible an object, the more mesh density it will need.
- Watch out for areas of sibling rivalry: where the chest, neck, and arms come together; where fingers attach to a hand; etc. Make sure the parent part has enough mesh between siblings as a buffer zone. (See also *Advanced figure design* in Chapter 4 for details on buffer body parts.)

If you have angled parts (jaws, thumbs, wing struts), try to keep them on regular angles, to make the axes easier to align. Build jaws open enough to insert JPs, but not so far open that closing them causes a lot of mesh crunch.

Keep an eye on parent–child and grandparent–grandchild relationships, to make sure you are not causing any joint situation where a body part will not be able to affect areas of the mesh that it should (or that it will affect areas that it shouldn't). (See *Advanced figure design* and *Clothing design* in Chapter 4 for tricky body part divisions and jointing.)

Always remember: Children Affect Their Parents!

Poser library files

CR2: Theory

This is the heart, soul, and mind of your figure. Although it is possible to create a simple figure without ever tinkering with the internal aspects of the CR2, there will no doubt come a point where you want to rearrange your morph order, or need to change the internal name of a dial. If you want to get into fancy tricks such as Easy Pose, Extended Remote Control, and Geometry Swapping, then you will need to be familiar with the structure of the Poser library files.

All the files are simple text files, and can be viewed in any plain text editor. I prefer using John Stallings' CR2 Edit(or), because it shows the file in a hierarchical structure, with branches that can be collapsed or expanded as needed. Dan Wilmes' CR2 Edit will also do this, and it also automates several fancy trick operations.

The CR2 has several levels of embedded code, demarked by nested opening and closing brackets. Information enclosed in one set of brackets is referred to as a node, branch, or channel. To avoid confusion, I will refer to the higher levels of nesting as "branches," and "node" as the information in the terminal branches. The term "channels" will be reserved for the nodes in the "channels" branch.

CR2 sections (top level)

At its most stripped-down, the hierarchy of a CR2 will look like this:

```
version
figureResFile :directory:obfile.obj
actor bodypart
figureResFile :directory:obfile.obj
```

```
actor bodypart
figure
```

There are four main sections, and two figureResFile pointers. The first, oft-overlooked, section is the Version section. It denotes what version of Poser the figure was saved under. The second section is called the "First" or "Top" or "Geometry" section. We will call it the Geometry section, because this is where the geometry pointers (or embedded geometry) reside.

The third section is referred to as the "Second," "Bottom," "Body," or "Channels" section because it contains the channels that control the body parts. In order not to confuse this section with the channels branch, we will call it the "Controls" section.

The fourth section has only one name: "Figure," which is what the top level node is called in the CR2, so it is easy to remember.

Note: You may see number tags on all the part names, such as BODY:2 or hip:1 or head:13. These are the figure number tags, and should be consistent for each figure. If you load and delete several figures in succession in your Poser workspace, they may all read as Figure 1, but they will have incremented tag numbers. The only time you will get :1 tag numbers is when you first open Poser, or use the "New" file option.

If you are working on a single-figure figure (i.e. one not made up of two or more figures parented together), it is safe to remove these tags by searching for ":1" (or ":3" etc.) and replacing it with " " (null). This will not cause any problems, as there are no other instances of colons and numbers appearing together, *unless* your Geometry directory begins with a number. (For example, I once accidentally changed :Runtime:Geometries:3DM:etc. into :Runtime:Geometries:DM:etc.)

Removing the tag number makes editing a bit easier, when you do not have to type :3 after every body part name. After you remove the tag number, and if it is not :1, check the Figure section for the figure name, which should be set to Figure 1 if you are not using a figure name. In addition, remember to check any Full Body Morph or other ERC pointers, to make sure they are using Figure 1, or the proper figure name.

Now we will delve deeper into the different sections, layer by layer.

FigureResFile pointers

```
figureResFile :Runtime:Geometries:norns:BBN.obj
```

or

```
figureResFile P:\P4\Runtime\Geometries\dogHi\dogHiP3.obj
```

(Poser 5 only).

This is fairly simple: the figureResFile statement is followed by the path (beginning in your top Poser directory) to your OBJ file. Note the directory dividers use the Mac format colons instead of PC format backslashes. Poser 5 may use backslashes and the full path. Proper capitalization is important here, or the file will not be found. In this case, BBN.OBJ or bbn.obj would be incorrect.

The figureResFile statement usually appears twice in the CR2, once at the head of the Geometry section, and once at the head of the Controls section. Sometimes the second entry may be missing, with no detriment to the figure. It is theorized that the second entry is used to "remind" Poser what geometry it is using for the following section, in the cases where other geometry appears between the Controls section and the first figureResFile statement. For example, the figure may have props or other embedded geometry in the Geometry section, or the CR2 may be a multi-figure character, with two or more figureResFiles in use. Both of the figureResFile entries should be identical.

You may be missing the top figureResFile entry, if your figure is made up entirely of embedded geometry (such as occurs when you use the P4 Hierarchy method of figure creation). In this case, you need not worry about the pointer, as there is no external OBJ.

The Version section (one level)

```
version
{
        number 3.0
}
```

Short and sweet, the version section contains a node with a number. This number is the version of Poser in which the figure was created (or later saved). This may be 3, 3.01, 4, 4.01, or 4.2, which is the Pro Pack, and now 5.

If you attempt to open a CR2 (or any file) with a version number higher than your current version of Poser, a warning message will be generated: "This file has a higher version number than expected. Poser will attempt to read it anyway." Normally, there is no problem reading the figure, even if it is a version 4 figure being read into version 3, with its transparency and reflection materials, full body morphs, etc. There are, however, certain things that will choke Poser 3. See the P4 to P3 conversion table in the Introduction.

Similarly, Poser 5 files can be read by P4/PPP, although these previous versions will ignore the dynamic stuff, dial groups, and the P5 Shader Trees.

If you are making a figure or prop for release to work with all versions of Poser, you might want to manually change the version to 3, in order to avoid that warning popping up when people use it.

Another item of note for the version section is a PZ2 trick. If you set a PZ2 (Pose) file to version 3, you can use the code "on" and "off" for each body part to show/hide the part. In later

versions, it is impossible to create a Pose file to turn parts invisible or visible. (See the MAT, MOR, and other special Pose files discussed under *CR2: Practice* below.)

The Geometry section (one level)

```
actor hip:2
{
        storageOffset 0 0 0
        geomHandlerGeom 13 hip
}
```

The BODY entry is an empty channel at the top. Then each body part appears, in its hierarchical order. There are two nodes in each branch, the storageOffset and the geomHandler.

The storageOffset is always 0 0 0. Theoretically, you should be able to create a repeating-element figure by using different offsets in each part. For example, a chain could be made up of one repeated link, if each copy of the base link were raised above the previous. However, in practice, this doesn't seem to work. All the links, no matter their offset value, appeared in the same place. However, the centers were all offset, so they rotated from different positions. Perhaps the storageOffset is not meant to affect the actual positioning of the mesh, only its center.

```
        geomHandlerGeom 13 hip
```

The geomHandler has three parts. First is the "geomHandlerGeom" statement. The second is an actor resource number. Number 13 means a body part. All the body parts, on all figures, should use this number. The third part is the name of the group within your OBJ file. Normally, this is the same as the body part name, but it doesn't have to be.

When I created the Norn, I named the toes as l/rToes. However, I later found that the standard naming convention is l/rToe, singular. So I just changed the body part name to Toe, and left the OBJ group name as Toes.

```
actor rToe
{
        storageOffset 0 0 0
        geomHandlerGeom 13 rToes
}
```

If your figure has embedded geometry, the body part branches will be very different. They will be much larger. Embedded geometry will have only one branch under the body part, labeled "geomCustom." (See Figure 3.1.)

Figure 3.1 This is a collapsed view of a geomCustom actor entry. Inside the actor, you will find the geometry: vertices, groups, materials . . . and tons of coordinates. This is basically the same structure as OBJ file data, plugged right into the CR2.

If the figure has any props associated with it, they will appear at the bottom of the body part list. This includes any Magnet or wave deformers on the figure. (See *Other Poser library files* under *CR2: Practice* below for details on Prop file structure.)

The Controls section: level 1 – basic body part controls

Figure 3.2 Basic controls for the BODY and hip actors.

Name [name/GetStringRes]

```
name GetStringRes(1024,6)
```

or

```
name Left Hand
```

This is the external name of the object. This may use a GetStringRes lookup table, if you have used a standard body part name.

On [Off]

```
on
```

This means whether the body part is on or off, or, more simply "visible" or "invisible," as in the Object Properties "Visible" checkbox in the Poser workspace. Not to be confused with "hidden." Change this to off to make the object invisible.

Bend [1/0]

```
bend 1
```

This tells the part to bend; that is, to let its mesh warp and stretch in the joint parameter blend zones. This is the same as the Object Properties "Bend" checkbox. Change to bend 0 to make the object unbending.

DynamicsLock [0/1]

```
dynamicsLock 0
```

This defines whether the body part is deformed by joint movement. This should be set to 1 (locked) for the BODY and hip (the base body part), and 0 (unlocked) for all other body parts. When you twist the BODY, for example, the whole thing moves, not like some huge Twist Bar that makes your figure spiral from top to bottom (which might be interesting, but not very helpful!). The same with the hip: when you twist or bend the hip, it doesn't deform its shape, the whole thing (and all its children) moves. In contrast, the abdomen can twist or bend along its length, depending on how its joint parameters are set up.

Changing this to 0 for the DynamicLocked parts will have no effect, unless you also add in JPs to affect them.

Changing this to 1 for DynamicUnLocked parts will also have no effect (probably need to delete the JP channels) but it is supposed to prevent the body part from deforming as it bends. If this is

what you are trying to accomplish, you can leave the DynamicLock alone, and just delete the joint channels (which are in the next level of the CR2, see below.)

Hidden [0/1]

```
hidden 0
```

This is not the visibility option of the body part; rather it defines whether you can select the body part. 0 means it is not hidden, you can grab it. 1 means you can see it, but not select it. This option also removes it from the body part list. If you have created buffer body parts that are not meant to be posed, you can hide them in plain sight. Or you can use this on your worst enemy to drive them crazy trying to select unselectable body parts!

AddToMenu [1/0]

```
addToMenu 1
```

This is supposed to place the body part in the body part list, or leave it out. It seems to have no effect in Poser 4 and above. The body part appears in the menu, unless its hidden attribute is 1.

CastsShadow [1/0]

```
castsShadow 1
```

As in the Object Properties "Casts shadow" checkbox, 1 will cast a shadow, and 0 will not.

IncludeInDepthCue [1/0]

```
includeInDepthCue 1
```

This controls whether the workspace fog affects the object when depth-cueing is turned on. I am not sure what use there might be for this. Perhaps you might one day want your figure to have eyes that pierce the fog, or something.

Parent [parent]

```
parent hip:1
```

Defines the object's parent. The parent for the BODY is the "UNIVERSE," for the hip it is "BODY." Other body parts follow the hierarchy. (Note: for IK chain goals, this value changes, depending on whether the IK chain is on or off. See below.)

InkyParent [parent] (optional)

```
inkyParent BODY:1
```

This only appears in body parts that are the goal of an IK chain. This defines the parent of the body part when the IK chain is turned on. Normally, it is the BODY, which means the hand or foot (usually) moves along when you grab the BODY and move it, but stands still when you move other body parts.

NonInkyParent [parent] (optional)

```
nonInkyParent rShin:1
```

The normal parent of the IK chain goal in the hierarchy. This is stored here, because when IK is turned on, the parent parameter changes to the inkyParent.

ConformingTarget [body part] (optional)

```
conformingTarget BODY:4
```

This appears when the figure has been set to conform to another, and is saved to the Library. It does not appear (nor needs to appear) on conforming figures that are saved by themselves. (See Chapter 4.)

AlternateGeom [body part_number] (optional)

```
alternateGeom hip_1
{
        name Genitals Off
        objFile 20 :Runtime:Geometries:newMaleNudeHi:newHipNoGen.obj
}
```

If a body part is using Geometry Swapping, this entry (or entries) appears here. (See *Geometry Swapping* under *CR2: Practice* below for details on these controls.)

[CHANNELS]

The channels branch opens a new level of the CR2; see the *Channels* section below for the controls located in here.

EndPoint [coordinates]

```
endPoint 0 0.175 1.123
```

This defines the end point of the body part, which is visible (in some parts) in joint editing as a red cross-hair.

Origin [coordinates]

```
origin -0.001337 0.175806 0.945396
```

This defines the center of the object, which is shown as a green cross-hair when editing JPs. Note that these coordinates also appear in the joint/joint/twist channel nodes as the "center" entry.

Orientation [angles]

```
orientation 0 0 0
```

This defines the rotation of the center (origin) and end point. This can be changed in the JP Window, by using the rotation controls, or by moving the center/end point and hitting the "Align" button. (See *Joint parameters: Theory* in Chapter 2.)

DisplayOrigin [0/1]

```
displayOrigin 0
```

This toggles the cross-hair display of the object's center. This is like the "Display Origin" checkbox option for Prop properties. Should you ever want all your body parts to have match-ing green lines sticking out of them, this is your parameter.

DisplayMode [mode]

```
displayMode USEPARENT
```

This defines how the object is displayed in the workspace, as in the menu Display: Element Style. Unless changed with the menu, all body parts use the figure display style by passing the display style down the hierarchy (thus the default mode: "USEPARENT"). Since the BODY's parent is the UNIVERSE, the BODY (and everything else) uses the document display setting. (See *The Figure section* below for a list of display mode values.)

CustomMaterial [0/#]

```
customMaterial 0
```

This entry allows you to change material settings on body parts, individually. The default value, 0, means do not use a custom material. Instead, the body part uses its assigned materials, as defined in the Figure section. If you assign a custom number instead, you can insert a new

material definition, which will override the normal materials for this part. This is used in some MAT Pose files (see *Other Poser library files: MAT-DIV Pose files*).

Locked [0/1]

```
locked 0
```

This defines if the object can be moved or changed (i.e.: with morphs). This can be set in Poser with the Object: Lock Actor menu command.

BackfaceCull [0/1] (Poser 5 only)

```
backfaceCull 0
```

This is a rendering option that is normally only controlled in the Render Options dialog; it tells the renderer not to bother with polygons that face away from the camera. If you have thin membranes, you need to turn the backface culling off, but since this entry is overridden by the render options, there is really no use to it here.

VisibleInReflections [1/0] (Poser 5 only)

```
visibleInReflections 1
```

This corresponds to the "Visible in Ray Tracing" property. When set to 0, an object will be ignored during the FireFly ray tracing when it is calculating reflections.

VisibleInRender [1/0] (Poser 5 only)

```
visibleInRender 1
```

There is no in-Poser control for this, but it makes your object not render. This would be handy if your figure has control handles or eye pointers or other tools that are not meant to be seen in the final image. This only works with the FireFly render engine, the P4 renderer will ignore this control.

DisplacementBounds [value] (Poser 5 only)

```
displacementBounds 0
```

This defines how far out a displacement map can push the mesh. If the displacement map tries to extend the mesh past the boundaries, clipping will occur. If your fuzzy sweater or mountainous terrain shows a lot of black triangles or lines when rendering, it is due to the displacement clipping. Extend the Displacement Bounds, which can be done in Poser with the Properties palette.

There is also a master Displacement Bounds control in the render options. Values entered there will add to the displacement limit assigned to each object in the scene.

ShadingRate [value] (Poser 5 only)

```
shadingRate 0.2
```

This controls the render engine polygon subdividing or "dicing," and defines how many sub-polygons to assign to each polygon during a render. Basically, it creates smoother shading gradients across the polygons. This control is available in the Properties palette for each object. There is also a master control for this in the render options.

SmoothPolys [1/0] (Poser 5 only)

```
smoothPolys 1
```

This is another rendering control; it will not affect how the object looks in Poser. When on (1), the render engine will smooth the polygons of the object. When off, it won't. For organic models, this should be 1, but if you are attempting to create hard edges, set this to 0. This is also controllable in Poser for each object, and in the render options.

MorphPutty (Poser 5 only)

```
morphPutty
{
        inactiveGroup Lipsync Morphs
        inactiveGroup Wrinkle Morphs
}
```

These settings work with the P5 Morph Putty tool, defining which morph groups to ignore during Morph Putty manipulation. See the *Channels* section below for dial group information.

The Controls section: level 2 – channels

Most of the nodes here are dials that are displayed in Poser, such as morph dials and Twist, Side-Side, Bend dials. Some of them are joint parameters, which do not have corresponding dials. Some are actually channels from other body parts.

Figure 3.3 Inside the Channels branch.

[BASIC ENTRIES]

The nodes in this branch have the same basic structure, as shown in Figure 3.4. Some controls have additional parameters, which will be detailed in the individual entries.

Figure 3.4 The basic entries of a plain dial.

Name [name]

```
name GetStringRes(1028,5)
```

This is the external name. If the node is a dial or joint parameter, this is displayed in Poser. Naturally, there are GetStringRes entries for use here, as well.

InitValue [value]

```
initValue 1
```

This is the memorized value of the object, which is set by the Edit: Memorize: Figure/Element menu. Note: it is *not* the initial value, which is located in the k 0 entry in the keys (see below). Most often, this initValue is the same as the k 0 value, anyway. (See *Finalization* in Chapter 4 for discussion of initial and memorized values.)

Hidden [0/1]

```
hidden 0
```

This specifies whether the control is visible in Poser (as a dial) in the workspace or not. Morphs, scaling, tapering, and rotation controls are typical dials you see in Poser. Sometimes the translation dials are displayed as well. The rest are not displayed as dials, and so are set to hidden 1.

ForceLimits [0/non-0]

```
forceLimits 0
```

When this is zero, limits for this channel will only be used when the Poser Workspace is set to "Use Limits." When it is non-zero (most often 4, although nobody knows why), the channel will obey its limits, regardless of the workspace setting.

Min [value]
Max [value]

```
min 0.1
max 100000
```

These are the minimum/maximum values allowed for this entry. If it is a dial in Poser, this can be set by double-clicking the dial. These can be a negative, zero, or positive value, and the max needs to be higher than the min (or the same). The default is .1–100000 for scaling dials, and −/+360000 for rotation dials (or, basically, ridiculously high numbers that are effectively no limit).

TrackingScale [value]

```
trackingScale 0.004
```

This controls the turning speed of the dial in Poser, by setting the increment value. If the value is 1, the dial jumps by whole integers, and turns very quickly. This is another parameter that can be set inside Poser by double-clicking a dial. Note that for some reason Poser ignores values entered here on morph dials, and uses its own (sometimes very minuscule) values when it loads the figure.

Keys

```
keys
{
        static 0
        k 0 1
}
```

These are keyframes, for animation. Normally, a figure will not have keyframes; a PZ3 or a Pose file might. (See *Scene files: PZ3* below.) The format is k [keyframe number] [value]. So here, keyframe 0, the value of this dial is 1.

k 0 is the initial value of the parameter when the figure is loaded, not to be confused with the initValue entry (see above).

The static entry defines whether the object is animating (static 0) or not (static 1).

InterpStyleLocked [0/1]

```
interpStyleLocked 0
```

This is set to 0 for all channels except Geom Swapper dials, in which case it is 1. It is not clear what this entry does exactly, but convention should be followed. (See *Geometry Swapping* under *CR2: Practice* below.)

[Slave Entries] (set of five, optional)

```
valueOpDeltaAdd
Figure 1
BODY:1
Belly
deltaAddDelta 1.000000
```

If the channel is slaved to another, these five lines appear just after the interpStyleLocked entry. The valueOpDeltaAdd tells Poser to add a change (delta) control to the master channel. The next three lines define where the master dial is located, via figure name, body part, and dial

name. Finally, deltaAddDelta tells Poser the control ratio used between the slave and master dial. (See *Extended Remote Control* under *CR2: Practice* below for details on master/slave dials.)

Channels

Now for the actual nodes present in the channels branch, in typical order of appearance. If you are working on a figure created in the PPP/P5 Setup Room, the channel order will be different.

Groups (Poser 5 only) (optional)

```
groups
{
        groupNode Nose Morphs
        {
                collapsed 1
                parmNode N_SmileOpen1
                parmNode N_SmileClosed2
                parmNode N_Furious
                parmNode N_CryOpen
        }
        groupNode Transform
        {
                collapsed 1
                parmNode taper
                parmNode scale
                parmNode xScale
                parmNode yScale
                parmNode zScale
                parmNode yrot
                parmNode zrot
                parmNode xrot
        }
}
```

These define the dial groupings in P5. The syntax for each group is "groupNode" followed by the group name.

The first entry is collapsed with a value of 1 for collapsed or closed, and 0 for open.

Then follows a list of which dials are in the group with the syntax "parmNode" and the internal name of the dial. Note that dial groups can be nested, so you may see more levels embedded here.

ValueParm [name] (optional)

```
valueParm Belly
[base entries only]
```

ValueParm is basically an empty dial that is used as a master dial to control other, slave dials. (See *Extended Remote Control* under *CR2: Practice* below for more information on master and slave dials.)

GeomChan [bodypart]geom (optional)

```
geomChan hipGeom
[base entries only]
```

This is a dial in Poser that controls which variant geometry is displayed on the body part. (See *Geometry Swapping* under *CR2: Practice* below for details on this control.)

TargetGeom [name] (optional)

```
targetGeom Jaw
{
        [basic entries]
        indexes 1543
        numbDeltas 3665
        deltas
[a huge list of ''d'' numbers]
}
```

"TargetGeom" is a morph dial, and the name is the internal morph name, which is assigned in Poser when the morph target is imported, or created from deformers. Note that the external name of the morph can be changed in Poser by double-clicking the dial, but the internal name cannot. (See *Telescoping morphs* in *Trouble-shooting: Morphs and morphing* in Chapter 6 for problems with the internal name.)

After the basic entries comes the "indexes" entry, which tells Poser how many of the original vertices have been moved with this morph. "numbDeltas" is the total number of vertices in the body part. It is not clear why Pose might need to know this in the CR2. Perhaps if this value does not match the actual number of vertices, the dial has no effect. Bizarre results may occur if you "fix" this number to make a morph designed for a different figure match a new target figure.

"deltas" introduces the delta listing, which is a huge list of numbers. The deltas are in the format

d [delta#] [vector coordinat]

```
d 29 0 0.0191741 0.00870335
```

The delta number is the number of the vertex being moved, and the coordinates define x, y, and z translation values. (See *Morphing: Theory* in Chapter 6 for discussion on vertex orders and vector differences.)

Twist/joint/joint[axis] [child]_twist/joint/joint[axis] (optional)

```
twistZ chest_twistz
{
        [basic entries]
        otherActor chest:1
        matrixActor NULL
        center 0 0.083675 0.559101
        startPt 0.609529
        endPt 0.459101
        flipped
        calcWeights
}
```

These are the "affectors," channels that tell a body part how to respond to its children's bending. There will be a set of entries for each child the body part has. If it has no children, there are no entries, of course.

These entries are identical to the child's joint/joint/twist entries (the joint parameters), with the exception of the name, which is tagged with the child's name; the otherActor entry which names the child; and the "flipped" parameter. (See *Affectors* under *CR2: Practice* below for discussion and structure details of this node and the related nodes in the children.)

Note that the entries after the basic entries will be different for twist-style joints than bend-style joints. (See *Twist* and *Joint* sections below.)

Taper[axis] Taper

```
taperZ taper
      [basic entries only]
```

This is the Taper dial in Poser, obviously. It is automatically applied to a body part's twist axis (Z in this example). If you add Taper dials to the CR2, only the first one will be read and used.

SmoothScale[axis] [child/parent]_Smoo[axis]

```
smoothScaleZ chest_smooZ
{
        [basic entries]
        smoothZones -100 -99 0.507361 0.587176
        otherActor chest:1
```

```
                    flipped (only for the parent entry)
                    calcWeights
          }
```

There will be one smoozing or smooxing (or smooying) entry for each child of the body part, then one for the parent.

The smoothZones define the red and green ends of the smoothing Twist Bar control. Note that these will match the entries of the other actor's smooxing, in reverse pairing and order. For example, take a look at the smoothZones for the abdomen smoothing with the chest (top) and the chest smoothing with the abdomen (bottom):

```
          smoothZones -100 -99 0.507361 0.587176
          smoothZones 0.507361 0.587176 99 100
```

There are two pairs or coordinates, with positions switched from parent to child. The first entry is also inverted, with reversed polarity.

Then again, you could just edit the Smooth Scaling in the JP Window in Poser. It is easier.

otherActor defines what the body part is interacting with; it will name the child or the parent, whichever the entry is for. You will see this in the joint/joint/twist, as well.

Note that the smoothScale entry for the body part's parent will be slightly different than the one for its child(ren). It will have a "flipped" line before the calcWeights.

I confess to having no idea what calcWeights is. This is also a typical entry for joint parameters. I expect it means "this is the end of the parameters, now calculate how they work" – or something like that.

[axis]OffsetA [axis]Offset

```
          zOffsetA zOffset
          {
                    name GetStringRes(1028,38)
                    initValue 0.419086
                    hidden 1
                    forceLimits 0
                    min -100000
                    max 100000
                    trackingScale 0.004
                    keys
                    {
                              static 1
                              k 0 0
                    }
```

```
                    interpStyleLocked 0
                    staticValue 0.419086
          }
```

The Offset A and B channels are used by Poser in some arcane way to calculate how to position and bend body parts. Note that the Offset A channels use the x/y/z coordinates of the body part's center. Experiment with changing the Offsets carefully; they may cause the figure to stop working properly.

Note this channel uses some non-default settings for the basic entries. In the keys, static is set to 1; it is not animating. Also below the interpStyleLocked, is an entry for the staticValue, which corresponds to the initValue.

The Offset B channels are located further below.

Scale scale or propagatingScale scale

```
          scale scale
```

or

```
          propagatingScale scale
          [basic entries only]
```

This is the universal scaling control for the body part. PropagatingScale is usually seen on the BODY, and it is used to scale all the body part's descendants with it. (See *Scaling* under *CR2: Practice* below for information on Propagating Scale.)

Remember that the base init and k 0 values are usually 1 (100%) for scaling channels, not 0 as is typical for translation and rotation channels.

Scale[axis] [axis]Scale or propagatingScale[axis] [axis]Scale

```
          scaleX xScale
```

or

```
          propagatingScaleX xScale
          [basic entries only]
```

These are just like the main scale control, but work only on one axis. They can also be propagating, whether or not the main scaling function is as well.

Joint[axis] joint[axis]

```
jointZ jointz
{
        [basic entries]
        angles -130.664 -154.914 -188.03 118.402
        otherActor chest:1
        matrixActor NULL
        center -0.006 0.361076 -0.018
        sphereMatsRaw
        0.0386172 0 0 0
        0 0.0386172 0 0
        0 0 0.0386172 0
        -0.0545312 0.359811 -0.0325525 1
        0.051102 0 0 0
        0 0.0502059 0 0
        0 0 0.051102 0
        -0.0525712 0.350929 -0.0317516 1
        doBulge 1
        posBulgeLeft 0
        posBulgeRight 0
        negBulgeLeft -0.05025
        negBulgeRight 0
        jointMult 1
        calcWeights
}
```

This is a Bend X style joint parameter. Below the typical channel entries are the JP controls.

Angles: These define the positions of the Bend X arms.

OtherActor [parent]: This defines what other actor has a stake in the bending going on for this joint. (When children bend they affect their parents – remember CATP!)

MatrixActor NULL: Nobody knows what this is, or what other values it may take. It could be a Poser 2 or Poser 1 control left over from the dark ages.

Center: Coordinates for the JP center, which match the Origin channel settings. Note that if you try to give each joint parameter its own center, it won't work. Poser will use the Origin for all JP centers.

SphereMatsRaw (optional): This appears when "Use Spherical Falloff Zones" is turned on for the joint. The numbers that follow define the inner and outer MatSpheres.

DoBulge [1/0]: When the "Bulge" option is turned on in the JP Window, this is set to 1, and the bulge settings are listed.

JointMult 1: If you change the value of this, the joint will act strangely and not bend smoothly. I have no idea what its purpose might be.

CalcWeights: Again, it is not clear what this does, except perhaps to tell Poser to do a calculation on the joint.

Twist[axis] twist[axis]

```
twistZ twistz
{
        [basic entries]
        otherActor hip:1
        matrixActor NULL
        center 0 0.088112 0.419086
        startPt 0.419086
        endPt 0.559101
        calcWeights
}
```

These are the controls for the Twist Bar JP. Basically, it is the same as the Bend X control, but it only contains a startPt and endPt entry. Note that if spherical falloff zones were in use, those would appear here, after the endPt and before the calcWeights.

Also note that the twist JP appears last in the channels, although it is the first axis and the first dial. The joint/joint/twist section of the channels are in reverse order. It is not clear why, but the order should not be changed unless you want to alter how the joint works.

Rotate[axis] [axis]rot

```
rotateX xrot
[basic entries only]
```

The rots are the rotation dials that appear in Poser. Don't confuse the joint/joint/twist with the rotate/rotate/rotate. Unlike the joint/joint/twist channels, you can rearrange the orders of these channels to suit yourself. However, do *not* put them above the joint/joint/twist entries, or the body part won't know how to behave when you turn the dials.

[axis]OffsetB [axis]TransB

```
xOffsetB xTransB
{
        name GetStringRes(1028,33)
        initValue 0.176
        hidden 1
        forceLimits 0
        min -100000
```

```
max 100000
trackingScale 0.004
keys
{
        static 1
        k 0 0
}
interpStyleLocked 0
staticValue 0.176
}
```

This is the other half of the Offset pair, which apparently calculates the position of the body part in space. As with the Offset A entries, it is not clear what these channels do, exactly, but Poser uses them to calculate the bending and positioning of the figure. Do not play about with the Offsets, unless you want to experiment with them and see what a mess you can make. Whatever you do, do *not* move the Offsets in relation to the other channels. The JP channels, in particular, need to be between the two Offset sets in order for the figure to work properly.

Translate[axis] [axis]tran

```
translateY ytran
[basic entries only]
```

These are the translation dials, as are typically seen on the BODY and hip, for moving the object around in the scene. On all other body parts, these are usually hidden, unless IK is turned on and the body part is the goal of an IK chain (or if you built the figure the Setup Room of PPP/ P5). On many figures the translation dials for the eyes are made visible, so the user can adjust their positioning. If you want your eyes to have these controls, you will have to edit the CR2 to make them appear. (See *Dial operations* under *CR2: Practice* below.)

Figure 3.5 This is a collection of information that deals with the figure parts in relation to each other, and the figure as a whole. This list is abbreviated to show all the relative sections.

The Figure section: level 1 – everything

Name [name]

```
name Figure 1
```

This is the figure name, obviously. Poser assigns a figure name/number as you load your figure into the scene. This may also be a real name, if the figure was saved with a hand-entered name. (This can be done in Poser by selecting the BODY and viewing the information (<Ctrl–I>) and entering a new name.)

Note that this must match the figure named in any slaved dials. Before Poser 5, this value (the figure name) was changed with each subsequently loaded figure, but the slave dials' figure name references were not, and thus cross-talk occurred. (See *Cross-talk* under *Morphing: Theory* in Chapter 1.)

Root [body part]

```
root BODY:1
```

This defines the BODY, which is usually the BODY. This is the "part" that represents the entire figure.

AddChild [child];[parent]

```
addChild hip:1
        BODY:1
```

This section builds the figure hierarchy. Each body part is added to its parent. If a body part does not appear here, it is not added to the figure, regardless of whether it has the Geometry and Control section entries.

InkyChain [name]

```
inkyChain leftDinoLeg
{
        on
        name Left Leg
        addLink lThigh:1
        addLink lShin:1
        goal lFoot:1
        linkWeight 0 1
        linkWeight 1 0.05
}
```

The inkyChain entries are the IK chains present in the figure. The first line, on/off, defines whether the IK chain is activated when the figure is loaded. Then the name, the addition of links in the chain, and the goal. Finally, there are linkWeights for each link in the chain. See the IK chain sample figure on the CD, and the accompanying text file for details on IK chains.

DefaultPick [body part]

```
        defaultPick BODY:1
```

This defines what body part (usually the whole BODY) is selected when you grab the figure. I have experimented with making the hip the defaultPick, but it does not seem to work well. Poser is very stubborn about grabbing things by the whole BODY.

DisplayOn[1/0]

```
        displayOn 1
```

This defines whether the figure is visible (1) or invisible (0). This is controlled in Poser from the Figure: Hide Figure menu.

Weld [child]; [parent]

```
        weld abdomen:1
             hip:1
```

Once more through the hierarchy! This time, all the children are welded to their parents. This prevents the seams between body parts from tearing as the figure bends. (See *Welding* under *CR2: Practice* below for more details on welding.)

AllowsBending [1/0]

```
        allowsBending 1
```

This allows the body parts to bend, or not to bend if their "Bend" option is un-checked in the Poser workspace. If this is 0, the body parts will not bend at all.

FigureType[1318/number]

```
        figureType 1318
```

This is apparently a leftover from Poser 1 and 2, where the skeleton, mannequin, and lo-res figures had different identifying numbers. 1318 seems to be the number for custom/new figures.

OrigFigureType [1318/number]

 origFigureType 1318

This is yet another leftover P1/P2 entry. Who knows what it meant?

CanonType [number]

 canonType 8

This is how many heads high the figure is. This is affected by the Figure: Figure Height menu in Poser. If you make your figure Baby or SuperHero sized, then save it, you will have a new canonType.

Conforming [0/1] (optional)

 conforming 0

This is set to 1 when a figure is saved as being conformed to another. But setting this to 1 will not magically make your figure able to conform to something. See the section on *Conforming* under *Figure design* in Chapter 4.

Material [name] and/or presetMaterial [name]

 material skin

or

 presetMaterial skin

The material entries contain information from the Render: Materials dialog box (or P5's Materials Room). Preset materials are just the same as materials, but are left over from Poser 3. If you find Preset materials that match your figure's materials, you can delete them.

If you have edited your figure and changed the number or name of materials in your OBJ file, you may have unused material entries left over in your CR2. These can be deleted, as well. (See *Finalization* in Chapter 4.)

The sub-entries will be discussed in the next section.

DisplayMode [mode]

 displayMode USEPARENT

This is the display type for the entire figure. Normally, this is USEPARENT, so the figure uses the display style chosen by the user for the Poser workspace.

Valid displayModes are:

SILHOUETTE	(silhouette)
EDGESONLY	(outline)
WIREFRAME	(wireframe)
HIDLINE	(hidden line)
SHADEDOUTLINE	(lit wireframe)
FLATSHADED	(flat shaded)
FLATLINED	(flat shaded with lines)
CARTOONNOLINE	(cartoon)
SKETCHSHADED	(cartoon with lines)
SHADED	(smooth shaded)
SMOOTHLINED	(smooth shaded with lines)
TEXTURESHADED	(texture preview)

Locked [0/1]

```
locked 0
```

This defines whether the figure is locked (1) or not (0). The figure can be locked from the Figure: Lock Figure menu. Normally figures are not locked (which helps when you want to pose them!) but conforming clothing can be locked, so it is not inadvertently posed instead of the underlying figure.

The Figure section: level 2 – P3/P4 materials

Inside the Material (or Preset Material) you will find these settings. See *Finalization* in Chapter 4 for information about materials and the material dialogs. Note that figures made in Poser 3 will not have transparency or reflection information.

KdColor [RGBS]

KaColor [RGBS]

KsColor [RGBS]

```
KdColor 0.455306 0.732963 0.134983 1
KaColor 0 0 0 1
KsColor 0.100522 0.0684225 0.101163 1
```

These are the diffuse, ambient, and specular colors. The colors are defined by decimal RGB values (which range from 0 to 1 instead of 0 to 256), plus a value for the strength or luminosity of the color.

TextureColor [1 1 1 S]

```
TextureColor 1 1 1 1
```

This corresponds to the strength of the texture map, as set in the P4 Material Window. The RGB is always "1 1 1," or white. The final number is changed based on the texture strength slider. Note that although the texture base color is always white, the texture multiplies with the Kd color, so it is not necessary to tamper with these color settings to tint your texture map. In fact, tampering with these numbers has no effect whatsoever. They are merely placeholders.

NsExponent [percentage number]

```
NsExponent 30
```

This is the highlight (specular) size, as adjusted by the highlight size slider. Instead of a direct correlation with the slider setting, this number is the leftover percentage. For example, the NsExponent 30 means the highlight slider is set to 70%. A value of 40 equals 60% and so on.

TMin [decimal percentage]

TMax [decimal percentage]

```
tMin 0
tMax 0
```

Transparency minimum, actually the transparency of the edges of the object. This is the slider percentage, with 1 being 100%. The transparency maximum is actually the transparency of polygons facing the camera. 1 is equal to 100%.

TExpo [number]

```
tExpo 0.6
```

The rate the transparency changes from the max in the main part of the object, to the edge.

BumpStrength [decimal percentage]

```
bumpStrength 1
```

The strength of the bump map, where 1 is 100%. Note that Poser will not save negative numbers here, although they are valid in the bump strength slider. Negative values will be saved as 0.

KsIngoreTexture [0/1]

```
ksIgnoreTexture 0
```

This corresponds with the checkbox under the texture setting that says "Apply texture to highlights." When the texture is applied to them, the ks (specular color) is told not to ignore the texture.

ReflectThruLights [1/0]

```
reflectThruLights 1
```

This corresponds to the reflection map checkbox "Multiply through Lights."

ReflectThruKd [1/0]

```
reflectThruKd 0
```

This corresponds to the reflection map checkbox "Multiply through Base Color."

TextureMap [NO_MAP/texture file]
BumpMap [NO_MAP/texture file]
ReflectionMap [NO_MAP/texture file]
TransparencyMap [NO_MAP/texture file]

```
textureMap NO_MAP
```

or

```
textureMap ``:runtime:textures:hair:gnblack_tx.jpg''
0 0
```

This lists the texture loaded for the color of the object. This (and the other texture maps) have the value "NO_MAP" when none is loaded. Be careful when making partial MAT Pose files that you do not add the NO_MAP to materials you meant to leave unchanged. (See *Other Poser library files: MAT Pose* below.)

Note: When a texture is loaded in any node that can have a texture, a second line will accompany the entry, which will say "0 0". This is a Mac file function. Although it has no use in Poser 4, if this line is absent in the Pro Pack, the texture will not load properly. This will not appear when the value is NO_MAP.

The bump, reflection, and transparency maps work the same.

ReflectionColor [RGBS]

```
ReflectionColor 1 1 1 1
```

This is the base color for the reflections.

ReflectionStrength [number]

```
reflectionStrength 1
```

This corresponds to the reflection map strength slider, with 1 as 100%.

The Figure section: level 3 – P5 Shader Tree

In addition to these settings, Poser 5 figures will have a channel for the Shader Tree, as built in the P5 Material Room. Note that many of the above values are repeated in the Shader Tree. As you change values in the Material Room tree, the changes will be applied to the "old" materials as well. (Most likely for the P4 renderer compatibility.)

The Shader Tree is made up of nodes. All objects have a main node called "Poser Surface," which corresponds to the main shader control. If there are other nodes, they are "plugged in" to points on the main Poser Surface.

Here is a typical entry for the main node:

```
shaderTree
{
        node ''poser'' ''PoserSurface''
        {
                name ''PoserSurface''
                pos 10 10
                showPreview 1
                nodeInput ''Diffuse_Color''
                {
                        name ''Diffuse_Color''
                        value 0.455306 0.732963 0.134983
                        parmR NO_PARM
                        parmG NO_PARM
                        parmB NO_PARM
                        node NO_NODE
                        file ''''
                }
```

Node "[type]" "[name]"

```
node ''poser'' ''PoserSurface''
```

This is the main node. The type is "poser" and the name (as displayed in the node title bar) is "Poser Surface."

```
node ''brick'' ''Brick''
```

This is an example of a brick node. It is a brick type named "Brick." P5 does not allow you to change the node names, so these are going to be obvious. If there is a second brick node, it will be "Brick_1" and so on.

Pos [x y coordinates]

```
pos 10 10
```

This positions the node in the material workspace.

ShowPreview [1/0]

```
showPreview 1
```

This opens (1) or closes (0) the preview image of the shader, located at the bottom of the node.

NodeInput "[name]"

```
nodeInput ''Diffuse_Color''
```

Each line of the node has an entry, and a subset of values.

The Figure section: level 4 – P5 material node inputs

Name "[name]"

```
name ''Diffuse_Color''
```

This is the name of the node.

Value [RGBS]

```
value 0.455306 0.732963 0.134983
```

This is the numeric value of the color. This works the same as the P3/P4 Kd, Ka, and Ks entries. For this particular one, the Diffuse_Color corresponds exactly with the Kd value.

Parm[R/G/B] [NO_PARM/ ?]

```
parmR NO_PARM
parmG NO_PARM
parmB NO_PARM
```

These are RGB values, obviously, but why they have no parms is a mystery to me. This may be an unused entry for Renderman compliance.

Node [NO_NODE/"name"]

```
node NO_NODE
```

This node entry corresponds to the current node's input jack. If something is plugged in here, then that node will be named, e.g.:

```
node ''Brick''
```

File ["''/file name]

```
file ''''
```

This is space to store a file name, but what file and for what purpose is not clear.

After the main Poser Surface node, the other nodes that are plugged into it will appear, with the same structure. For example, if that brick node were plugged into the Poser Surface, the node brick "Brick" would appear next, with its information. Each type of node will have different types of information; they are too numerous to dissect each one here.

Other Poser library files

Scene files: PZ3

The PZ3 is the same as a CR2, with more information stored in it. Or, more accurately, a CR2 is a stripped-down PZ3. Besides the Version, Geometry, Control, and Figure sections we have seen, the PZ3 contains Light, Camera, and Document information.

The layout of the PZ3 goes like this:

```
[Version]
Movieinfo
prop Ground
```

```
actor UNIVERSE
Light Actors
Camera Actors
[Geometry section of the CR2]
Ground Controls
Light Controls
Camera Controls
[Control section of the CR2]
[Figure section of the CR2]
Doc
IllustrationParms
RenderDefaults
[setGeomHandlerOffset]
```

You may be used to dividing the CR2 by the figureResFile lines, but in the PZ3 the ground, lights and camera items come before the figureResFile lines. Don't let this confuse you; they "belong" to the section below them.

We will not go into the details of the new entries here, as they have no direct bearing on figure creation. If you are working with P3, you should know how to chop a PZ3 to create a multi-figure CR2. This isn't hard; you just delete the sections of the PZ3 that aren't in a CR2. You could simply change the PZ3 extension to CR2 and throw it in your library, but when you load that figure, extra lights and cameras will be added to your scene.

Prop files: PP2 and HR2

Prop files are fairly simple compared to the CR2, since the props do not move around much, and they do not usually have moving parts. Here is the basic structure:

```
Version
Prop Actor
Prop Controls
Doc
```

When you save an object to Poser's Props library, the geometry is embedded right into the PP2. If you wish to use a geometry pointer, you need to edit the file. The process is similar to removing geomCustom entries from a CR2. (See *Removing embedded geometry* under *CR2: Practice* below.)

Simply put, you need to delete the geomCustom entry (and all the v lines in it), and replace it with two lines:

```
prop box_1
        {
        storageOffset 0 0.3487 0
        objFileGeom 0 0 :Runtime:Geometries:props:box.obj
        }
```

Notice that the storageOffset for a prop is different from that for body parts in a figure. Instead of 0 0 0, it is 0 0.3487 0. This simply places the prop slightly above the floor, instead of embedded in the middle of it.

The geometry pointer uses an objFileGeom instead of a geomHandler, as in a CR2. Before you go removing your geomCustom, make sure you have an OBJ file to use! If you created your OBJ to the proper size and position for Poser, you can use that OBJ file. If you brought it into Poser with the "Percentage of Standard Figure Size" or "Centered," "Placed on Floor," or any other import options, or if you resized and repositioned the prop after importing it, you should export it from Poser in this new configuration and use that as your base OBJ. Be sure you settle on your final configuration before creating any morphs for your prop.

Smart props and prop subsets

Starting in P4, if the prop has a parent when it is saved to the library, you have the option of saving that parenting information. Also, you have the option to "Select Subset," which allows you to save more than one prop in a library file, which can be used to save a pair of earrings, for example. The only caveat is, you cannot do both at the same time. If you select a subset, they will not remember their parents. Lastly, if your prop was parented with "Inherit Bends" turned on, it will not reload as a bending prop.

So, what is a CR2 (or PP2) wrangler to do? I like to save the subset of props, and then edit their parents by hand, since it only requires the editing of one central file. You could also save each prop as a smart prop, and then throw all the pieces into one PP2 file.

If you are doing the latter, the PP2 should keep its section ordering. That is, throw all the prop geometry entries in the top, and all the prop channel entries in the bottom. All the addActor bits should go into one doc branch. However, this is not crucial. You can create a geometry/control/doc, geometry/control/doc, geometry/control/doc type PP2 and it should work fine.

Now for parenting the orphaned subsets, we need to find "parent UNIVERSE" in the prop controls branch, and change it to "smartparent [parent]." For example:

Before:

```
parent UNIVERSE
```

After:

```
smartparent head:1
```

This will parent our earrings to the head. Use the :1 as the default for the figure numeric tag. You can also parent props to each other, of course. If your prop has differing internal and external names, make sure you use the internal name here.

Bending props

Props that Inherit Bends literally inherit their parent's joint parameters. If you look at a bending prop within a CR2, you will find the affectors and JPs of its parent copied into the channels branch. If you want your prop to be smart *and* remember to Inherit Bends, you will have to save it in a CR2 (or PZ3), and then extract the prop entries from there. To make things simple, you could save the prop(s) as a PP2, and then just replace the PP2 prop control entries with the CR2 prop control entries. Or, simply put, you have to get the affector and JP channels into your prop in the PP2 (and, if necessary, make sure it has a smartparent).

For example:

Before:

```
prop HH-f-lf
{
        name fet-LFbase
        on
        bend 1
        dynamicsLock 1
        hidden 0
        addToMenu 1
        castsShadow 1
        includeInDepthCue 1
        parent UNIVERSE
        channels
        {
                xOffsetA OriginX
                yOffsetA OriginY
                zOffsetA OriginZ
                scale Scale
                scaleX xScale
                scaleY yScale
                scaleZ zScale
                rotateY yRotate
                rotateZ zRotate
                rotateX xRotate
                xOffsetB xOffB
                yOffsetB yOffB
                zOffsetB zOffB
                translateX xTran
                translateY yTran
                translateZ zTran
        }
        endPoint 0.1 0.055 0.099
        origin 0.1 0.104 0.09
        orientation 0 0 0
```

```
        displayOrigin 0
        displayMode USEPARENT
        customMaterial 1
        material skin
        material Preview
        locked 1
}
```

After:

```
prop HH-f-lf
{
        name fet-LFbase
        on
        bend 1
        dynamicsLock 1
        hidden 0
        addToMenu 1
        castsShadow 1
        includeInDepthCue 1
        smartparent lWrist:1
        channels
        {
                twistY lHand_twisty
                jointZ lHand_jointz
                jointX lHand_jointx
                smoothScaleY lForeArm_scaleY
                smoothScaleY lHand_scaleY
                xOffsetA OriginX
                yOffsetA OriginY
                zOffsetA OriginZ
                scale Scale
                scaleX xScale
                scaleY yScale
                scaleZ zScale
                jointX jointx
                jointZ jointz
                twistY Twist
                rotateY yRotate
                rotateZ zRotate
                rotateX xRotate
                xOffsetB xOffB
                yOffsetB yOffB
                zOffsetB zOffB
                translateX xTran
                translateY yTran
```

```
        translateZ zTran
    }
    endPoint 0.1 0.055 0.099
    origin 0.1 0.104 0.09
    orientation 0 0 0
    displayOrigin 0
    displayMode USEPARENT
    customMaterial 1
    material skin
    material Preview
    locked 1
  }
```

HR2 files

Hair props are exactly the same as prop props, with the exception that they are always parented to the head, and (most importantly) any hair prop that is loaded will *replace* any existing hair prop that is on a figure. This can be a problem if you have hair and a beard in the hair library. Loading the hair is fine, but if you then load the beard, your figure will be bald! This is built into the Poser program, so there is nothing you can do about that.

If you want to load multiple hair props, you will have to save them as regular props. Just select the hair and save it to the Props library. If you save them as smart props, parented to the head, they work just like always (except the removing other hair first bit). Some long hair props actually work quite well as parented to the neck (or upper neck), with Inherit Bends turned on. That way, the hair follows movements of the neck and head.

Dynamic hair

For discussion of the Poser 5 dynamic strand hair, see Chapter 5.

Pose files: PZ2, FC2, HD2

The Pose (PZ2), Face (FC2), and Hand (HD2) files are all Pose-type files. In comparison to the CR2, they only contain information on posing elements of the figure.

The basic PZ2 structure looks like this:

```
Version
thighLength
actor [body part]
      {
 [channels only]
      }
Figure (empty)
```

If you are looking at a P3 pose, the thighLength entry may be absent. Nobody is sure exactly what that does, but Poser 4 and up calculates that and puts it in your Pose file. You should be able to remove this without detriment.

Inside the body part Controls, you will only find the channels branch. And inside the channels branch, you will only find the rotation and translation channels, the hand grasp channels, geometry channels, and morph channels (which are optional in Poser 4.02 and above). And inside *those*, you will only find the k entries.

Notice that the BODY actor is not included when you save your pose from Poser. This can cause several headaches. First, if you are doing multi-figure poses, you cannot position the figures using their BODY translations and rotations; you must only move the hip. And, of course, any Full Body Morph settings are not saved in a pose, nor any body scaling.

But all is not lost. You *can* manually insert the BODY channels into a PZ2. You can either save your pose as a CR2, then strip it out to make a PZ2, or you can save the body parts in a PZ2 and your BODY settings in a CR2 and copy them over (which may be faster). Editing tools such as P-Wizard and CR2Edit6 can help automate these tasks.

You can also add things into the pose that do not normally go there. For example, you can insert the hidden 1 line into the channels to hide dials, or use hidden 0 to unhide them. You can insert the scale channels if your pose depends on scaling. You can also include settings that are outside the channels branch of the body part. We will see more details on these types of tricks in the *Alternate Pose file* section below.

FC2 files

The Face (renamed Expression in P5) files are Pose files that only have information for the head body part, and then only the morph channels.

Like the PZ2, these can be edited to include the rotation and scaling of the head (if you desire), and you can even add information for other body parts, such as the eyes, that may be a part of your face or expression. To create a head and eyes FC2, you can save your figure to the Pose library (with morphs included), then strip the PZ2 so only the head and eyes remain. If there is a thighLength in your PZ2, you can delete that as well.

HD2 files

The Hand files are Pose files that only have information for the hand, obviously, and it uses the right hand. If you save a Hand pose from your figure's left hand, it will be translated into a right hand pose. You must be careful with saving and applying poses on the left hand. If you are using limits, the limits of the right hand will be applied to the left hand, which will mess up your pose. The right index finger may bend from -70 to 120, but the left will bend from -120 to 70. As you can see, applying a limit of -70 on the left finger's bend will prevent it from being able to bend to its full range. Always turn the workspace Use Limits off before saving or applying poses on the left hand.

The HD2 file itself, instead of a thighLength entry, has a clearFigureKeys 1. While this sounds as if it would erase all the pose information in your figure, it does not. It isn't clear what it does, exactly, but I suspect it is an attempt to fix the application of grasp dials. Grasp dial settings are notoriously hard to save and apply. Poser 4.02 and above translate the grasp dial settings into rotations of the individual fingers before saving as a pose. If you are working with an earlier version, note that your grasp settings may not save and apply from your poses.

Hand Pose files are unique in that you can apply the same pose to either hand. I have experimented with using Hand poses to make arm or leg poses that can be used on either side, but it did not work out.

If you add information to the HD2 (the forearm, perhaps) it may not apply to your figure when you load the Hand pose. Items placed under the right hand seem to work, but this is not reliable.

Other Poser library files: Alternate Pose files

MAT Pose files

It was discovered that the empty Figure section of a PZ2 could be filled with material information from a CR2, and thus materials could be applied and changed automatically, using a Pose file that came to be known as a MAT Pose.

A MAT Pose is really a CR2 that is stripped of all sections except the Version, and the Figure section, which only contains the material entries. MAT Pose files can apply or change the base colors, the bump map, transparency settings and map, and apply (or un-apply) texture maps.

Partial MAT files allow you to change the eye color and texture, while leaving the rest of the materials intact. This involves deleting all the material entries you do not wish to affect. If you wish to only change the base color, or highlight size, or a portion of the material settings, you must be careful to delete the settings you do not wish to alter. If you create a CR2 with no maps loaded, your material settings will have the NO_MAP value for the texture maps. If you leave those in, any texture you have loaded will be taken off the materials, which may not be what you meant to do.

Here is a sample of a typical MAT Pose file:

```
version
        {
        number 4.01
        }
figure
{
material EyeBall
        {
        KdColor 1 1 1 1
        KaColor 0 0 0 1
```

```
        KsColor 0.0588083 0.0588083 0.0588083 1
        TextureColor 1 1 1 1
        NsExponent 89.4272
        tMin 1
        tMax 1
        tExpo 0.6
        bumpStrength 1
        ksIgnoreTexture 0
        reflectThruLights 1
        reflectThruKd 0
        textureMap NO_MAP
        bumpMap NO_MAP
        reflectionMap NO_MAP
        transparencyMap NO_MAP
        ReflectionColor 1 1 1 1
        reflectionStrength 1
        }
[other materials, etc.]
```

The body parts are left out, as the Pose file is not meant to affect the actual pose of the figure.

Here is an example of a material that is designed only to change the base colors and highlight settings:

```
material EyeBall
        {
        KdColor 1 1 1 1
        KaColor 0 0 0 1
        KsColor 0.0588083 0.0588083 0.0588083 1
        TextureColor 1 1 1 1
        NsExponent 89.4272
        }
```

Note that the transparency, reflection, and all the texture information has been left out.

MAT-DIV Pose files

There is a special type of MAT Pose that uses the customMaterial option of the CR2 to create on-the-fly material divisions. Using the customMaterial option you can change an entire body part's material, independent of its usual material settings. Here is an example from a MAT-DIV file:

```
version
        {
        number 4
        }
thighLength 0.177885
actor hip:1
```

```
        {
customMaterial 1
material SkinBody
        {
        KdColor 1 1 1 1
        KaColor 0 0 0 1
        KsColor 0.18822 0.129412 0.0941024 1
        TextureColor 1 1 1 1
        NsExponent 1
        tMin 0
        tMax 0
        tExpo 0
        bumpStrength 0.904762
        ksIgnoreTexture 0
        reflectThruLights 1
        reflectThruKd 0
        textureMap ``:McfsTextures:MMBody_Fabric.jpg''
        0 0
        bumpMap NO_MAP
        reflectionMap NO_MAP
        transparencyMap NO_MAP
        ReflectionColor 1 1 1 1
        reflectionStrength 1
        }
            }
```

Note that this type of material entry appears inside the body part itself, not in the figure section. If you recall from *CR2: Theory* above, the body parts' customMaterial is usually set to 0. When you change this number, you can then insert a custom material into the body part, as shown here.

The customMaterial 1 entry is followed by the materials that exist on that body part. The abdomen may only have skin, but the chest will have skin and nipples. The head contains skin, eyebrows, lips, etc. Each material contains the material setting information, just as it appears in the Figure section.

This particular file is changing Michael's torso, arm, and leg skin into a linen material as a sort of "long underwear" effect. This can also be used to create skin-tight gloves, spandex shorts, etc.

MOR Pose files

These are simply Pose files that change the morph settings of a figure, and nothing else. Although similar to setting morphs on a non-posed figure and saving it to the library with the morphs, it is *not* the same. A true MOR Pose file has the rotation and scaling channels removed, so the morphs can be applied to a posed figure without resetting that pose to zero.

MOR Pose files may affect the whole body, or selected areas; simply delete out information you do not want to affect. Normally, any morph channel set to zero should be left out of your MOR

Pose file, unless the effect requires that particular morph set to zero. In this way, your morph pose can be added to the user's existing morph settings.

Hide/Show Pose files

These files make body parts visible or invisible by changing the parts' On/Off entry. Here is an example, to hide the arms:

```
version
        {
        number 3.0
        }
actor lShldr:1
        {
        off
        }
actor rShldr:1
        {
        off
        }
```

Note that this type of file uses 3.0 as its Version value. They seem to work better this way, as P4 and above may ignore pose information that is not in the body part channel branch. Traveler has a set of Hide/Show poses you can download from Morphworld.

Lock/Unlock Pose files

Similar to Hide/Show Poses, these use the locked entry to lock or unlock body parts. Here is an example:

```
        version
        {
                number 3
        }
        actor rHand:1
        {
                locked 1
        }
```

"And Anything Else We Can Think Of" Pose files

Scaling information can be inserted into a Pose file, so I am sure we will see some Length Pose files for long or short arms and legs. Joint parameter information can be added, if your pose requires an adjustment of the JPs in order to work properly. The shoulders (collars) may benefit from this; they might bend up or back better with the JP center in one spot, and bend down/forward better with the center in another spot. This information could simply be planted into

the PZ2, along with the rotation dial settings. Experiments are being done on injecting code into a CR2 via a PZ2 file, such as slave dial entries, or different morphs. Check out the online resources for communities with Poser Techs.

Instead of creating a new CR2 for different characters, all the information could be saved to a PZ2: the head morph settings, the body scaling, the materials, etc. Because PZ2 files only save dial settings (and not, for example, the entire targetGeom delta list), they take up much less room than a CR2.

One thing to be careful of is to create a reset file for your adjustments. MOR Pose files that zero every morph target on the figure, for example, are very popular, as are MAT Pose files that change all the surfaces to blank white, ready for you to load your textures. If you lock something, you need an unlock pose; if you hide something, you need an un-hide pose. And if you play around with the scaling or the JPs, you need to be able to reset them to defaults.

One final note. These Alternate Pose files do not need to be PZ2s. MAT Pose files in particular work fine when they are changed to LT2 (light) or CM2 (camera) extensions and placed in the Lights/Cameras directories. This alleviates some of the clutter that builds up in the Pose library, with all the extra goodies that can be placed there. You can have one character with one CR2, a dozen Pose files (that actually pose it!), four MAT Poses to load each of the four textures it comes with, six MAT Poses to change the eye color, eight MOR Poses that produce different characters... It builds up quickly.

CR2: Practice

Plugging in a new OBJ file

This is fairly simple. Locate the two (sometimes only one) figureResFile lines in the CR2. Change them to point to your new OBJ file.

Before:

```
figureResFile :Runtime:Geometries:dogHi:dogHiP3.obj
```

After:

```
figureResFile :Runtime:Geometries:norns:BBN.obj
```

Note that in P5 you may see a standard PC-style full directory. For example:

```
figureResFile P:\P4\Runtime\Libraries\character\grafttest.obj
```

These point to geometries outside your Poser 5 Runtime structure. Use the same structure as whatever file you are editing.

Also remember, in all cases, that the directory and especially the file name are case-sensitive. "Doghi" is not the same as "dogHi" and "bbn.obj" is not the same as "BBN.OBJ."

Removing embedded geometry (geomCustom)

If you are creating a figure for commercial distribution (or using a commercial figure for a new CR2), you will want to make sure that none of the copyrighted geometry gets embedded in the CR2. If you at any time touched the Grouping Tool in Poser 4, you are in danger of this happening to you. If you used the P4 Hierarchy Window method of figure creation, all you have is embedded geometry. If you are not sure, simply search your CR2 for "geomCustom." If you find it in your body parts, that part is using embedded geometry. (If you find it in a prop, that is normal; unless you are using or creating a copyrighted prop. See the PP2 section in *Other Poser library files* for details on prop geometry.)

The first step to getting rid of embedded geometry is to make sure you have an independent OBJ file. If you built an OBJ, and only used the Grouping Tool for Magnet morphs, you should be set. With the P4 method, you will have to create a base OBJ. Turn off all IK, open the JP Window and Zero Figure. Also make sure both Hip and BODY Trans dials are set to 0. (Also, all morphs and scaling should be turned off.) Then export the OBJ to a directory under ..\Runtime\Geometries. For export options, turn on "Include Body Part Names," "Weld Body Part Seams," and "As Morph Target." Turn off "Include Figure Names." Before you close Poser, open your exported OBJ in UVMapper or a 3D viewer so you can check that your body part names came out intact. If you see :1 on the end of all the group names, or you see Left Shoulder instead of lShldr, check your export settings. (Or do a search and replace, which might be faster.)

If you use the Grouping Tool in the Pro Pack or Poser 5, the geometry is not embedded in the CR2. Instead, it is saved out to an OBJ file in the library where the figure is located. If you want to keep the grouping information, you will need to use this new OBJ, or replace your starting OBJ with this new version.

Now you need to change the CR2 to point to your OBJ file. First, there should be two figureResFile entries in the CR2. One appears just after the version entry, and the other (if it is present) appears between the actor list and the channels section. It should look like this:

```
figureResFile :Runtime:Geometries:raptorHi:raptorHiP3.obj
```

This is using a Mac-style directory listing (that's with ":" instead of "\" for PC users) starting in the Poser directory and pointing to your OBJ. So if your OBJ is under "MyStuff" in the Geometries directory, it would go like this:

```
:Runtime:Geometries:MyStuff:myobj.obj
```

Now search for the geomCustom in the actor list. For each body part that has a geomCustom entry, we need to replace it with two standard entries, a storageOffset and a geomHandler.

The storageOffset is always 0. It looks like this:

```
storageOffset 0 0 0
```

The geomHandler looks like this:

```
geomHandlerGeom 13 chest
```

The geomHandlerGeom 13 will always be the same. Then the name of the OBJ group. This is the chest, obviously. The rShldr will be rShldr, and the head will be head, etc. Watch your capitalization and spelling! Also note that the geomHandler does not have to point to an OBJ group that is identical to the actor name. So if you named your rToe as rToes in your OBJ, tell the rToe actor to point to the rToes group. That will work.

Dial operations

Changing dial orders

As innocuous seeming as this is, it should not be undertaken lightly. You cannot arbitrarily change the orders of the channels in a CR2; this can cause your figure to not load, to not work, to freak out, and/or to crash Poser. However, it is safe to change the order of channels that represent dials in the Poser workspace. That would be the scale and rotation dials, the translation dials, and any morph or geometry swapping dials. You should try to keep them in their relative positions. For example, do not put the rotation dials before the joint parameter channels. You can change the order of the dials amongst themselves. If you have used the Twist axis to bend your limb, you might want to move the corresponding rotation dial to the bottom of the three, where Bend usually goes. Remember, the rotation dials are named Rotate*. The Twist*/Joint* entries are the JPs.

Morph and geometry swapping dials are a bit more flexible. You can stick them anywhere in the channel order, including after the rotation and translation dials.

Moving dials around just entails grabbing the entire channel and cutting and pasting it somewhere else.

Locking/hiding/deleting dials

Let us say you are building a posable prop, such as a chest of drawers that slide in and out and doors that open and close. If you start rotating these bits on all axes, you will end up with crooked doors and twisted up drawers. There are three ways to prevent the user from turning things the way they shouldn't go.

Option number one is to set the min/max limits of the dial both to 0. When Use Limits is on in Poser, the dial cannot be turned past 0, so it does not move. This method is simple, and can be done in Poser without any fancy CR2 editing. However, if the end user does not usually turn on

the Use Limits, or turns them off during the course of working on a scene, then the dial limits are not going to have any effect.

You can fix this by editing the channel's forceLimits entry. When set to greater than 0 (1 is fine; the morph channels like to use 4 for some reason), the dial will obey its limits, even when the workspace Use Limits option is turned off. (Of course, the user could always go in and change the min/max settings to thwart you anyway.)

The second way to prevent unwanted dial turning is to just hide the dial, so it does not appear in the workspace. If you can't see it, you can't mess with it. To hide a dial, just change its hidden parameter to 1. Hidden 0 is visible, if you wanted to make some dials visible. The Trans dials for a figure's eyes are often handy to be able to use, so these can be made visible. Hiding unused dials keeps down the workspace clutter.

Note: Morph dials do not respond to the hidden parameter, as it is set up in a morph channel. You can hide a morph dial, however, if you create a hidden 1 entry after the delta list. You can insert a new hidden entry, or just move the one that exists.

The final solution is to just delete the unused dials altogether. I don't recommend this, unless you very desperately need to cut down the size of the CR2. You might not want your users to twist your cabinet doors off their hinges and make them crooked, but who knows? There might come a time when they want crooked doors. I might want to make a derelict cabinet in a junkyard or a broken down house. If the rotation dials are not there, I would have to rebuild them myself, rather than just un-hiding them or changing the limits. Very annoying.

Poser 5 dial groups

These allow you to organize the dials into logical groups, as well as collapse and expand the groups, so you do not have to scroll down through 120 head morphs, and 15 pbm morphs just to get down to the rotation dials.

You can create and edit dial groups in P5, in the Parameter palette. Or, if you hate dragging things around (or maybe you do not have P5 yet but want to prep your characters for it), you can insert the groups into the CR2.

The format is pretty simple. At the top of the Channels branch (where the Geom Swapper and Morph dials are) is a node named "groups." For example:

```
groups
            {
                    groupNode Nose Morphs
                    {
                            collapsed 1
                            parmNode N_SmileOpen1
                            parmNode N_SmileClosed2
                            parmNode N_Furious
                            parmNode N_CryOpen
```

```
                    }
                    groupNode Transform
                    {
                            collapsed 1
                            parmNode taper
                            parmNode scale
                            parmNode xScale
                            parmNode yScale
                            parmNode zScale
                            parmNode yrot
                            parmNode zrot
                            parmNode xrot
                    }
            }
```

Each group has a groupNode entry, stating the name of the group: "groupNode Morphs" and "groupNode Pose" for example. Inside this branch is the collapsed tag, and then a list of "parmNodes" that names the internal name of each dial in the group. Make sure you are not using the external name here. The actual channels themselves stay put within the channels section. This is just a list of their names, which can be placed in any order.

It is also possible to nest groups within each other. You may want to divide your Morphs dial group into Brow Morphs, Nose Morphs, Lip Morphs, etc. Here is an example of a groupNode within a groupNode. Note that the groupNode appears on the same level as any morphs that may be in the parent group.

```
            groupNode Morph
            {
                    collapsed 1
                    parmNode Mouth O_r
                    parmNode Mouth O_l
                    parmNode OpenMouth
                    groupNode Lipsync Morphs
                    {
                            collapsed 1
                            parmNode Mouth F
                            parmNode Mouth M
                            parmNode Mouth O
                            parmNode OpenLips
                            parmNode Tongue L
                            parmNode TongueT
                            parmNode Smile
                    }
            }
```

Grasp, Spread, Thumb grasp dials

These are special dials for Poser hands that control the fingers (and thumb) as a group. They do not have any special controls, they are basically just empty dials. They are hard-coded into Poser to work. The bad news is that you cannot adapt these dials to work on other body parts (petals of a flower spreading, or closing down into a bud, for example, or a hand with six five-jointed fingers). They will only work on body parts with the Index/Mid/Ring/Pinky/Thumb names that are children of the body part where the dial is. Usually, this is the hand, but I was able to insert grasps into the DAZ Eagle feet, because the talons were named with finger joint names. (The wing tip feathers were named Index1, etc., and the talons had two joints, named Index2 and Index3, etc.; thus the wing "hand" could spread and fold (grasp) the feathers, *and* the feet could grasp.)

Inserting the grasp dials is simple; just open any figure that has them (such as the *CodeSnippets* on the CD), and copy them into your figure. It does not matter what body part they are on (as long as it has the finger children), or what side (l/r) they are on, the three dials are the same wherever they are found.

A few things to keep in mind. When you put the grasp dials on a body part that is not named l/rHand, Poser will not save them (except Poser 5). Every time I saved my modified Eagle figure from Poser, I had to re-insert the grasp dials into the feet. The other thing to watch out for is the rotation orders of your "finger" limbs. The grasp dials use Z as the finger Bend axis and Y for the Side-Side. If your "hand" is pointing another direction, the dials may not manipulate the finger joints properly. You can try using "Off" rotation orders and rotating them to your fingers' axes. (See *Limb angles and rotation orders* under *Figure creation: Theory* in Chapter 4 for more information.)

Scaling

There are two types of scaling in Poser. The usual scaling used in body parts is Smooth Scaling. If you have ever tried to transform a Poser figure into another type/breed/species by scaling body parts, you probably already know how annoying this is. If you haven't, try X-Scaling the horse's chest. Or scaling up a human hand.

Even if the body parts scale fairly well, they still get wonky when you try to bend them.

Smooth Scaling works along the child's twist axis, and the smoothing is controlled by the JPs, with a Twist Bar style control. (For Scaling JPs see *BBN Practice: Basic Joints* on the CD.) It is possible to change the axis of the Smooth Scaling, but you cannot have more than one Smooth Scaling axis. Poser will only recognize the first one.

The other type of scaling is Propagating Scale. This is normally only used on the BODY. Propagating Scale causes all of the object's descendants to scale along with it. When you scale the BODY, you scale the entire figure. In contrast, when you scale the hip, you change the size of the hip and crimp the hip's children. If you replace the hip's scaling entries with Propagating Scale, then scaling the hip will scale the entire figure.

This is handy for body parts with several children, located near or at the end of limbs. The head is a prime example. If you want your eyes (and jaw and ears and eyelids and whatever else you put on your head) to scale with the head, then Propagating Scale is for you. Similarly, hands are a good candidate. When you use Propagating Scale on them, all the finger joints will scale along with the hand instead of getting all crimped. (See Figure 3.6.)

Figure 3.6 On the top: Michael's hand scaled to 150% size. On the bottom: the same, but with the hand using Propagating Scale.

So how is this miracle performed? Quite simple: you change the scale channel entries to propagatingScale. Just rename it from "scale" to "propagatingScale." Be sure you get the capitalization right.

Before:

```
scale scale
{
        name GetStringRes(1028,5)
        (etc. etc. etc.)
}
```

After:

```
propagatingScale scale
{
        name GetStringRes(1028,5)
        (etc. etc. etc.)
}
```

Note: You may want to change the name of the dial to indicate that it is using Propagating Scale, so the user can recognize the control. On my Wee Beasties' tail base, for example, I used Propagating Scale so the tail could be lengthened or resized as a unit. In this case, I named the scale dial to "TailScaling" to indicate that it was a master control.

You can use Propagating Scale on the Scale, and/or on each axis scaling entry. So, for example, you could have your ForeArm scale by itself on the Y and Z axes to make it thicker, but have Propagating Scale on the X axis, so when you lengthen it, the hand (and fingers) will scale along with it. Or you could have Propagating Scale on the main scale for the ForeArm, and regular Smooth Scaling on the individual axes, in case you wanted to change the ForeArm size independently from its descendants.

The only thing you cannot do is have *both* Smooth and Propagating Scale on one single axis, or the main scale dial. If you copy the scale entries and make one set Propagating, Poser will only read the first set and use those.

When using Propagating Scale, the Smooth Scaling JP has no effect; you can delete that channel, if you wish.

There are some important things to watch out for when using Propagating Scale. Because it does not use the Smooth Scaling JP, your P-Scaling body part will have a sharp edge between itself and its parent. Note in the comparison illustration that the bottom hand has smooth transitions to its fingers, but the wrist has a sharp angle. This can be alleviated with the parent's Taper dial. (See Figure 3.7.)

Figure 3.7 The ForeArm is tapered about 30% to achieve a smoother transition to the enlarged hands.

Stacking Propagating Scale on bent limbs can be disastrous. I wanted to stretch the DAZ Eagle legs into a Secretary Bird's, without messing up the talons. I thought I could P-Scale the leg joints on the Y axis, and then un-do the scaling on the feet by using its P-Scale to shrink the Y axis back to normal. When I tried posing the feet, they began stretching wildly. (See Figure 3.8.)

Generally, Propagating Scale will cause less joint distortion in your figure, but it has the potential to cause an even bigger mess! My advice is to use it only on end-bits, such as the head and hands, and not on the torso or limbs.

Figure 3.8 Propagating Scale can be dangerous when it is stacked along a limb. Here, each segment of the Eagle's legs are using Propagating Y-Scale. It looks okay at first, but weird things happen when you try to pose the limb.

Welding

There are a few reasons why you may want to insert weld statements into your CR2. With the Pro Pack, the hip might not be properly welded to its children after you create the figure in the Setup Room. Another instance would be where you have "illegitimate children," or a body part that touches another part that is neither its parent nor its child. (See *Figure creation: Theory* in Chapter 4 for more details, or the Mantabat on the CD for an example.) Poser will only weld children to parents; not to co-parents, not to siblings. That is the natural order of things, but you can add welds.

Just one big note of caution. The extra welds sometimes cause a rendering fluke that shoots a vertex out into space. Whenever you add extra welds to a figure, be sure to do a test render. If you see a big long triangle pointing towards Alpha Centauri, and Poser locks up if you try to render again, then you have this bug and you must take out the extra weld statements. It is unclear what causes this anomaly, but it has been theorized that unmatched points along the seam are the culprit.

Adding welds is fairly simple. Find the weld statements in the Figure section of the CR2. The syntax is

```
weld child
        parent
```

Or in our special cases,

```
weld bodypart
        whatever-we-want
```

You should insert the weld near the body part's other weld statement, and try to follow the hierarchy structure of the figure. Sometimes weld order affects if and how well the weld works, so if your weld fails, or you get that "lost in space" vertex when you render, try changing the order of the weld statements. You may also try welding the other way around, in cases where there is no hierarchical structure (i.e.: welding two siblings). So the statement would be structured

```
weld whatever-we-want
        bodypart
```

You can insert both weld statements, but this is overkill and not necessary.

Welding will not work, of course, unless the two parts share identical vertices.

Affectors

Affectors are channels in a body part that define how that part is bent and distorted by its children. These channels appear at the top of the body part's channel entries, after morphs and such. There is one affector for each of a child's joint channels.

Except for the names, otherActor entry, and a flipped entry, they are identical to the child's joint/joint/twist entries. The name (internal and external) will have the child's name appended to it. The otherActor will name the child.

For example, here is the rHand bend entry:

```
jointZ jointz

{
        name jointz
        initValue 0
        hidden 1
        forceLimits 0
        min -100000
        max 100000
        trackingScale 1
        keys
        {
                static 0
                k 0 0
        }
        interpStyleLocked 0
        angles -45 -135 -225 45
        otherActor rForeArm:1
        matrixActor NULL
        center -0.591452 0.043536 0.70732
        doBulge 0
        jointMult 1
        calcWeights
}
```

And the affector channel, in the ForeArm:

```
jointZ rHand_jointz
{
        name rHand_jointz
        initValue 0
        hidden 1
```

```
                    forceLimits 0
                    min -100000
                    max 100000
                    trackingScale 1
                    keys
                    {
                            static 0
                            k 0 0
                    }
                    interpStyleLocked 0
                    angles -45 -135 -225 45
                    otherActor rHand:1
                    matrixActor NULL
                    center -0.591452 0.043536 0.70732
                    flipped
                    doBulge 0
                    jointMult 1
                    calcWeights
            }
```

Items in bold type indicate the differences in the entries. In the case of our body part (rHand), we are looking at the actual Z-axis rotation. These are the values and limits, settings for the Bend X joint control, and other sundry entries. The otherActor is its parent, the body part that will be affected by the motions.

In the case of the ForeArm, this entry tells the parent how it will be moving as the child moves. The parent obeys the joint settings of its child; i.e.: the rHand('s)_jointz. The values and limits are the same, of course, as well as the positioning of the JP controls. In this case, however, the otherActor is the child. The "flipped" entry, I believe, tells the Poser engine that this rotation entry belongs to the child, not the current body part, thus the roles of the JPs are flipped.

Deleting affectors

To stop a child from affecting its parent on one or all rotations, simply delete the affectors from the parent. There is no need to edit the child's entries.

For example, to stop the hand from causing the wrist to bend, we would look in the ForeArm's channels section for twistX rHand_twistx, jointY rHand_jointy, and jointZ rHand_jointz. Remove these entries, and the ForeArm will be oblivious to the hand's movements.

Adding affectors

If you should find yourself in the unenviable position of having to create affectors by hand, instead of being able to copy them, this is the procedure.

Copy the child's joint/joint/twist channels, the joint parameters, and paste them into the parent's channels branch, at the top. Refer to the JP vs Affector comparison above. You will need to make four changes:

1 The jointX jointx will have to become jointX [child]_jointx.
2 The name jointx will have to become name [child]_jointx.
3 The otherActor [parent] will need to be changed to otherActor [child].
4 Flipped 1 will have to be inserted after the center coordinates.

Other affector tricks

It is possible for the joint entries of the child and the affectors in the parent to be different. For example, take a look at the BallSocket example figure. If you turn on bending for the ball, rotating the sphere will deform the box. However, instead of twisting the box with the ball's Twist Bar controls, the box behaves as if it has Bend X style joint controls. Why? Because when I changed the sphere's joints to all twist-style joints, I did not bother to change the affectors in its parent. They still have the original settings. What good is this? I cannot imagine, but it might come in handy one day. A body part might work well with straight Bend X joint controls, but its parent might bend better with spherical falloff zones. You could set up the spherical zones in Poser, then delete them from the child's joint entries, and just leave them in the parent.

Another trick is to add affectors into body parts that are not the parent. When I was adding control "bones" to my fur cape, I experimented with having the control parts affect the parent, as well as other body parts that bordered the side of the cape. It did work, the control would move the entire side of the cape. However, this caused the other parts to not bend correctly by themselves. I believe they became confused as to how to behave between themselves when a part that was not their child was affecting them. Especially since the zones of effect of the controller overlapped the zones of the children, the conflicting effects caused the vertices to run this way, then that, and end up in a mess. Try out the FurCape02 to see how this turned out. Also see *Clothing design* under *Figure creation: Theory* in Chapter 4 for an alternate way to build draping cloth using unusual affectors.

Changing rotation orders

Sometimes, after doing all the JPs, you realize you should have used a different rotation order for your joint. And you really don't want to do the hierarchy building all over again, and the JPs and the . . . let's stop there. So, there's a simple way to just edit the CR2 to do this, isn't there? Well, there's a way, but it's not entirely simple. If you have Pro Pack or Poser 5, you are in luck, because the JP Window will let you change the rotation orders right there in the JP Window. Just pick a new order and edit the JPs on their new axis. The rest of you, read on . . .

First, recall that there are two types of joints: Twist and Joint (i.e. the Twist Bar type and the Bend X type). If you are switching the order of the two Joint joints, you are in luck: you can just transpose the entries for them. If, on the other hand, you want to exchange a Twist and Joint, then you need to pay a bit more attention.

Before we go into details, remember there are three places you need to look when changing rotation orders. First, in the body part itself, where the rotation orders are (obviously!). You should also change the rotation dial order to match the new rotation axis order, but this is not fully necessary. Lastly, remember to change the affectors in the body part's parent. If you are swapping the twist axis, you should also look at the smoothScale entries for the part and parent, unless you want the smoothScale to continue to be on the current axis, and not move when you change the twist axis to a different one.

The rotation order is controlled by the JP entries in the body part. They are after the Scale and before the Rotation entries, and they look like joint*/joint*/twist*. They will be in reverse order (i.e. bend/side-side/twist) instead of the order you are used to seeing them. After them are the three rotation dials in the standard twist/side-side/bend order. (*Note:* if your figure was created in the PPP/P5 Setup Room, the channels will have a different order than the standard. The joint/joint/twist will appear at the end.)

Figure 3.9 The joint parameters and rotation dials in the CR2. The joint/joint/twist are the JPs, while the rotate/rotate/rotate are the rotation dials.

The easiest way to swap the two Joint joints is, as I said, to just transpose them. In your CR2 editor, you can just drag the first below the second, and you are done. If you are using a text editor, it might be better to swap the axis letters instead, as described below.

When you are changing between a Twist and Joint, you will need to be more careful, and change the axis letter assignment in each entry. Change the two letters in the top branch (jointX jointx) and check the name (jointx). The twist name may have a GetStringRes entry, in which case, you can just leave it.

Here is the jointX entry with items that need changing in bold:

```
joint**X** joint**x**
{
        name joint**x**
        initValue 0
```

```
        hidden 1
        forceLimits 0
        min -100000
        max 100000
        trackingScale 1
        keys
        (etc. etc. etc.)
    }
```

Yes, just the three Xs need to be turned into Zs or Ys. Remember to also look in the parent for the jointX abdomen_jointx and get those Xs, as well.

As you change the rotation orders, keep in mind that you are shifting JP settings. So if your JointX had spherical falloff zones and your JointZ did not, and you swapped them by changing axis letters instead of transposing them, the JointZ will now end up with the JointX falloff zones, and the JointX will end up with the JointZ settings. This may not be what you had in mind.

You have no choice, of course, when you swap the Twist with a Joint. Your former twist axis will inherit the Bend X settings, and your former Joint will inherit the Twist Bar. The Twist Bar will not still be positioned the same way it was before, of course; it will follow the new axis. Just be sure to double-check your JPs in Poser, to make sure nothing got turned backwards or set the wrong way.

You can change the rotation dials by simply transposing them. The dials do not care about Twist Bars and Bend Xs – they are just dials. They do store limits, so make sure you want the limits to stay with the axis they are on (the X Bend limits will transfer to the X Twist limits, if you move the X axis from the bottom of the rotation order to the top). They also store names, so if you swap your Side-Side and Bend, you might want to fix the naming. Or you can swap the letters, if you prefer.

If you want the smoothScale to go along the new twist axis, change its lettering as well. This is located in the parent's channels.

```
        smoothScaleY abdomen_smooY
        {
                name abdomen_scaleY
                initValue 0
                hidden 1
                forceLimits 0
                min -100000
                max 100000
                trackingScale 1
                keys
                (etc. etc. etc.)
        }
```

Now go into the body part's parent, and do the same switches on the affector channels. Those are at the top (under any morphs and such), and they have the body part's name in them, so they are easy to recognize. Remember to perform the same operation on them as you did in the body part itself: transpose if you transposed, and change letters if you changed letters. The parent also has a smoothScale entry, so change that if you are changing it. (See *Affectors* above.)

Changing rotation types

If you look at the Twist and Joint type of joints, you can see how they differ. The Twist has simple controls: start point and end point. The Joint type has an angles entry, and doBulge and such like.

If you want to, you can change one type of joint into the other. For example, you can have two axes that use Twist Bars – or even all three. Or all three can have Bend Xs. All you need to do is copy the type of joint you want, and change the letters to match the new axis. Delete the original axis' entry.

Check out the BallSocket sample figure for a three-twist-axis figure.

See *Limb angles and rotation orders* under *Figure creation: Theory* in Chapter 4 for instances where you might want different rotation types.

Grafting on body parts

If you complete a figure and end up wishing it had an extra neck part, or you discover you need a buffer body part between the thigh and hip, or you just want to add a tail tuft to the end of the tail, then you will want to graft on (or in) a new body part.

Pro Pack and Poser 5

Drag your figure into the Setup Room and build a new bone into the hierarchy. Select the bone that is to be its parent, and then draw a new bone. If you are inserting a body part between two existing bones, make sure the new bone takes on the child's connection. See the section on the PPP/P5 Setup Room in *Figure creation: Practice* on the CD to see how to insert bones between bones, working with the Mantabat's tail.

Make sure you name the bone and follow all other figure setup procedures. When you exit the Setup Room, you may get a warning concerning ungrouped bones (or unboned groups). If you plan to slice the mesh in your own modeler, you can ignore this warning; at this point you are just setting up the joints and hierarchy. If you wish to use Poser to slice the new groups from the mesh, use the Grouping Tool, either before you enter the Setup Room, or after you create the bones. Do not use the AutoGrouping option in the Setup Room, unless you want to lose all the current grouping your figure has. Destroying all that to get an automatic cut for one new part is not a practical plan.

If you are creating an end-part (tail tip, finger tip, jaw, or anything that does not have children itself), you can experiment with not creating geometry for it, or you can toss in a triangle or tetrahedron as a "Poser bone." See *Control handles* under *Figure creation: Theory* in Chapter 4 for details. Not having geometry makes it difficult to grab in the workspace (although you can select it via the body part list). It may also cause problems with setting up the JPs.

Once you have successfully inserted the new bone between its parent and child, you are ready to finish up the new JPs, tweak the child's JPs if needed, and be on your way. Note that the new body part will show some anomalies associated with creating figures in the Setup Room, and the channels may be different from those of the rest of the figure, especially if it is an older figure. (See the section on the PPP/P5 Setup Room in *Figure creation: Practice* for details.) Also note that Poser has created a new OBJ file for you, with the same name and in the same directory as your CR2. Edit the CR2 to point to the OBJ you want, where you want it.

All other versions

If you have P4 or P3, you will have to do quite a bit of CR2 wrangling to graft on a new body part. Make sure you are familiar with the *Affectors* section above and how affectors work, and you may need to brush up on *Changing dial orders* in the *Dial operations* section above.

First, edit the mesh to slice out or stick in the new body part, and create your new OBJ. Point the CR2 to the new OBJ, of course. (See *Plugging in a new OBJ file* above if you are not sure how.)

Next, you are going to insert the new body part (NBP) into the hierarchy between its parent (PAR) and its child (CH), if there is a child. This will occur in three sections of the CR2.

New body parts in the Geometry section

The simplest way to achieve this is to copy the parent or child entry (or any entry, it does not matter), paste it into the hierarchy between the parent and child, and then change the names to the new body part name.

Before:

```
actor tail1:1
{
        storageOffset 0 0 0
        geomHandlerGeom 13 tail1
}
actor tail2:1
{
        storageOffset 0 0 0
        geomHandlerGeom 13 tail2
}
```

After:

```
actor tail1:1
{
        storageOffset 0 0 0
        geomHandlerGeom 13 tail1
}
actor tail1a:1
{
        storageOffset 0 0 0
        geomHandlerGeom 13 tail1a
}
actor tail2:1
{
        storageOffset 0 0 0
        geomHandlerGeom 13 tail2
}
```

New body parts in the Controls section

Next will be the very complicated task of inserting the NBP into the Controls section. We are going to do this by copying and pasting an existing body part, and then changing it into a new part. Which part you select depends on which channel nodes you prefer to edit. If the parent has a child with the same rotation orders you want for your NBP, then you can simply copy the child. If the parent has no children that it is going to adopt out to the NBP, then you can use any body part (preferably an end-part) with the rotation orders you want. If the parent does not have a child with the right rotation orders, you can either use the child and change the rotation orders, or use another body part and change the parenting, which may be easier. (You can use the parent, if it has the rotation orders you want.) (See *Limb angles and rotation orders* under *Figure creation: Theory* in Chapter 4 and *Changing dial orders* above for details on those.)

Once you have copied an existing part in between the parent and child, edit the body part. First, delete any morph targets or geometry swapping code that may be in there. That was the easy part.

Look in the main branch for the parent line, and change it to name the parent. (If you pasted a child, you will already have that.)

In the channels branch, look for the affectors from the child(ren). If this is an end body part, you are in luck; just delete any that are in there. If you are grafting between a parent/child relationship, you can copy the affectors from the old parent into your new body part. Check the otherActor entries, and make sure they name the correct other actor (the child, in this case).

Look for the smoothing for the parent and child. You can copy the child smoothScale from the parent, and the parent smoothScale from the child. Or just change the names in those nodes.

If you are changing rotation orders, you can do that now, or wait until you get the part grafted in, and then go through and do that. (See *Changing dial orders* above for fun with that.)

In the joint/joint/twist channels, change the otherActor to the parent. If these are copied from the former child, they are done too.

Don't worry if you feel confused. The chart in Figure 3.10 explains all the interrelationships that need to be addressed.

Figure 3.10 Red box – Parent: items in blue used to point to the child, but now must point to the new body part. Blue box – Child: items in red used to point to the parent, but now must point to the new body part. Green box – New Body Part: items in red can be swiped from the parent's channels; items in blue can be swiped from the child's channels. Make sure the twist/joint/joint settings of the new body part and child match the affectors of the parent and new body part, respectively.

The parent Inside the parent the affectors need to be changed to the affectors of the new body part. If the new body part is a copy of the child, then they will be done. Just change the name of the child to that of the NBP in three places: the joint* NBP_joint*, the name NBP_joint/twist, and the otherActor: NBP.

If the NBP is not a copy of a child, you have to edit the joint/joint/twist of the NBP to get the affectors. See the *Affectors* section for help with that.

Also remember the smoothScale for the child/new body part.

The child (Or children, that should be challenging!) Change the child's parent entry. Look for the smoothScale in the channels and make the parent smoothScale name the new body part.

Change the otherActor for the joint/joint/twist entries to the new body part.

The new body part in the Figure section

The hard part is over now, but we still need to go into three areas of the Figure section.

First, AddChild. Insert your new body part into this section. Remember to change any children to be added to the new parent.

Before:

```
addChild tail2:1
        tail1:1
```

After:

```
addChild tail1a:1
        tail1:1
addChild tail2:1
        tail1a:1
```

Second, Welds. Weld your new body part to its parent, and the child(ren) to it.

Before:

```
weld tail2:1
        tail1:1
```

After:

```
weld tail1a:1
        tail1:1
weld tail2:1
        tail1a:1
```

And thirdly, IK chains. If you previously inserted a body part into a limb that has IK on it then you will have to edit the IK chain statement. It really isn't that hard, however, to insert a link into the chain.

Before:

```
inkyChain tail
{
        on
        name tail
        addLink tail1:1
        addLink tail2:1
        addLink tail3:1
        goal tail4:1
        linkWeight 0 1
```

```
        linkWeight 1 0.2
        linkWeight 2 0.04
    }
```

After:

```
    inkyChain tail
    {
        on
        name tail
        addLink tail1:1
        addLink tail1a:1
        addLink tail2:1
        addLink tail3:1
        goal tail4:1
        linkWeight 0 1
        linkWeight 1 0.2
        linkWeight 2 0.04
        linkWeight 3 0.008
    }
```

You do not have to insert a linkWeight in the same location in the chain. Just add another linkWeight to the end. The linkWeight secret code numbers follow a simple progression. The first number goes 0, 1, 2, 3, 4 etc. The second number goes 1, .2, .04, .008, .0016, .00032, etc. Look at the IK Sample figure and text file on the CD for more fun with IK chains.

Editing the joints

There is no more editing to do in the CR2, now you need to open the figure in Poser again and adjust the JPs for your new body part. When you start, they will have the JP settings of the body part you initially copied, so don't be surprised if they overlap the child's joints. Also, if you copied the left eye for the tail tuft (they had the same rotation order and they were end-parts!) don't be surprised if your joints are over in the head somewhere. Just edit them as you normally would.

Here's a tip. Make sure you at least move the center a little. Put it back if you want, but this will help keep the limb center and end points lined up. If you have trouble with your grafted body part, double-check the parent, NBP, and child branches of the Controls section. This is the most likely trouble spot. Also see *Trouble-shooting: CR2 problems* in Chapter 6.

Chopping (deleting body parts)

You may wish to "chop" a CR2 so you can use parts of a figure. For example, I chopped all my animal CR2s to create the Tail Library. It is much more convenient, if I want to stick a tail on

somebody (or something), to grab a chopped tail rather than load the animal whose tail I want, and then turn everything but the four (or more) tail parts invisible.

When deleting body parts, check the three sections. First, delete all the actor references for the body parts in the top section. Next, look for the same parts in the Channels section. If you want to be extra thorough, open the channels of the parents, and delete the affectors for the parts you have deleted.

Down in the Figure section, remove any addChild statements that add the deleted parts. Remove any welds that weld the parts to their parents. Also check through the materials for any that are only on the parts you have deleted: toenails if you have removed the feet, or eyes and tongue and inner ears if you have chopped the head off. Also, delete any IK chains that contained the removed part(s).

If you are deleting the hip, you will have to take some extra steps.

One of the remaining body parts should first become the "base" body part. If you are chopping a tail, the first tail segment will become the "base." If you are chopping off a pair of wings, the first joint of each wing can become a "base." This will cause the wings to behave as if they are two figures, since you can independently move them by dragging their bases around. (If you want to avoid that, you can add a dummy, like a box, to be the new "chest." See *Grafting on body parts* above.) The steps are as follows.

In the Controls section of the CR2, just make sure the first body part's parent is listed as BODY.

```
parent BODY:1
```

In the Figure section, make sure to also add it as the BODY's child.

```
addChild tail1:1
        BODY:1
```

And, lastly, list it as the body part in the defaultPick entry. (Or change this to the BODY.)

```
defaultPick tail1:1
```

See the Tail Pack 2 file at 3D Menagerie for typical chopped tail files.

Combining figures

If you combine figures in Poser, for example, if you put a human torso on the horse to create a centaur, you also have invisible body parts in the CR2 that are unnecessary. These can simply be deleted. There is a more detailed tutorial at MorphWorld.

Conforming

See the sections on conforming under *Figure design* in Chapter 4 for instructions on creating the perfect conformer CR2.

Extended Remote Control (ERC)

ERC uses the master dial and slave entries of a Full Body Morph to slave any channel to any other. You can create joint-controlled morphs, scale-controlled translations, translation-controlled rotations, master-controlled geometry swaps, etc.

The master dial

Your slaved dials can point to any existing dial. However, if you want a master control dial, you will have to insert one. It is basically a plain vanilla valueParm dial.

```
valueParm PointyEars
{
        name PointyEars
        initValue 0
        hidden 0
        forceLimits 0
        min -100000
        max 100000
        trackingScale 0.004
        keys
        {
                static 0
                k 0 0
        }
        interpStyleLocked 0
}
```

This is placed in the Channels branch of the BODY, or any body part (or prop) you wish. Values of a valueParm dial may not be saved in a Pose file, so you can trick Poser by naming your dial targetGeom (i.e., as a morph dial). Aside from the targetGeom tag replacing the valueParm tag in the example, the dial is the same.

The slave code

A channel is slaved to a master via five entries that appear after the interpStyleLocked entry.

```
valueOpDeltaAdd
Figure 1
BODY:1
PointyEars
deltaAddDelta 1.000000
```

valueOpDeltaAdd: This instructs Poser to perform an operation to add a delta to another channel.

Figure 1: This points to the figure that contains the master dial.

BODY:1: This points to the part within the figure where the master dial is located.

PointyEars: The internal name of the dial to which you are slaving the code. This is the name that appears with the valueParm or targetGeom, or jointX or zRotation, not the value that appears in the "name (whatever)" entry of the dial.

deltaAddDelta 1.000000: This defines the control ratio between the master dial and the slave. In a one-to-one correlation, the master dial set to 1 sets the slave dial to 1. At .5, the slave dial value is half that of the master dial. To calculate the AddDelta, use the formula slave/master, or just put in whatever number you want the slave dial to be set to when the master dial hits 1. The smaller the delta, the slower the dial increments.

Alternate ERC – linkParms

I recently discovered that Poser 3 (and even earlier) had a primitive sort of dial-slaving. If you open the Skeleton Woman CR2 and look in the Figure section, you will find linkParms entries.

```
linkParms head:4
scale
jaw:4
scale
```

This slaves the jaw's scale to the head's scale. The structure is thus:

```
linkParms [master body part]
[master dial]
[slave body part]
[slave dial]
```

In my experience, the two dials will affect each other. In the above example, the jaw will scale with the head, and the head will scale with the jaw, although in the skeleton, both orders are used. Les Bentley has done extensive tests on the linkParms phenomenon, and it is not fully reliable; some items refuse to be linked at all, without any apparent reason.

I found a use for linkParms in the Songbird Remix, to slave the eye translations (except the xTrans) to each other. When you move one eye, the other follows along with it. Unlike ERC slaving, it does not matter which eye you move.

Other than that, linkParms is immune to cross-talk, and may be a solution for Poser 3 Full Body Morphs. A valueParm (or targetGeom) dial could be inserted into the BODY or hip for the P3 figures, and the linkParms used to slave all the SuperHero morphs to it. However, this has not been tested yet.

Easy Pose

The Easy Pose concept was developed by Ajax based on the ERC concept. It is used to pose long segments of figures more easily using master dials. If you have never used Easy Pose, you don't know what you are missing. Try out the free Easy Pose (EP) Tube on the CD.

Imagine you have a posable rope, with say 42 segments, and you want to coil it up. Normally, you would start at the beginning and bend the first segment a bit, jump to the next, bend a bit; and the next, bend; next, bend, etc., etc. By the time you got a quarter of the way through, you would notice that you are not bending the bits enough to make them coil up tightly. Or you have bent them too much. Or you are bending them all the same amount (you thought that bend, copy, cursor down, paste was going to make this easy, didn't you?) but in fact coils bend each part at different ratios.

Well, you can wake up from your nightmare, because you can coil that rope just by turning the SpiralBend or SpiralSide dial. One dial does it all; you can make it as tight or as loose as you want it. Truly a miracle of modern Poser technology.

Now imagine your Cthulu-headed, eight-tentacle-armed beastie with Easy Pose controls for all those squiggly bits. Amazing! So how does it work? Well, it is fairly straightforward, but monstrously tedious. (Hint: get Ajax's Easy Pose Underground to do it for you. EPU has everything you need for Easy Posing, and a whole lot more. Or the Easy Pose Wizard plug-in for P-Wizard.)

First, the BODY or the main node (which can be any body part) has the following master dials:

```
TwistAll
SideSideAll
BendAll
S-Side          These are S-curves.
S-Bend
SpiralSide
SpiralBend
Wave1S          These are waves (S/B refers to Side-Side/Bend).
Wave2S          Waves 1 and 2 are offset from each other.
Wave1B
Wave2B
```

These are simply standard valueParm master dials. However, if you place them in a body part, and use targetGeom instead of valueParm, you can save them with a Pose file (if you elect to save morphs with it).

Here is an example of the master dial for TwistAll:

```
targetGeom deyeTwistAll
{
        name TwistAll
```

```
                          initValue 0
                          hidden 0
                          forceLimits 4
                          min -100000
                          max 100000
                          trackingScale 0.02
                          keys
                          {
                                  static 0
                                  k 0 0
                          }
                          interpStyleLocked 0
                          indexes 0
                          numbDeltas 0
                          deltas
            }
```

Note that the internal name has a cross-talk prevention prefix. This was designed by Ajax to prevent cross-talk between two (or more) Easy Pose figures which all have the same controls. (See *Cross-talk* under *Morphing: Theory* in Chapter 1.)

That's the easy part! Now within each body part in the Easy Pose sequence are these controls:

```
TwistBef
SSideBef
BendBef
TwistAft
SSideAft
BendAft
```

These dials affect rotations for segments before (Bef) and after (Aft) the current segment. These are for adjusting the posing of your long figure. For example, you may want to loop your rope around a figure's hand and wrist. Once you bend it into position with the master EP dials, you can use the before and after dials to tighten the loops and create new bends and curves in the rope along its length. See Ajax's web page for tutorials on using these controls.

Again, these dials use the standard valueParm master dial controls. (Or targetGeom, as mentioned above.)

Note: In order for the Bef and Aft dials all to work properly, there must be an IK chain in your figure that encompasses the entire EP chain. This allows master dial controls to be passed both up and down the chain of body parts. IK can be on or off, but it does need to exist.

Now comes the tricky part. Easy Pose uses cascading ERC. Think about what is going on here. The main TwistAll dial is going to control the twist dial of every part in the EP chain. The twist rotation for each part is also slaved to the TwistAft control for its parent and all its antecedents.

It is also slaved to the TwistBef controls for its child and all its descendants. If you have a 42 segment rope, that's going to be a lot of valueOpDeltaAdds for one twist rotation control!

Fortunately, we don't have to do it that way. If the middle body part twist is slaved to its parent's TwistAft dial, and that TwistAft dial is slaved to the grandparent's TwistAft dial, and so on up the chain, we will end up with all the twisting after covered (actually, it is slaved to its own TwistAft dial first, see below). The same with the Bef dials. Our middle part's twist is slaved to its child's TwistBef, which is slaved to the grandchild's TwistBef, and so on down the chain. (See Figure 3.11 for the Easy Pose interrelationships chart.)

While you are doing all that slaving, don't forget the deltaAddDelta control ratio. For Twist, Side-Side, and Bend these should all be the same number. You can use 1 for the control ratio,

Figure 3.11 This diagram shows the slaving paths for the master dials, and simple diagrams for the cascading sequences. Red: All Twist dials are slaved to the TwistAll master dial. Blue: Side-Side and Bend rotations are slaved, at different ratios and sequences, to the various other mater dials. Dark/Light Violet: Each body part Twist is slaved to its TwistAft dial, which is slaved to the next body part's TwistAft dial. Dark/Light Green: The Side-Side/Bend dials are slaved to the next body part's Side-Side/BendBef dials, which are slaved to the previous part's Side-Side/BendBef dials. Not all interrelationships are shown, for clarity.

or 0.25 or whatever you like. Ajax recommends using a tiny incremental tag for each type of rotation. For example, 1.00000123 for twists, 1.00000456 for bends, etc. This allows you to do search and replace actions on your CR2 to tweak the Twist/Side-Side/Bend ratios independently.

So here's an example from the EP Tube:

```
rotateY yrot
{
        name GetStringRes(1028,2)
        initValue 0
        hidden 0
        forceLimits 0
        min -360000
        max 360000
        trackingScale 1
        keys
        {
                static 0
                k 0 0
        }
        interpStyleLocked 0
        valueOpDeltaAdd
        Figure 1
        Node:1
        QT1UTwistAll
        deltaAddDelta 0.250021
        valueOpDeltaAdd
        Figure 1
        Tube06:1
        QT1UTwistAfter
        deltaAddDelta 0.250003
        valueOpDeltaAdd
        Figure 1
        Tube07:1
        QT1UTwistBefore
        deltaAddDelta 0.250003
}
```

This is the twist rotation dial for segment #6. It is first slaved to the TwistAll in Node1 (the body part with the main controls; which you could also place in the BODY. Remember, if you place it in the BODY, Pose files won't record the settings.)

Next, it is slaved to its own TwistAft dial. When you use the TwistAft dials, the body part and everything after it will twist. We will see how the TwistAft dial cascades control in the next example.

Lastly, the twist is slaved to the child's (Tube07) TwistBef dial.

While you're looking at this, notice the QT1U prefix on all the dial names. These are the internal names, with weird prefixes to prevent the Tube from cross-talking with the Whips and Chains or the Easy Pose snake, etc. (See *Cross-talk* under *Morphing: Theory* in Chapter 1.)

Also note the control ratios of the deltaAddDelta. The tiny fraction at the end is different for the TwistAll slaving than for the Bef/Aft slaving. There is no reason for this, except as mentioned before to do a search and replace. What if the TwistAll dial goes too slow? Replace "0.250021" with "0.750021."

Segment #6's Twist Aft dial:

```
valueParm QT1UTwistAfter
{
        name TwistAft
        initValue 0
        hidden 0
        forceLimits 0
        min -100000
        max 100000
        trackingScale 1
        keys
        {
                static 0
                k 0 0
        }
        interpStyleLocked 0
        valueOpDeltaAdd
        Figure 1
        Tube05:1
        QT1UTwistAfter
        deltaAddDelta 1.000000
}
```

Note that it is slaved to the TwistAft control of the parent (Tube05). Notice also that this control ratio is simply 1. Don't make the cascading controls a fractional value, or your fractions will cascade and cause smaller and smaller incrementation down the line. Use 1 for these.

Now for Tube07's TwistBef:

```
valueParm QT1UTwistBefore
{
        name TwistBef
        initValue 0
        hidden 0
        forceLimits 0
        min -100000
        max 100000
        trackingScale 1
```

```
keys
{
        static 0
        k 0 0
}
interpStyleLocked 0
valueOpDeltaAdd
Figure 1
Tube08:1
QT1UTwistBefore
deltaAddDelta 1.000000
}
```

Again, this master dial is slaved to the next TwistBef dial down the line. Use a control ratio of 1.

Once you have done all the Twist controls up and down the line, you can do the Side-Side and Bend the same way.

But wait, there's more! Next are the S-curves. In an S-curve the first section bends one way, and the rest bends the other. The good news is that there is no Bef/Aft nonsense with this control, so you just need to slave all the Side-Side and Bend rotations to the master dials.

Parse through the EP Tube CR2, searching for this string: QT1USSideSide. You will notice for the S-Bend (or the S-Side, technically) the first segment is slaved at a .25 ratio, then #25 is set at 0, and the end segment is set to −0.25. You can put in a 0 middle value, or leave it out. There is very little difference; experiment if you like, and put it in or take it out to suit your taste.

That was easy. Next are the Spirals. As mentioned in our nightmare above, each segment in a spiral bends more and more, so the center is tightly wound, and the outside is less so. There is a formula for calculating the spiral ratios for any length segment. The basic formula is:

$$\text{current\#}^2 \ / \ \text{total\#}^2$$

If you are on segment 5 out of 8, that would be 25 (five-squared) divided by 64 (eight-squared) or 0.390625.

This works in most cases, unless you are only spiraling a segment of your limb, and/or you want the first segment to have a zero spiral value. The complex formula is:

$$(\text{current\#} - \text{first\#})^2 \ / \ (\text{end\#} - \text{first\#})^2$$

If you are doing a spiral segment from parts 10 through 20, and you want to calculate the spiral ratio for part 15, it would look like this:

$$(15 - 10)^2 \ / \ (20 - 10)^2 \ = 25 \ / \ 100 = 0.25$$

Once you have the spiral ratio calculated for each part, you plug those into the valueOpDeltaAdd for each Side and Bend rotation in the sequence.

Spirals are the worst. Waves are not so bad. Waves are like S-curves, but there are several S's along the length. The simplest Wave is to alternate each segment: +−+−+−. This is not really a wave; Ajax calls it a "concertina." If your limb is very short, this may be the best you get from it.

A true Wave comes in sets of four, or multiples of four. Wave 1 starts at the beginning of the sequence; for example: ++++ −−−− ++++ −− −−, etc. Wave 2 is one-quarter of a cycle out of phase with Wave 1, or simply put: ++ −−−− ++++ −−−− ++, etc. Do not make Wave 2 the opposite of Wave 1 (i.e., −−−− ++++ −− −− ++++, etc.), as you can get that by just turning the Wave 1 dial in the negative direction. Using Wave1 and Wave2, it is a simple matter to create an animating transverse wave along your limb. (See Ajax's web site for details on that.)

Use the same ratio control (+/−0.25 is good) for all the segments in the wave. However, if you find your limb moving too far sideways in the wave, reduce the ratio of the first segment so it does not wiggle your limb out too far.

Geometry Swapping

The most common application of Geometry Swapping is Poser's built in "Genital" switch. Turn it on, and the male figure's genitalia appear; turn it off, and the dangly bits disappear, and the hip is transformed into a smooth, unbroken surface. Because this is a Poser program internal control, it isn't very flexible. However, the same idea was used in older versions of Poser figure hands. Instead of having posable fingers, each hand was a single, complete unit. You had a set library of hand poses, which were actually accessed by changing the hand geometry, or swapping one hand for another. This can still be seen in the skeleton figures.

This code was reverse-engineered by the Poser Techs, and built into a concrete example by Jeff Howarth. Anton Kisiel further developed the technique for his line of Changing accessories for Poser figures.

There are two parts to Geometry Swapping (besides building the actual alternate geometry). First, is the alternateGeom entry (or entries), which is a geometry pointer, and then within the body part channels is the Geom Swapper dial.

The alternateGeom entries go just above the Channels section of the body part, after the parent entry (or the inky/nonInkyParent entries, if the body part has those, too). The entry looks like this:

```
alternateGeom lHand_2
{
        name GetStringRes(1037,2)
        objFile 1002 :Runtime:Geometries:hands:lHandShape_2.obj
}
```

The alternateGeom tag is the body part name, an underscore, and a number of which geometry it is. This is the first entry for the male skeleton's left hand. (You can start with 2 or 1, which may make more sense, as the dial set to 0 will be the base geometry.)

Inside this branch is a name tag, and the objFile pointer. Each objFile pointer must have a number that is unique within the figure. The male skeleton's left hand numbers run from 1002–1020. The right hand uses 2002–2020. You can use any numbers above 1001, and you can rig your hierarchy with any number sets you like. It is standard to use the first two digits for your body part, and the last two for the alternate geometries. I have never seen any pointers with more than four digits, but it should be possible. Using two or three digits should be possible, but you may run into a number Poser is using for something else. These numbers are ACTR resources, or tags that Poser uses to keep track of which bit in your scene is which. GeomHandler 13, for example, is the default for body parts.

The channel entry, which creates a dial control for the swapping, has a fairly basic dial channel structure. Items of note are in bold.

```
        geomChan handGeom
        {
                uniqueInterp
                name hand type
                initValue 0
                hidden 0
                forceLimits 4
                min 0
                max 19
                trackingScale 0.045
                keys
                {
                        static 0
                        k 0 0
                }
                interpStyleLocked 1
        }
```

The channel type is geomChan, and it is defined with the body part name with "Geom" appended. The Geometry Swapping channels have the UniqueInterp entry as the first entry, then the name that appears on the dial. The rest are standard entries, although the final, interpStyleLocked is 1, not 0.

The limits should be set to the number of variants, or at least one greater, although this isn't absolutely necessary. If the dial is turned to values above/below the number of geometries, nothing will happen. Values between whole integers will be ignored, so you may be tempted to set the tracking Scale to 1, but I find it works better if a lower value is used. When the

tracking scale is 1, the dial will jump from number to number very quickly, and cycle through the various geometries too fast to be able to easily see and select one.

Correlations

Geometry Swapping is not that confusing, once you become familiar with the correlations between entries. Here is the alternateGeom entry, with the actual values replaced with identification tags, in bold type.

```
alternateGeom bodyPart_variant#
{
        name bodypart variant #
        objFile bp#var# :Runtime:Geometries:hands:1HandShape_2.obj
}
```

So, for the hip, the alternateGeom would be hip_1, hip_2, hip_3. The name would be hip1, hip2, hip3. Then for the objFile tag number, you would pick two digits for the body part and two for the variant. Let's say we're using 1000s for the hip. So 1001 is hip1, 1002 is hip2, 1003 is hip 3. It does make a certain sort of sense.

Now, inside the dial:

```
geomChan bodyPartGeom
{
        uniqueInterp
        name dialname
        initValue 0
        hidden 0
        forceLimits 4
        min 0
        max #variants
        trackingScale 0.045
        keys
        {
                static 0
                k 0 0
        }
        interpStyleLocked 1
}
```

The body part name appears again in the geomChan entry, so our hip would be geomChan hipGeom. The dial name would be something obvious like "Hip type" or "Swap" or "Hip Geometry". The maximum dial value will match the maximum number of geometry types. So if we had hip_1/hip1/1001, hip_2/hip2/1002, and hip_3/hip3/1003, the max value would be 3. (Or 2 if you want to count it from 0 to 2 as 3 entries. It is just as easy to use the last number of your geometry entries.)

The hardest part is keeping the tag numbers straight. Anton's advice is to create a standardized setup for your hierarchy and use it on all your swapping figures. For example, you might decide the hip tag numbers should be 1000, the abdomen 1100, the chest 1200, and so on. Perhaps for left and right parts, you would use 7 and 8; so 7100 would be the left collar and 8100 the right collar. Then 7200/8200 for the shoulders, 7300/8300 for the forearms. Design something that makes sense to you, and use it for all your figures.

Now, as for building the alternate geometry, there are some things to be aware of. First, the geometry should be built from the original geometry's edges, to make sure they weld correctly in Poser. Poser is very picky, and even using vertices that match the original geometry may not be good enough if they were not the actual vertices that were welded together in the original figure.

Each piece has to go in a separate OBJ file. You cannot build, say, two variants of your armor and have the Swapper dials find the correct group in the alternate OBJ. The second suit has to have all the pieces separate. You cannot have an empty group in your original or alternate objects. Well, you *can*, but once you switch to a non-empty geometry, you cannot switch back to no geometry. For example, my Barding Pack I had no abdomen segments for any armor but the fourth variant, and thus the base geometry had no abdomen group. The alternate abdomen was kept in a separate OBJ, and this worked up to a point. The armor would appear sans flank panels, and when the dial was turned to 1, the flank panels would appear. However, turning it back to 0 did not make them disappear.

So, if you want "empty" geometry as a variant in your body parts, you have to create at least some bit of geometry. I use single triangles. Assign them a material that will not be used, and which can be set to 100% transparent for rendering. (Or, in this case, for *not* rendering.)

Each variant can use its own materials; they do not need to use the same material(s) as the parts they are replacing.

The variants must all occupy pretty much the same space, in order for the joints to work. If your base sleeve is very narrow, and the alternate is quite puffy, the puffed up version may "stick out" of the JP blend zones and not work properly. Keep this in mind while doing joint parameters.

Each variant can have its own morphs, although it is not clear how Poser keeps track of which morphs belong to which variant. You can use Magnets on the body part and spawn morph targets for each geometry. Just be sure not to name them all the same, or they will telescope when the CR2 is loaded. You should number them according to which variant they belong to. "TiltUp1," "TiltUp2," "TiltUp3," etc. You can also load morph targets the usual way. Switch to the proper variant, then load the morph designed for it.

Also by some mysterious inner workings, when you change the geometry by turning the dial, the morphs for only that variant will appear. That is, if you have geometry variant #1 dialed in, the "TiltUp1," and "Width1" morphs will appear, while the others will not. This feature sometimes gets "stuck". You can turn the geometry dial and swap the geometry, but the morphs will not swap. If you click on another body part, and then return, they will appear.

Poser 5 gets around this little glitch by simply showing *all* the variant morph dials all the time. But, you can segment them into dial groups. You can do this right in Poser5, using the Parameter palette controls to create new groups, and then dragging the dials to the appropriate group. You could also edit the CR2 itself to create your own dial group entries, if you prefer typing to dragging. (See *Dial operations* above.)

Geom Swapper dials can be slaved, just like any other dials, so you can create master dials that change segments of geometry. For different shirts, for example, you need to change the abdomen, chest, collars, and perhaps even arm parts. All these could be slaved to one "Change Shirt" dial. (See *Extended Remote Control* above.)

Because the Geom Swapper dials are in the body part channels, they will be saved with Pose files.

When you swap geometry, Poser will alter/append to the geometry RSR. If you change the base OBJ, or any alternate part OBJ files, you will need to delete the geometry RSR before the changes will take effect. Also keep an eye on this if your geometry RSRs tend to get corrupted. To build a good RSR, you should load your figure, turn each dial through all its variants, then write-protect the RSR. This will ensure all the geometry information was written to the RSR before it was locked. You should also save the figure to the library after passing all the alternate geometries, so the material entries for each can be set and saved within the CR2.

Swapping props

It is possible to put swapping code into a PP2 file, but it is not recommended. The swapping code seems to only work reliably in figures. It is unclear why (just another of those Poser mysteries).

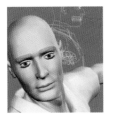

4

Figure creation

Figure creation: Theory

Poser works with the Wavefront OBJ format. It is not, in itself, a modeler, so you will need to build your meshes in another application. Because there are so many, and the working style and tools are so varied, actual mesh creation will not be discussed in this book. However, there are universal guidelines you should follow in your figure design and creation.

Basic mesh structure

Quads and triangles

Poser uses only quads and triangles, although it prefers quads. Actually, I should say Poser *users* prefer quads. The main reason is quads rack up a lower polygon count than triangles (after all, it takes two triangles to make one quad). Polygon count is a concern with many Poser users, as it is a main eater of computing resources. Not only do all the polys of a model need to be read, but each morph on the model contains yet more vertex information for those polys. Then there are the high-res texture maps, and the high-res shadow maps; they all take huge chunks of memory (while rendering). So you get two 15,000 polygon Victorias into your workspace, add their hair, a few pieces of clothing (or some sword and temple props), all textured and trans-mapped, and Poser starts to grind. Try to keep your models lean and of reasonable polygon count.

The other reason for preferring quads is for the morphers. It is easier to follow rows of squares across a figure's body, and easier to select vertices you want to move to achieve a particular effect.

N-gons

Poser hates polygons with more than four sides (n-gons). Eliminating these should be one of the final steps in your modeling process, before converting the mesh into a Poser figure and UVMapping. If your modeling application does not have a tool that allows you to find and eliminate polygons by vertex count, you can run your model through dePent. DePent is a freeware PC utility by Anthony Appleyard, and is an indispensable tool for Poser figure creators. You can find it on the CD.

Poser 3 cannot display or render n-gons. Poser 4 and up can handle them a bit better, and sometimes display and render them. Other times, however, the n-gons cause rendering anomalies.

Lines

Poser can read two-point polys (lines), but they display very oddly (as if they are always "behind" regular polygons) and will not render. At the time of this writing, they will only render in Poser 5, and then, only in the P5 Poser 4 render engine, not the Firefly ray tracer. This is odd, since P5 dynamic hair is made up of lines, which render perfectly well of course.

If you were planning to create hair or whiskers with lines, you had better change your plans. A small triangle can be extruded to create a thin line for your whisker, hair, string, etc.

Double-sided polygons

Poser has been going downhill with this issue. Poser 3 has no problem handling double-sided polygons, but Poser 4 and the Pro Pack don't like them. They sometimes work, but sometimes they cause black patches or holes in the mesh. This is due to P4/PPP's intolerance of overlapping polygons, whichever way they are facing. If two polygons share the same space, you get a black mess.

Poser 5 also does not like two-sided polygons. They display all right, but both render engines have problems rendering them.

Naming the groups

Poser can be very picky about the names you use for your OBJ groups. It does not like them to begin with capital letters. (I don't know why.) Be sure you are using rShin and lShin, not Rshin and Lshin. It also hates most punctuation marks, so r-Shin, r!Shin, and r*Shin are out. You cannot use spaces in the group names, so do not try r Shin. If you use spaces in the name, Poser will create body parts with pre-made groups. (See *Dynamic hair* in Chapter 5 for an explanation of the use of pre-grouping.)

If you want your figure to work with Poser's Symmetry command (Poser 4.02 or later), the left and right sides must have the exact same names, after the initial "l" or "r" of course. So name things rWing/lWing, rEye/lEye, etc. LeftEye and RightEye don't count – "eftEye" is not the

same as "ightEye." But do keep in mind that these refer only to the internal names. Once you get the figure into Poser, you can change the display names to anything you like.

If you want your figure to take standard poses and work with the walk designer, you must use the standard human internal names (as well as being built and bending in the normal humanoid fashion). That means you must use r/lCollar for the shoulder blades and r/lShldr, not r/lShoulder, for the upper arms. Look in Poser's Figure directory for StdGimbals.txt, which will list the proper names and rotation orders.

If you are creating a hexapedal, one-eyed, one-horned flying purple people-eater (or a chest of drawers, perhaps), and are not at all concerned about it taking any human poses (or even animal ones), then you can of course name the body parts anything you like.

One thing you might want to always do in your figures is name one part "head," and one each "lHand" and "rHand." This is because Poser has special cameras for these body parts, and if you want to commandeer those cameras to do your bidding, that's how you do it. Dragon Factory hind legs, for example, have the feet named "l/rHand." This is so they can take poses from the front legs, and hand poses. You can also zoom in on the feet with the hand cameras, which is a joy, especially if you want to pose somebody's feet and toes to stand exactly on something.

Size and location

Poser's universe is quite infinitesimal compared to other 3D applications. If you build your figure to a normal size you are used to working with in Max or Rhino, you may find yourself dealing with something much bigger than you bargained for when you load it into Poser. Don't attempt to joint it and then shrink the figure size; always shrink the mesh before you begin working. You can either import a Poser figure OBJ into your workspace to get an idea how small to work, or you can import your mesh into Poser, size it there, and then export it as the final OBJ.

You should position the figure in the center of the Ground Plane, with its feet (or whatever the bottom of it is) on the ground. If you are making a flying or swimming creature, also place it on the ground, not up in the air. The Poser universe's 0, 0, 0 point is on the ground, in the center of the ground plane, and when you create your figure, Poser is going to stick the center of the BODY right there.

You may have noticed some figures that, when you scale them, go flying off somewhere as you do so. And when you rotate their body, they fly around the workspace. This is because the OBJ was not built at Poser's Ground Zero. Now the joints all work fine, and the figure works fine, but its BODY center is off-center, and thus the effects I have just described.

There is a way to set the BODY center yourself, but it gets tricky. First, if your body has a hip and abdomen body part, Poser is going to stubbornly stick the BODY center right between the two, no matter what you tell it. Otherwise, it is going to place the BODY center at 0, 0, 0.

You can move the BODY center with the JP Window. Select the BODY and the JP Window will display the center coordinates. It won't show the center cross-hairs, nor allow you to directly select them, so you will have to estimate where the center is. (In the Display Menu, turn on Figure Circle, that will help.) You can read the center point coordinates from your hip (or your abdomen, or other body part where you want your figure's BODY to rotate and scale from), and plug them into the coordinates for the BODY center. Things will be fine, until you (or the users) move the figure by its hip. This will move the figure outside of its BODY circle while the BODY center stays put, and you end up with the flying figure syndrome all over again.

Intermediate mesh design

Construction lines and bending

After numerous experiments of constructing the same figure in different manners – with more dense mesh at the outside of a bend, or inside; cross-sections slanting towards or away from the bend; curved cross-sections; cross-sections becoming more dense near the bend, or less dense; etc. – the only conclusion I can come to is that it doesn't make the slightest bit of difference. Poser bent them all exactly the same way, with the exact same amount of smoothness and crunching. I had hoped that at least changing the mesh density as it went from the inside of the bend to the outside would help create smoother elbows, but it didn't. You can try out the library of BT (Bend Test) figures on the CD. That is supposed to be an abstract representation of a typical limb, such as an animal head on a two-part neck.

The only difference occurred when I subdivided the whole mesh, to use four times as many polygons. Then the bends were more smooth.

Mesh density

Now comes the big question: how dense should the mesh be? In my opinion, it should be as un-dense as possible. I have already pointed out the dangers of a high polygon count. In many cases it is not necessary, as Poser performs an in-engine smoothing logarithm.

Here are some situations where you can use a looser mesh density.

- Things that don't bend – a robot with girder limbs, a crustacean or insect leg, a rigid carapace, etc. These things can get away with fewer cross-sections, with more space between them. You can also lower mesh density on broad flanks, but don't cut out too much so that you cannot do decent morphs or a bit of surface detail, like ribs or muscle shapes.
- Interior bits – the inside of a mouth or up your nose. Do you really need to model all those ridges and bumps on the upper palate? (Use a bump map.) Or all those convolutions inside a nostril or ear canal? Only if you are doing a medical illustration of such bits. For regular-use figures, the inner mouth and nostrils can dissolve into big, broad polygons with no detail.
- Detail bits – things like the gums and teeth and eyelashes, claws, fingernails, belly-buttons, etc. Again, there is no need to use 150 polygons to model one tooth's every

ridge and curve and piece of the root. Compact rows of teeth (especially molars) can be one unit. There is also no need to use polys between teeth, where they will never be seen, anyway. Some people like fully modeled eyelashes for those extreme close-ups, but they can use props when that time comes. For most use, a flat arc on the eyelids, with a trans map is fine. And do you really need the back end of your eyeballs? Be careful you do not cut out too much, though, because sometimes they need to be rolled quite far in their sockets.

Now here are some instances where you want to *increase* mesh density.

- Near bends: Remember Stumpy! When you bend a limb, Poser needs some vertices to work with, to stretch and deform with the motion. Try not to make it too dense, or you will exacerbate the crunching that occurs when the limb folds down.
- For surface detail and morphing: Do not go so far as to make all your limbs plain cylinders. Use enough mesh to model large surface details like muscles and bones where they push against the skin. (But don't use the mesh to model every vein.) In addition, wherever you want morphs, you should have enough vertices to mold into different shapes. This is most important on the head of your creature. Keep the lip mesh rather dense, especially if you want your beast to snarl (or to lip synch). The forehead/brow area will also need to be flexible, and perhaps the jaw/throat area, depending on what type of creature you are making. If you want to be able to morph wrinkles (for age, for a furrowed brow, or for snarl wrinkles on a muzzle), keep that area of the mesh quite dense. However, do not overdo it. It is just as hard to manipulate vertices that are too close together as it is to get a decent result from vertices that are too far apart. Even broad effects with Magnets will run into problems with this – it won't help if your vertices collide with their neighbors at a 90% scale of the Magnet. (See *Morphing: Theory* in Chapter 1 for examples of designs for morphing.)

Limb angles and rotation orders

You must build Poser figures with straight limbs, preferably all along the three major world axes. Most of the time. If you build (or snag from a free mesh site) a pre-posed figure with the arm bent so the hand touches the shoulder, you are going to have some serious "fun" trying to get the JP angles to follow the arm angles and fix the Bend X controls so the elbow unfolds without sucking the bicep along with it.

If you create a humanoid monster with Creature Creator, you need to make the legs point straight down if you want them to use standard poses. If you built your humanoid with the arms down at the sides, again, this is not going to work with standard poses. But you may want to experiment. I have a theory that the shoulder joints would work better with the arms built in that position, and some fancy JP tweaking.

For taking standard poses (and using the walk designer, for bipeds), you also need to follow the standard rotation orders.

The rotation order rule is "Twist, Side-Side, Bend." Or, the long axis of the limb is the first rotation order, and the axis of the main bend is last. If your body part is on an angle, you will

need to pick the closest axes, of course. If your body part is on a 45 degree angle, it could go either way. You should take a look at the body parts around it, and try to keep them with all the same rotation orders. All the segments of your legs, for example, should have the same rotation orders. Not only will it keep things neat, but you will be able to copy and paste poses from segment to segment.

There are times when you will want to use a non-standard rotation order. This will happen if a Twist Bar is just what you need to properly bend your body part. When I built the leg figures for Dragon Factory, I needed to be able to swing the shoulders/thighs in a wide arc; in fact, I wanted them to be adjustable to any angle. Standard rotation order called for the Twist axis to be down the Y axis, along the length of the limb. Instead, I put it on the X axis. (See Figures 4.1 and 4.2, pages 120–121.)

Another case where you will want to use non-standard rotation orders is when you want to use Hand Grasp dials. These are hard-coded to use the Z axis as the "Bend." If your hand is pointing in a different direction than the human's, the Z axis may be the logical twist or side-side axis. However, you can assign XYZ as the rotation order, and then rotate the JP centers until they are aligned with your particular body part.

This is basically what I did with the Dragon Factory webbed wings: each strut, no matter which way it is facing, uses the XYZ rotation order. (See the *Mantabat Webbed Wing Tutorial* on the CD.)

Splitting the OBJ

Examine Figure 4.3 on page 122, which presents a simplistic sample figure, representing a body part with a limb (torso and arm or leg, hand and finger, etc.). It shows four different ways the "torso" and "limb" could be split as we create our OBJ groups. Which is the correct way to cut the figure?

Well, #2 is obviously the joke entry, but how about #4? Who could possibly want to split things that way? Did you pick #1 or #3? Do you feel smug? Well, don't. The actual correct answer is – *it doesn't matter*. For joint parameters, it doesn't make one shred of difference; they will all bend the same way. If you don't believe me look at Figure 4.4, page 123, which shows all four, plugged into the exact same CR2, using the exact same joints, posed in the exact same pose.

Always remember – Children Affect Their Parents. (You will have learned that from Chapter 3.) And it isn't the shape or the size of the child, nor the parent that dictates how things move. It's all in the JPs.

When splitting an OBJ into body part groups, there are three things you need to take into consideration. The most important is the seam locations. Poser will only weld a body part to one parent. Not to two parents, not to an aunt or uncle, not to a sibling (although you can fake it, but it may not always work. (See *Welding* under *CR2: Practice* in Chapter 3). If you are working with fingers, the best type of split to use will cut the finger well above the knuckle where it joins the hands, so there is a buffer of "hand" polygons between each finger seam: i.e., example #1, see Figure 4.3, page 122.

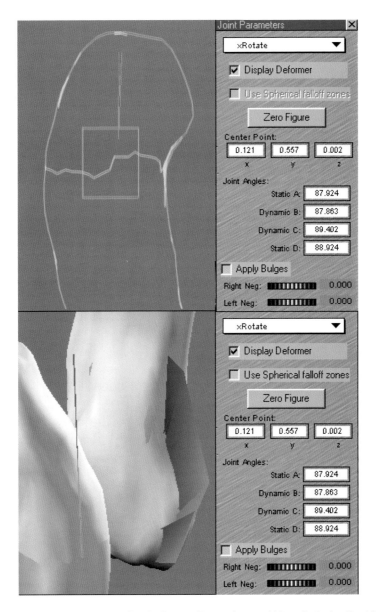

Figure 4.1 This is how the standard xRotate for the Dragon Factory leg would have looked, a Bend X centered in the shoulder. The red arms are pointing straight up, and the green arms almost touch them. With the Bend X, some part of the mesh is not going to move, and you can see the results of rotating the shoulder 180 degrees.

The second consideration should be morphing. If you are going to want to make gnarly knuckle morphs on your hand, it would be better *not* to split the fingers in the middle of the joint. If you do, each gnarly knuckle morph will have to span two body parts, which is quite annoying and a lot of work: both to spawn all the morphs, and for the user to turn them all on and off, even with FBMs. If we wanted our "limb" in the examples to have knuckle morphs along its length and

Figure 4.2 This shows the actual Dragon Factory rotation order: the twist is along the X axis instead of the Y. The Twist Bar can be pulled back to include the entire shoulder (note the center point is still in the same location as before). Now the front leg can be rotated to 180 degrees or more, with no distortion on the shoulder.

where it joins the "torso," example #3 would work well. Or perhaps #2, if you want to put all the morphs on the torso part instead.

JPs should be the last thing you worry about, since that is so flexible. The parent–child split can go almost anywhere. But keep an eye on the grandparent–grandchild relationship. Children cannot affect their grandparents. This may be a good thing or a bad thing. You could engineer

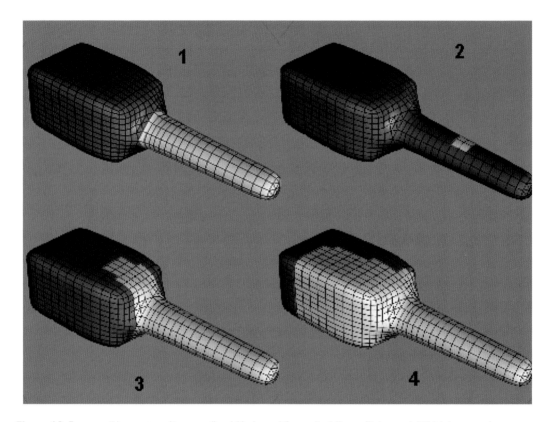

Figure 4.3 Four possible ways to split a torso/hand (dark grey) from a limb/finger (light grey). Which is correct?

your figure so that a body part acts as a buffer between two other body parts. If your thigh is warping your hip out of shape, no matter what you do with the JP matSpheres, you could create a buttock buffer zone between them. See the *Advanced figure design* section below for more on buffer body parts.

Versatility and interchangeability

Why make just one figure? What if your one figure could pose as several similar figures? When I created my first Poser figure, the Deluxe Multi-Species Swan, I didn't just make the one swan. I then put morphs on the head, and painted different textures for a tundra swan and a black swan and a mute swan, not to mention the brown juvenile swans of each species. Then I shortened the neck and turned it into a goose, with a Canadian goose texture. To top it all off, I even made a cygnet figure to go with it.

When I created the Heavy Horse, I wanted it to be able to have a long tail, a docked tail, and an all-out fantasy flowing tail. So, I made the horse without a tail and made the tails separate figures. The fetlocks are two separate conforming figures, and there are four conforming manes. With all that, plus the head and body morphs, you can get a pretty accurate rendition of many draft horse breeds.

Figure 4.4 Answer: it doesn't matter. The body part splits do not affect how the object bends, the joint parameters do.

I'm a big fan of expanded figure use. Not content with DAZ's buck, I remapped, made props, and morphed it to the limit. Then I created over a dozen antelope species for it: the Antelope Expansion Pack. The same is true with the Eagle and the Eagle Expansion Pack I. The Eagle is not just for eagles any more: I had to make hawks and falcons and kites out of it. One model, hundreds of uses: that's my motto!

Morphs are one way you can extend the range of your creature's repertoire. The Cat O'Nine Lives morphs from Capsces turned the Poser cat into a big cat, a raccoon, a fox, and a rabbit. The cat was also scaled in various ways to recreate these animals. Body part scaling is another option, but not a very good one. Things that are scaled too far usually pose terribly. It is better to scale your base object and create a new figure. This would be very handy for creating baby animals (or baby aliens, if that's your thing).

Don't forget Geometry Swapping. For changes that are too extreme for morphs, you can use alternate geometry. You can turn your mare into a stallion, or you can swap heads on your alien monster.

Look at parts of your figure that might be modular, such as manes, tails, wings. If you take the wings off the Wee Beastie Winged Horsie, you get a little pony. And what about things that might be props? Spikes, spines, fins, all kinds of decorative bits are props for Dragon Factory. DAZ's Millennium Dragon also has different tail-tip props as well as a set of conforming spikes. Think about customizing hot rods: change the hubcaps, get a new rearview mirror style, a panther hood ornament, trade your fuzzy dice for a fuzzy duckie. Anything that allows your figure to be customized means more versatility for the user, which means more use for your figure.

Not only do modular bits work well on your figure, but the user can use them on other things too. Dragon Factory props have been used on horses, humans, and the Li'l Devil hatchie. The old Zygote Dragon wings were chopped and used on all sorts of winged figures. DAZ themselves chopped the Eagle wings for their creature pack.

Interchangeable texture maps are another plus for versatility. I don't know where I would be without April's remapping of Stephanie to take all of Victoria's texture maps. The P5 figures co-opted the Millennium style maps to also take advantage of the wealth of textures already available.

Geometry families

Geometry families are different figures that use the same base mesh (edited). Victoria and the Millennium Girls (and the DAZ Ogre, perversely enough) all use the same base mesh. Stephanie was created from Michael's base mesh.

It is very difficult to model different figures from the same mesh – in my opinion, anyhow. I cannot imagine how they got Stephanie out of Michael, but the results are good. I can instantly double my use of any morphs by sharing them with both figures.

The Wee Beasties were designed to re-use each other's meshes and JPs. All the creatures were built with the same proportions. The Horsie and Hippocampus obviously have the same geometry for the forequarters. The Hell Puppy and Manti-Kitty use the same body and paws. Then there was the Griffies, for which I only had to build the forequarters. Slap on the Horsie wings and hindquarters – instant Hippogriffie. Plug in the Manti-Kitty hindquarters – instant Griffin.

This type of design will give you a broad range of figures, and cut down on modeling time. The Griffies were completed in a total of 12 days. They would have been done sooner if I hadn't spent at least three days trying to rearrange vertices in the proper order. But the joints were 90% done, the textures were half done, and even the head morphs were easy to do, since I had saved all the Magnets from the Hell Puppy.

UVMapping

In order to use textures in Poser, your object needs to have UVMapping, even if you have a simple prop and want to use only square textures. The textures will not apply unless there is *some* type of UV info.

There is a UVMapping tutorial on the CD, plus the free UVMapper for Mac and PC.

Advanced figure design

Buffer zone body parts: preventing movement

Now we will look at the theory of buttocks and the evolution of the female figure.

When the P4 Nude Woman bends her leg back, her buttock is completely crunched into a bizarre, unnatural fold. When her leg bends forward, the buttock stretches out and gets a strange squared-off shape. The groin, always a problem area, gets a strange indent. (See Figure 4.5, page 126.)

Steve Torino set out to fix the P4NW hip/thigh area, and to do so, he invented a buffer body zone. The buffer zone is not meant to be posed (at least, not as fully as a regular body part), but it simply divides a body part from its usual parent to prevent interaction between the two body parts. Since children cannot affect their grandparents, the thigh was isolated from affecting the hip by the buttocks. (See Figure 4.6, page 126.)

The buttocks are designed to move sideways and to twist, in limited amounts, but they are not made to bend. Instead, the thigh JP centers are placed inside the buttock and leg bends are produced by the thigh. Thus the damage area produced by the thigh's extreme bending is limited. Note how Eve's buttock leaves the iliac crest within the hip body part, where the thigh cannot mangle it (Figure 4.7, page 127). This, coupled with the new joints, allows the leg to bend forward without the big, square buttock being produced, and allows the groin line to be smoother, and the hip to be undistorted as the thigh moves. (This is also very noticeable in side to side leg movement, where the thigh would pull the hip out of shape along the groin line.)

Also notice with the leg bent forward, a crease develops on the side between the leg and hip, which is not present in the original P4 figure (Figures 4.5 and 4.6). While this crunching can be seen as a fault, it is actually quite natural. If you study photographs of nudes with their legs bent, a Y-shaped crease develops between the hip and thigh. It isn't Y-shaped in Poser (and it looks a little crinkly instead of smooth), but it's a start.

Figure 4.5 Here is the P4NW with her leg bent at 80 degrees, both forward and back. The two problem areas are the buttock and groin.

Figure 4.6 Here is Eve with her leg bent at 80 degrees. Although not perfect, you can see a marked improvement over the P4NW in these poses.

Figure 4.7 Eve uses the same mesh as the P4NW (with the exception of a hip with modeled genitalia). Only the joints and the addition of the buttock buffer zone are different.

If you wish to study Eve, you can download her from MorphWorld.

Buffer zone body parts: facilitating movement

Now let's look at dividing the mesh to facilitate the bending of body parts. I wanted my Wee Beastie Manti-Kitty to have mobile shoulders like a real cat. The shoulder blade ("collar" in Poser parlance) could affect the chest, where it was embedded. But what about the upper foreleg ("shoulder")? This body part also merges into the chest, and is connected with flaps of skin, etc. The solution is an enabling buffer zone.

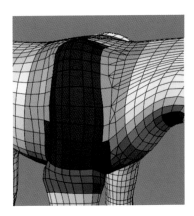

Figure 4.8 Here is a close-up of the Wee Beastie Manti-Kitty shoulder area. The chest is light grey, the shoulder is dark grey, and the upper foreleg is medium grey. Take a moment to analyze what part can move which sections of the mesh, and which it cannot.

The shoulder is sliced rather thinly from the chest; the entire scapula is not included in the collar body part (see Figure 4.8). Why not? It doesn't need to be. It can affect that part of the mesh whether it belongs to the chest (its parent) or to the collar. The neck also needs some of the chest mesh to work with and bend, so this is also a consideration. The neck should be able to stretch the skin, but not move the crest of the scapula. Thus the skin area is left in the chest, while the main part of the bone and core is in the collar body part.

The collar also extends down further than the scapula and takes up the bulk of what is actually the upper foreleg or "shoulder." The shoulder itself is relegated to a small slice near the elbow, similar to the Standard Poser Cat and Horse. Again, this is because the shoulder can affect that area of the mesh whether it is in the body part itself, or whether it is in the parent.

Yet again: Children Affect Their Parents.

You can think of this as pushing the body parts down the limb. If you really wanted to, you could leave each body part inside its parent. The collar area would be the chest, and the shoulder area would be the collar. Then the forearm would be the shoulder, and the hand (paw) would be the forearm. Bizarre, yes, but you have to realize that it doesn't matter which side of the parent/child division the polygons are on. The JPs define how they bend.

Now, the collar body part not only commandeers the bulk of the upper foreleg, it also claims a ring of polygons around the area where the foreleg blends into the chest. This prevents the foreleg from touching its grandparent, and also gives part of the chest mesh over to the foreleg to be stretched when the leg is pulled out to the side. (See Figure 4.9.)

In operation, the center of rotation for the shldr body part is placed at the point where the humerus meets the scapula (i.e., well inside its parent). Thus it bends from the correct point.

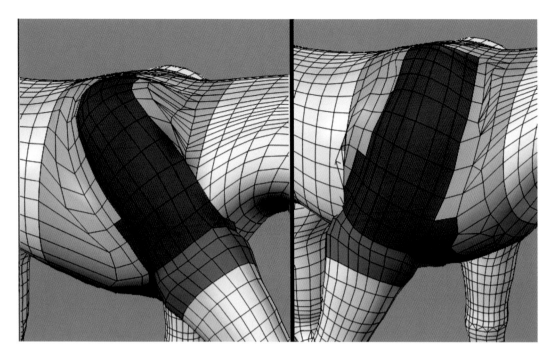

Figure 4.9 This is the collar body part bent forward and back. Note how the scapula stretches the skin in the chest area.

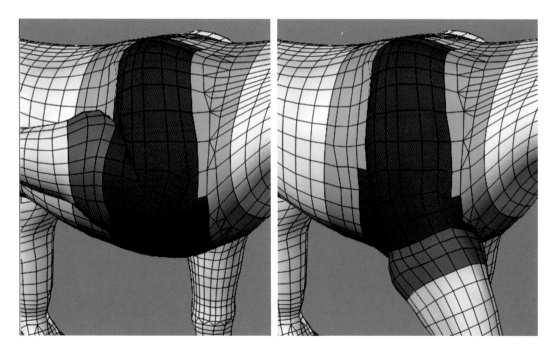

Figure 4.10 Here the shldr body part is bent forward and back. Note the area just behind the elbow, where a section of what is essentially chest skin is stretched by action of the foreleg. When the upper leg is bent back, you can see the point of the humerus where the center of rotation is located.

Control handles: "Poser Bones" or "Body Handles"

This concept started out with the jawbone I put in the P4 Lion's head, so I could make the jaw posable without messing up the existing head morphs. I then experimented with a "flubber" figure, which was a blobby humanoid figure that was all of one piece, but had triangular bones inside it for the limbs. The idea was that the body could be morphed into almost any shape, but still be posed via the "bones." The flubber figure is on the CD if you want to play with it.

"Poser Bones," as I called them, are good for adding posability, while preserving morphs, or making morphs easier. Jaw bones are a good example: instead of slicing off part of your creature's head to make the jaw, you can leave it all attached and use a bone to pose it.

This concept can also take the place of morphs. Anton Kisiel took the "Poser Bones" idea and developed it into "Body Handles." (See Figure 4.11.)

In Anton's Long Flowing Fantasy Beard, for example, the hair, beard, and mustache is all one body part. To make the hair flow and sway, you pose the handles sticking off it. This method

Figure 4.11 Michael's Fantasy Beard, by Anton Kisiel, showing the Body Handles (in red) used to help pose the sections of the hair.

takes up less CR2 space than doing morphs for every possible motion and position of the hair. And it works much better than stacking morphs, which tend to distort each other, as you may recall if you tried the dog head morphing exercise.

Anton also uses Body Handles on several clothing items to adjust the fit, rather than trying to rely on morphs to cover every circumstance. It is easier to nudge a Body Handle to get a sleeve to cover pumped-up biceps rather than try to incorporate every upper arm muscle morph in existence. And then what happens when somebody makes a new biceps morph?

Handles are very handy on posable clothing items, especially flowing bits that have no obvious hierarchy, such as capes. They are also useful in addressing the old sitting dress problem. See the *Clothing* section below for more uses of handles in clothing.

Webbed wings, webbed fingers, webbed toes

When siblings share a seam, such as with finger joints that have webbing between them, you end up with a big headache.

One way of constructing webbed wings is discussed in the Mantabat tutorial in the *JP Practice* section on the CD. This method uses standard Poser figure practices to slice and joint the wings.

Another way to deal with connected siblings is to add weld statements between them. This (and the potential hazards of this) is discussed in *Welding* under *CR2: Practice* in Chapter 3.

Yet another trick is to use "Reverse Hierarchy Affectors," which will be discussed in the *Clothing* section a bit later on. You can see this concept from dresses and skirts in effect on a webbed hand with the WebHand figure on the CD.

Inverse morphing, or things that inconveniently stick out

We first ran into this with the webbed wings (See the Mantabat tutorial on the CD). It was impossible for the joint controls to properly encompass the wing struts if they were bent. So, they had to be built straight, and then morphed into a more natural arching shape.

I call this "Inverse Morphing," because it goes against the natural order of things. Normally, the base figure is the proper shape, and morphs change it into alternate shapes. But in cases like the webbed wing, the base figure is the wrong shape, and the morph puts it into the final shape.

Other uses of this concept occur with things that stick out from body parts in such a way that it is difficult or impossible to properly include/exclude them in the joint zones. (See Figure 4.12.)

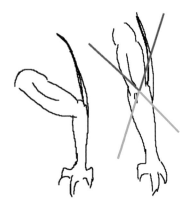

Figure 4.12 Here is a concept sketch for a spiky alien creature. Note the elbow spike sticks up along the upper arm. If we use normal JPs for the elbow here, the spike will bend and stay along the upper arm, when it is supposed to stick out. The solution? Hide the spike inside the arm, where it can be included in the bend zone, then morph it out to its desired length.

Figure 4.13 shows another example concerning a posable jaw: what if we have really long teeth, fangs, or even tusks? If we open the jaw to make sure all these sticking-out bits are clear, the thing will be halfway to the throat!

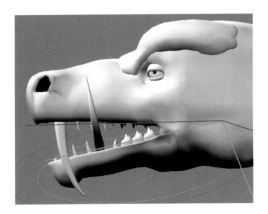

Figure 4.13 On this head the jaw is open to 15 degrees, ready to be jointed – except for all those huge teeth that are in the way.

The solution is to "morph" the teeth down inside the gums, well inside the lips where they are out of the way of the JP zones. This "morphed" model can then be used as the base figure, and the "teeth-out" model can be applied as a morph. (See Figure 4.14.)

Set up the joints, morph the teeth out, and *voilà*! The mesh of the teeth will obey the joint settings as applied to their original vertex location.

Pointing things: pistons, gravity, anti-gravity, and eyes that follow you around the room

Poser has a "Point At" command (Object: Point At) that is mainly used to have a figure's eyes look towards the camera. If you try this same trick on a human head to get your subject to face the camera, you end up with a nutcase who points the top of his head at you all the time, as if he is a bull about to charge. This is because the "Point At" is not very smart, and it basically

Figure 4.14 The huge teeth are shrunken down inside the gums, and now can be easily encompassed within the JP inclusion zone where they belong (and not in the one where they don't!).

follows the twist axis of the body part. The head's twist axis is vertical, so you get the scalp pointing at you all the time.

But there is a trick to this. The "Point At" command is not really using the twist axis, it is using the end point to control the pointing. It draws a line through the center, end point, and the target's center. So all we have to do is pop open the JP Window and move the head's end point cross-hair out in front of the face. (See Figure 4.15.)

Gravity and anti-gravity Pointing at is not just for mugging the camera; it can be useful for gravity as well. Even in P3 and P4 you can have gravity with this simple tool. You could use this on posable hair such as the P4 Long Curly Hair.

Note that in Figure 4.16, the dangly bits are actually slanting, not hanging straight down. This is because they are pointed at the Ground Plane. The 'Point At' command actually points the object at the center of the target, and the center of the Ground Plane is at 0, 0, 0, so that's where the dangly bits are pointing. If you move your figure around on the Ground Plane, you'll notice that the hair or whatever points back towards the center of the Ground. To work properly, the "Point At" command needs a center of gravity prop to point at. This could be a simple square, or even one triangle. It should be positioned at an extremely large negative Y-axis distance. This will shove it down into the center of the earth, and gravity will work normally.

For anti-gravity, such as flames and helium balloons, you will need to invert the center/end point relationship. That is, place the end point above the center point, so the object points away from the center of gravity. Or, you could create an anti-gravity prop and stick it off in the sky somewhere at a huge distance on the Y-axis.

Now if you want to save your figure with gravity on, there is a bit of a snag. You cannot parent the center of gravity prop to the figure, or else it will leave the center of the earth when you rotate the figure. And if it is not parented to the figure, you cannot save it into the CR2. However, you can hack it into the CR2 from a PZ3, or more simply, a PP2.

In Chapter 3 we saw how the structure of a PP2 differed from that of a CR2, even one that has props in it. In a regular CR2, the props are inserted into the scene in the addChild segment of

Figure 4.15 Fortunately, we can move the head's end point without changing the twist axis (just don't hit "Align" or try to rotate the centers). Now the head moves so there is always an imaginary line between the center point, through the end point, and to the target. Remember, don't move the center point, or you will throw off the center of rotation.

the Figure section. In a PP2, they are added in the doc branch. All you need to do is insert the doc branch into your CR2. (See Figure 4.17.)

Pistons　Suppose you are building a robot or a spaceship with retractable legs, or something with a piston in it that connects two body parts together. If you build it along the limb, it will bend at the joint hinge, just like the rest of the limb. What should you do?

Figure 4.16 Here's my "Very Tall Guy in a Hairy Yak Suit." He has dangly bits of trans-mapped hair hanging off his arms. On the left (our left) are the dangly bits in their default state. On the right, all the dangly bits are pointing at the Ground Plane. When you raise the arms, the dangly bits dangle.

Figure 4.17 A simple CR2 and a regular prop file. To insert a non-parented prop into the CR2, place the prop geometry at the end of the figure geometry section (red), the prop control at the end of the figure control section (yellow), and the doc branch after the figure branch (blue).

First, you must build the limb properly. Make the main limb straight, of course, but make the two ends of the piston separate children of each piece. For example, the sleeve part of the piston will be attached to the upper arm, and the rod part of the piston will be attached to the lower. Don't build the pistons together, build them at right angles to their respective parents.

Figure 4.18 The joints are not critical at this juncture, but the position of the red and green cross-hairs for the piston pieces are. The center point goes in the hinge, and the end point goes at the end of the piston section.

Set up the figure as you normally would, and make sure to use the proper rotation order for the piston pieces. That is, the twist must go along the long axis. (Actually, you can mess with that, if you want to set the "Point At" by placing the end point.) The arm joints will be typical arm joints; the default should work fine for testing. You may want to turn bend off for the different pieces, or for the entire workspace (Display: Bend Body Parts). The piston JPs are important; make sure the center point is at the center of the hinge, and the end point is centered at the end of the piston part. Do this for both the sleeve and rod of the piston. (See Figure 4.18.)

Now all you need to do is point the piston sleeve at the piston rod, and the piston rod at the piston sleeve. Make sure you do both. Your piston should snap together. Now bend the arm (don't pose the piston pieces), and the piston should work like a real piston. As the arm bends, the piston pieces will rotate so that they face the hinge of the other part, and they will shove together as the distance between the wrist and shoulder decreases. (See Figure 4.19.) You can also try out the sample Piston figure on the CD.

Figure 4.19 The piston sleeve points at the rod's hinge, and the rod points at the sleeve's hinge, and as you bend the arm, the piston works like a well-oiled machine. It's a thing of beauty.

You will run into problems if you bend the arm too far closed, or too far open. The piston may poke through it or pop apart, so be sure to set your joint limits.

If you are having problems with the piston segments distorting, or they distort the arm, try turning off the bend for any problem part. Or, you could remove the specific affectors that are giving you trouble. See *Affectors* under *CR2: Practice* in Chapter 3 for information on that.

Also note that you can add pistons to existing figures by attaching the piston pieces as props. To set the center and end point for the props, use the JP Editing Window, rather than "Display Origin." With the JP Editor, you can position the red and green cross-hairs.

Hair and fur

This is one of the holy grails of Poserdom (the other is folding wings). P5 users can also see *Dynamic hair* in Chapter 5, but don't discount trans-mapped hair and fur just yet. P3 users are out of luck, as P3 doesn't support transparency. (You can, however, use trans-mapped hair in other rendering engines.)

First, any humanoid figure should have separate hair, saved as an HR2 file in the hair library (or PP2 file in the prop library, if you prefer). This makes the figure more versatile and customizable. Also you don't have to worry about hair getting in the way of the figure joints. (Well, if you have very long hair, you might be quite happy to include it in the neck and chest joints, but in that case, you can make it conforming.)

The most realistic hair available in Poser is trans-mapped hair. See DigitalBabes 2 for the definitive trans-mapped hair tutorial, and to get the best hair available anywhere. Basically, trans-mapped hair is made up of relatively simple shapes, either a mold of the outline of the hair style, or in several strips and/or sections. These should be layered for the best effect. A hairy trans map is then applied to the pieces, as well as a texture, and the job's done.

For best results, the texture at the base of the hair should be fairly dense, and only the tips and edges should show markedly separated strands. Do not paint the strands all the way to the edge

of the UV map, or the hair will appear to be cut off abruptly. Similarly, design the hair mesh so it is longer than the actual length you want the hair to be, to compensate for this edge difference.

The trans map should be of fairly high resolution, to delineate the strands best. If your hair appears smudged at the edges, you may have too much greyscale blending between the strands where they fade into the black transparency. Try adjusting your image to use only black and white. If those results suit you, you can save the map as a 2-color GIF file to cut down on the file size, and the rendering times will be cut down, as well. If you want to use JPG, use little or no compression, as this may compromise the fully black areas.

In Poser, the highlight color must be set to full black, or you will see a plastic-wrap sheen in the render, that will show the base geometry's shape and ruin the effect. You can experiment with the ambient color, but black should be fine there, as well.

If you are creating trans-mapped fur, you can create it as part of the figure (as in my "Very Tall Guy in a Hairy Yak Suit"), or as an add-on prop. Or as a conforming figure, if you like.

Trans-mapping for fur has not been as successful as for human hair, mainly because human hair is relatively long and only viewed from the outside. Fur is quite short, and can be seen sticking off an animal at any angle. If you create fur in the manner of hair or clothing, you will not get a satisfactory result. The hair will envelope the body in a cylindrical manner, and the trans map will show the skin/pelt underneath, but the edge of the fur will still be smooth and un-furry. (See Figure 4.20.)

In order to get a furry edge, the hair mesh must be perpendicular to the skin surface, not parallel. This causes the main headache, because it takes a lot of pieces to be perpendicular to every section of the surface. Even with simple square strips, you are talking about a lot of polygons.

Brycetech has developed a trans-mapped fur technique. This involves stacked rows of cones that follow the course of the body's surface. Each cone is identically mapped, so it only takes one trans map for the entire coat of fur. (See Figure 4.21.)

This technique achieves decent results for short fur, but it has shortcomings. At certain angles, the gaps between the fur cones can be seen in the render. Also, it is not possible to create a vari-colored animal; all the fur cones must have the same color and texture map. They could be divided into different material zones, however; perhaps on the fly with the Grouping Tool. In this manner, fur on the top could have a darker texture applied, and fur on the bottom a lighter; or patches of different colored fur could be constructed, possibly even stripes. Trying to create leopard spots or tiger stripes with the Grouping Tool, however, may end up being too frustrating.

It may be possible to design conforming fur based on the base geometry, and mapped in such a way that the fur would use the same texture as the "skin." But in that case, trying to create a trans map for each bit of fur would be a nightmare.

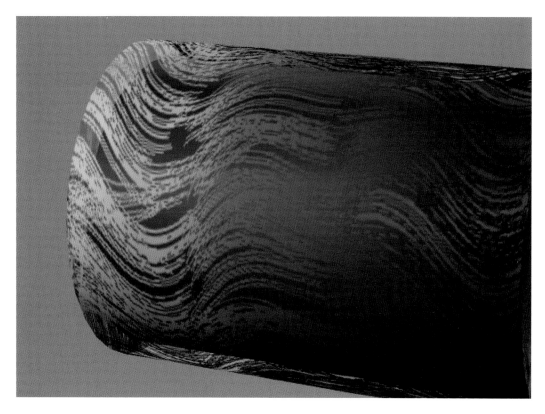

Figure 4.20 Here is a representation of a cylindrical animal torso, with an overlying trans-mapped layer. While the fur may appear hairy from the side, the edges of the creature's pelt are still flat lines without "fuzz."

Clothing design

For Poser 5 Dynamic Cloth props, see Chapter 5.

Conforming clothing: theory and practice

Conforming clothing must have these characteristics:

1 It is built upon the base OBJ of the target conformee.
2 It has the same body parts and hierarchy as the target conformee.
3 The joint centers are located in the same locations as the conformee's.
4 The conforming figure must be completely unposed and zeroed.

Now here's the painlessly easy way to go about making conforming clothing. Follow steps 1 and 2, as usual. Build the clothing upon the base OBJ and group the clothing item so it has rShlders and lThighs etc. The seams do not have to exactly match up for the conformer to work. Use standard figure design when slicing the clothing mesh: keep in mind morphs and such that you

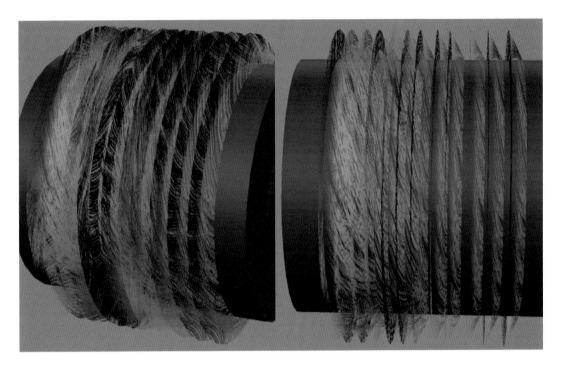

Figure 4.21 Stacked cones along the cylindrical "torso." These create fur edges along the pelt of the creature for a more fuzzy look. However, at certain angles, the gaps between cones are apparent.

might want to be doing. Lastly, you may find it easier to leave off the end body parts altogether. For example, if your horse blanket falls just below the line of the thighs, you don't need to slice off any bits for the leg below the thigh. If your blouse has a sleeve halfway down the forearm, you can just leave the whole thing in the upper arm (shldr) body part. You will see why when we discuss phantom parts, below.

Speaking of phantom parts, many early conforming figures were built with geometry in the unused parts. If you look at the OBJ file for some of the shirts, for example, you will see weird bits sticking out the neck and abdomen. In the CR2, those bits are not visible, so they can be somewhat of a surprise. You do *not* need to put geometry in for every part of your target figure. Only use your clothing geometry, and only slice it into those body parts that it is covering.

Once you have your clothing OBJ, you now need a CR2 to put it in. The good news is that you do not have to go through the whole new figure and JP routine to get one. In fact, it is better if you don't.

What are the characteristics of the conforming clothing CR2? It has the same body parts and hierarchy as the target conformee, the JP centers are in identical locations as the conformee, and it is in a completely zeroed out pose. How do you think we could get a CR2 that matches all these criteria? Load up your conformee, turn off all IK chains that might be on, open the JP

Window and hit the "Zero Figure" button. Now make sure both the hip and BODY are not translated anywhere, and make sure the BODY is not scaled. Memorize the figure, and save it to the library as, say, "WhateverFigure-Base Conformer."

Now if you change the geometry pointers in that CR2 to point to your clothing OBJ, you will have an instantly working conformer. It really is that simple. (*Note:* For some arcane reason, this method does not work with Victoria. You can assemble a conformer base for Victoria using existing conformers.)

There is some housecleaning you should do on your base conformer CR2 before you use it, however. First, all morphs should be deleted (a quick trip through Morph Manager or Maconstructor should take care of that). If it is a male figure, the Geom Swap for the hip should be removed – unless you plan to make an alternate hip geometry for the genital switch. You should also go through and delete all the material entries in the Figure section. When you load up the CR2 with your OBJ inserted, Poser will create new materials for the ones that actually exist. You might also consider taking out parts you will never conform anything to. The eyes, for example, can be completely removed. Finger parts can be left in or out. If you ever want to make gloves, leave them in. (See *Chopping* under *CR2: Practice* in Chapter 3 for details on chopping CR2s.)

After you have your OBJ plugged in, and have saved to a new CR2 (don't overwrite your base conformer; you can use it over again), you can clean up a bit more by removing unused parts from the CR2. When you are removing unused parts, remember not to remove too many. First, never remove the hip; this part is vital so that the rest of the figure knows where it is positioned. Keep the hip and the hierarchy from the hip up to your body parts. For example, if you have a left arm conforming gun assembly for the hand, forearm, upper arm, etc., you would keep the hip, abdomen, chest, and lCollar.

And now for the Phantom Parts: always keep the child(ren) of the last body part in your clothing (Children Affect Their Parents). When you put your shirt on your figure, the chest of the shirt needs a phantom neck, so that the shirt's chest reacts when your figure bends his head forward. Same thing with sleeves: if they go down to the end of the forearm, include the phantom hands, so the ends of the sleeves will stay on the wrist as the conformee bends.

But how can you have hands in your CR2 if your OBJ does not have hands? Well, this is why they are Phantom Parts. After you plug your OBJ into your base conformer CR2, and load it into Poser, and re-save to the Library, check out the CR2 in an editor. You will see the parts that are there have the storageOffset and geomHandler stuff in them. Parts that are not there just have an actor and name. But they are not *gone*. Down in the Channels section, everything is there: all the dials and JPs for all the parts, whether they are real or "phantom." So when the conformee's hand bends 60 degrees, this pose information is passed to the conformer's hand channels, and the appropriate effect is seen in the sleeve.

Now one last thing before your conformer is perfect: you may need to adjust the JPs. If your clothing is particularly loose or bulky, you may find odd bits poking out and sticking to their original locations as you move the figure. In cases like this, you need to adjust the JP inclusion zones to include the larger size of your clothing. It is perfectly okay to do this; move the JP bend

X arms, adjust the spherical falloff zones . . . as long as you do *not* move the JP center. Do not move the bend X control around anywhere, just its arms.

Lastly, you may see in some CR2s a channel that says conforming 1 or conforming 0, or a conformTo channel. You can ignore these; using them does not make a figure conform any better. Actually, I think they make things worse.

You can also use P-Wizard by Patrick Magill (Kattman), which has a conformer-creating module. With it, you plug in your OBJ file, and the target conformee's regular CR2, make sure all the pieces correspond, and out pops a conforming CR2. (You will have to edit it though, if you use your final OBJ; the Conforming Wizard creates a new OBJ file in this process, and places it somewhere else.)

Dresses and the eternal sitting problem

Now a dress or skirt (or kilt or sarong) on its own is a potentially simple construct as a figure. You have the top, which is the waist/hip, and then a bunch of posable segments down the length that let you bend it forward, bend it back, say from side to side, twist it, etc.

Except, of course, that it is supposed to be worn by a figure with two legs. And if you want to conform it, the dress needs two legs, too. The big difference, though, is that the dress is connected down the middle, while legs are not. So, either you need to attempt to weld siblings together (the dress's proposed thighs and shins), or you need to do some figure-slicing contortions to avoid the illegitimate parenting. (See Figure 4.22.)

If you make the hip a long T-shape, then have the two sides as the left and right thigh, you are in shape. The thighs will weld to the strip of hip polygons between them, and manipulate that part of the mesh as they move.

This works fine for short skirts and kilts, but what about this long dress? What about shins?

You can run the thighs down along the center of the hip T, and thus create a buffer between the hip and shins, and avoid the illegal weld. But look at the areas of effect in Figure 4.23 (page 144). There's a stretch of material down between the shins (that belongs to the hip) that they cannot bend. So when your figure sits and bends her legs, that bit in the middle is going to stay sticking up!

One solution to this problem is to create a morph to push that bit down where it belongs. Another solution would be to create a control handle down between the shins that is parented to the hip, and designed to control that wayward bit of fabric. My Fur Cape (see the CD) uses this design on the sides.

Another solution we will discuss later is using Reverse Hierarchy Affectors.

But . . . now what about buttocks? If we want to include them into the equation, then everything goes out of the window. (See Figure 4.24, page 145.)

Figure 4.22 Here is a basic dress design. Outlined in red is the hip. The two sides of the dress are the thighs.

The good news is, you can just leave the buttocks out. Dodger designed his Elf Mage dress for Victoria with only the hip and thighs, and it conforms just fine, even with the buttocks completely removed from the conformer's CR2. Thank goodness!

Reverse-Hierarchy Affectors and the soft body revolution

Anton Kisiel developed this alternate method of dealing with long dresses in his Egyptians clothing set. It works much like my "flubber" figure, with one solid mesh as the main body

Figure 4.23 To add shins, there needs to be another "T" zone where the thighs go down and surround the shins, to prevent them from trying to weld to the hip. Note the range of effect (colored arrows) and the limits of effect (lines ending with an X).

part, and control handles dealing with the posing of it. But whereas flubber can only have one generation of children, the Reverse-Hierarchy Affectors (RHA) can simulate a full hierarchy.

There are three parts to this design. First, the whole mesh is one body part, and the posable limbs are control handle body parts that affect it. Second, all the body parts in the hierarchy are children of the main part, rather than each other. Lastly, their affectors are listed in reverse of the normal hierarchical order.

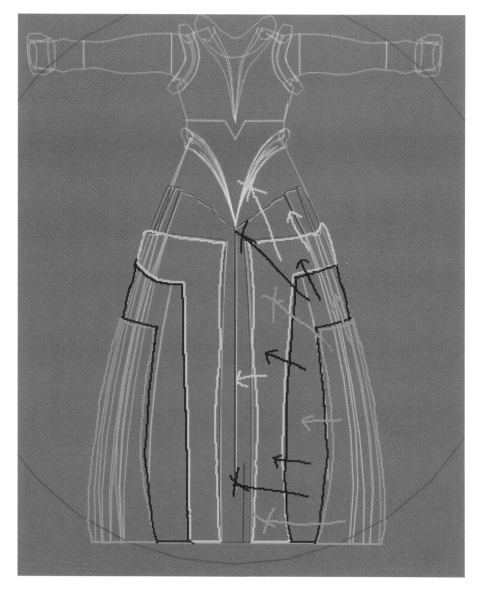

Figure 4.24 If our conforming target has buttocks, the T-style dress diagram will end up like this: a total mess. Now there are two strips of polygons between the shins that they cannot manipulate, and now there is a section between the thighs that is not going to move with those body parts! Forget about sitting down, if you have buttocks.

In the webbed hand, for example, the entire hand, web, and finger joints are the hand. Each finger joint (index1, index2, index3, etc.) is a child of the hand. The affectors within the hand channels are "backwards;" that is, index3 comes first, then index2, and index1. (Check out the WebHand CR2 on the CD to see how it works.)

Let's look at Anton's design (Figure 4.25). The whole mesh (well, most of it) is the "hip." The thighs and shins use overlapping spherical falloff zones in their JPs. The thighs control the entire sweep of fabric below the hip, and the shins control the lower half of that sweep.

When the thighs are bent, the shin control handles don't move, which is rather disconcerting until you get used to it. The shins don't move, because they are not children of the thighs, of

Figure 4.25 Here is a diagram of an alternate dress design. Anton's Rulers of Egypt long drape assigns the majority of the mesh to the hip, and a small square patch to the thighs (purple). The shins (green) are Body Handles out to the side (left). If I were designing a dress this way, I would not bother to slice out the small patch for the thighs. Instead, I would make both the thighs and shins into internal "bones" (right).

course. They only move with the hip. When you bend the shin control handles, however, the "leg" of the dress bends properly, as if the shin *did* bend with the thigh. This miracle is accomplished with the Reverse-Hierarchy Affectors. If you put the affectors in the "correct" order, it doesn't work. (See Figure 4.26.)

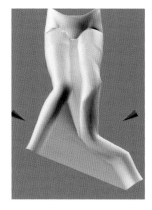

Figure 4.26 The Egyptian Long Drape in action. On the left leg (right side), I have put the thighs before the shins in the "normal" hierarchy order. You can see it doesn't work properly that way.

Despite the total 3D environment of Poser, it is still basically a linear process. The hip reads the affectors from the children in the order they are stored in the CR2. When the thigh affectors come before the shin affectors, the program is unable to calculate the correct location of the shin's area of effect. In reverse order, the shin bend is calculated first, and then moved with the thigh bend (remember, the thigh JPs overlap the shin JPs, so they move the shin polygons as well).

If you make the shin a child of the thigh, but leave its affectors in the hip, again, it doesn't work. Moving the shin with the thigh bend moves the location of the shin's center, and areas of effect, and the leg becomes broken when posed.

The amazing part is that the Egyptian skirts take the same poses the figures do. So when you pose the figure, and apply the pose to the skirt, the hip, thighs, and shins all line up just where they are supposed to. They are not made conforming, but I believe they could be. The only real difference between their structure and a normal clothing figure is the hierarchy. Since the figure works normally with regular poses, it should also work fine with conforming.

Which means, theoretically, you could create a single-mesh Poser figure, without seams, and pose it with an internal bone structure. The only caveat is, the bone limbs would not pose as normal. You can see this with the WebHand sample figure. When you bend the first finger digit, the rest of the finger bones stay up in the air. But it is an interesting idea.

Conforming clothing or prop clothing?

With the advent of conforming clothing in P4, people went conforming mad and started making everything conforming – conforming shoes, conforming hats, conforming bracers. This is not

necessary. Even the P4 bikini top and bikini bottom do not need to be conforming; these items can all be props.

I prefer clothing items to be props whenever possible, because it is easier to keep track of a collection of props than it is a group of conforming figures. Figure files have so much overhead (all those channels and joint information, etc.), while the props just have – well, just the prop. Also, prop clothing can be parented to any figure, while conforming clothing fits only one specific figure.

Here is my guideline for conforming vs props. If the item touches three consecutive body parts or fewer, then it can be a prop. If it touches more than three parts, then it should be conforming.

So, how many body parts does a hat touch? Obviously just the one – the head. So just put it on the head and parent it. To make a hat conforming would require information in the CR2 for the unused hip, abdomen, chest, neck (and upper neck, where appropriate).

Now how about a shoe? It touches the foot and the toes. But if you parent it to the foot, and bend the toes, the toes poke out! Well, they won't, if you parent the shoe to the foot with "Inherit Bends" turned on. Inherit Bends stuffs the prop into the body part's joint setup. Which means that segments of the shoe that poke out into the toes' area of effect will be affected by the toes' bending. In addition, the shoe or boot will be affected by bending between the foot and the shin. So now if your boot touches the shin, foot, and toes, you can use a prop with Inherited Bends. If you have a thigh-length boot, then you would need to make it conforming.

Now look at the bikini pieces. If you parent the bikini top OBJ to the chest with inherit bends on, it will work fine. Bending of the collars/neck will affect it just the same as if it were conforming. The same with the bikini bottom; parent it to the hip, and the thighs (or buttocks) and abdomen can affect it as usual.

Footwear: one or two?

For some reason, most conforming shoes/boots/sandals etc. use two different figures for the left and the right members of the pair. Ostensibly this is in case you want somebody with only one shoe on, and you want to take the other one off and throw it across the room. But how often does that happen? One shoe in each figure means you need to load two figures for a pair, and that is two more figures making clutter in your scene. If someone occasionally wants to take one shoe off, those body parts can be made invisible. If they want to throw it across the room, they can load another figure and turn the other side parts invisible.

Armor: bending conformer or un-bending props?

This is a difficult question, and it all depends on the design of your particular suit of armor. Logically, armor is made of rigid metal bits, and your chest plate certainly does not bend at the abdomen as you bend over (or try to). But, if you put an unbending chest plate on your character's chest, and then apply standard poses, you will find the bottom of the chest plate poking through your figure's abdomen as the chest bends and the armor doesn't.

You are faced with two choices: (1) make the armor unbending and force the user to not move the figure's body around as freely as they normally do; or (2) make the armor bend unrealistically, to keep it on the figure no matter how it is bent. Although the first is more realistic, your best bet is to go with number 2. If the user wants realism, they can take pains to make sure the torso does not bend too far and make the armor crinkle up like aluminum foil. If you make the armor unbending, you will hear no end of complaints from people who want their knights to do acrobatics on the backs of their horses, that their spry knights are always falling out of their outfits.

Now as for the one conformer or a set of props question, if you create your armor as a set of props, people can mix and match the different pieces, assemble partial armor sets, and even combine it with other armor props they may have. It is also easier to scale and position props onto other figures that the armor may not have been designed to fit. This makes it more versatile, but more difficult to assemble a full suit of armor. If you put everything into a conformer, it is all in place and can be applied to the underlying figure in two simple steps. Which route you go is up to your personal preference. Or, you could just make a conforming suit plus a set of armor props that match.

Lastly, you may want (or need) to break your armor into a figure and some props. For example, if your armor has shoulder plates that stick out at an angle, you will not be able to build these on the base conformer. Those shoulder plates are designed for normal human figures, who have their arms hanging down at their sides. Poser figures, as you know, have their arms sticking out straight. Trying to figure what the shoulder plates would look like with the arms up like that, and designing them to look correct as they bend down with the arms is just too much of a headache. Build the underlying armor as a conformer, then build the shoulder plates as props on a figure with the arms down. Parent the plates to the armor's shoulders (or collars), and it will work much better. You may need to experiment if you want the shoulder plates to inherit bends or not. If they do not, they might hit your warrior in the head when he lifts his arm too far (this could be more painful if the shoulder armor has spikes!). Of course, if you do make them bendy, they will fold and expand like accordions rather than steel plates, so you need to decide which option best suits your particular situation.

Conforming, partially conforming, or just parented?

If you are making a hat with a long train or veil, you can make the dangly bits posable. So should this be a conforming figure or just a hat figure that can be parented to the head? My vote is make it a plain figure and parent it to the head. It is easier all around that way (though you may have to spell this out in your instructions several times; people are obsessed with conforming everything, even when it is not necessary).

Now it could be that the veil drapes down to the chest, and you want the veil to conform to the movements of the chest and neck of your figure. You can make partially conforming figures, where part of your clothing (or armor, or horse mane, or dragon spikes) corresponds with the underlying figure's body parts, and other bits do not. Your fancy hat may have the front veil corresponding to the chest, neck (and upper neck), and the hat as the head of the conforming figure. Then the long trains down the back can be train1, train2, train3, train4, etc., which can be posed independently of anything the conformee is doing. The DAZ trenchcoats (for the

Millennium Man or Woman) have a partially conforming version, where the upper section of the coat stays on the chest and arms, and the lower sections are able to flap about free from the hip and legs.

Prop design

Prop set vs posable prop

Imagine you want to make a bureau with a set of drawers that slide in and out. Or a cabinet with doors that open and close. Or a really fancy piece of furniture with drawers that slide in and out, doors that open and close, *and* a mirror that tilts up and down. All this varied motion, with independently-moving pieces, cries out for being a figure, and not a prop with a huge number of morphs.

There are two ways you can go about doing this. First, you can create a figure, a "posable prop." (A posable prop is just a figure that is not a living creature or an anthropomorphic robot.) Or, you could assemble the pieces as separate props and construct them in their own hierarchy, and save them as a group. For items with non-bending parts, this method will work fine. If you are creating a vacuum cleaner with a hose, or a plant that bends, or something else flexible, you will want to go the figure route.

The figure route works the same as with any other figure. You will need one part of your prop to be the base body part, the "hip." (No, it does not need to be named "hip," but don't name it "body.") With your bureau, it can be the main structure, and all the various drawers, doors, and mirrors can be its children. With your plant, it can be the pot, the root, the trunk; whatever.

Some bits might require special handling. For example, a drawer will slide in and out – this would require you to unhide the Trans dials so the user can move the drawer (well, the one dial that represents the sliding in and out axis). You may not want the drawer to rotate at all, and the cabinet doors may rotate on only one axis to open and close. (See *Dial operations: Locking/ hiding/deleting dials* under *CR2: Practice* in Chapter 3 for help with all this.)

Remember, if all this sliding and opening/closing is deforming your base, turn off the bending for that body part. The various rigid bits may also need their bends turned off, as well.

Now how can a prop, or a group of props, imitate a figure? Well, they can't, unless all the pieces are unbending. In our fancy bureau example, each part would be a separate prop: the base, the drawers, the doors, the mirror. Each piece would have its parent set to be the base. Then you need to make the origins visible, and position them over the hinges or rotation points of your pieces. Set the limits for rotating and translating, lock or hide your unused dials, and save the whole set as a prop set. Be sure when you save it to use the Select Subset button, and grab all the pieces. After saving, edit the PP2 to be sure the parenting information was saved properly.

The prop set will likely be smaller than the figure setup (unless you leave the props as embedded geometry. (See *Prop files: PP2 and HR2* under *CR2: Theory: Other Poser library files* in Chapter 3.) Choose which method suits you and your prop.

Posable prop vs morphing prop

Don't make every prop posable, just because you can. A gun will work perfectly well with morphs to pull the trigger, slide the slide, cock the hammer, etc. The only situation where morphs will not have an advantage are in rotations. If you have a revolver-style gun, you can create a morph to roll the chamber out to the side. But as you know, the morphs move vertices only in straight lines. Therefore, in positions between fully closed and fully open, the chamber will deform out of shape.

Another instance where morphs are at a disadvantage is when they become stacked. If you are moving a rope or tongue or tentacle, you will need morphs to bend it up, bend it down, to the side, lengthen and shorten it, make an S-shape, etc. Now what happens if you have an S-shaped tongue bent to the right, and you try to lengthen it? You get a mess. Posable ropes are not easy to work with, to try to get all the pieces exactly in place, but they work better than morphs. (And, of course, there is always Easy Pose! See *CR2: Practice* in Chapter 3.)

Figure creation: Practice

There are three paths to Poserizing your figure. Each version of Poser supports previous methods, so if you have Pro Pack or P5, don't feel you have to use the Setup Room all the time. The basic steps are outlined below; full tutorials for each method can be found on the CD.

Poser 3 PHI method

This method will work in any version of Poser, and it is the one I use exclusively. I find it the most logical and controlled. The other methods rely on Poser's grouping tool a bit too much for my tastes.

Steps

1 Build and "slice" the mesh into body parts.
2 Build the PHI text file.
3 "Convert Hierarchy File" in Poser.

Poser 4 hierarchy method

This method uses the Poser Hierarchy Editor to set up a new figure, without all that work with PHI files. There are a few headaches associated with this method, however. If your OBJ is not already divided into body part groups, you will have to use the Grouping Tool to slice the mesh. (See *Grouping Tool* under *Morphing: Theory* in Chapter 1 for help with that.) Next, you will need to use the 'drag and drop, then go back and drag some more' method of building IK chains. Then you use the Hierarchy Editor to rearrange the rotation orders. Lastly, when you're all done, your geometry will be fully embedded in the CR2, and you will have to extract it out,

unless it is a very small and non-commercial figure or you are using Pro Pack/Poser 5. (See *Removing embedded geometry* under *CR2: Practice* in Chapter 3.)

Steps

1 Assemble or slice the geometry into body parts in Poser.
2 Arrange everything into a hierarchy in the Editor.
3 Save the figure to the Library.

Poser Pro Pack/5 Setup Room method

The Pro Pack and Poser 5 extend the in-Poser figure creation tool palette with the Setup Room. This is a separate workspace for slicing and creating the hierarchy for a figure, using a boning system. This system is a quicker and more visual way of setting up the hierarchy.

You can begin with an OBJ that has the body part groups already named, or (if you are very brave) you can try the Grouping Tool's Auto Group function, which will slice the object based on the bone structure you give it. You can use the Auto Group feature even on an OBJ with pre-set groups, but those will all be erased once you Auto Group. You can manually adjust the groups with the Grouping Tool as well.

Steps

1 Import the base OBJ.
2 Create or import a skeletal structure in the Setup Room.
3 Save the figure to the Library.

Note that creating a figure in the Setup Room will introduce several faults into the figure. None of these faults will cause the figure not to work, but you should be aware of them.

1 Affectors for the children will name bone_# instead of the child's actual name. This means that instead of twistZ tail2_twistz, the affector will read twistZ bone_3_twistz. Apparently, the affector channels are inserted into the parent body part when the child bone is created, before it is named. Once the child bone is named, the parent body part is not updated with the child's name in its affectors. The otherActor entry seems to correctly name the child, which is probably why it still manages to work. This will also occur in the Smooth Scaling for the child bone. (See *The Controls section: level 2 – channels* under *CR2: Theory*, and *Affectors* under *CR2: Practice* in Chapter 3 for information on affectors.)

How to fix: You can do a search and replace to rename the bone_#'s to the correct body part names.

2 No taper dial will be created. This means that only that the user will not be able to taper the body part. Taper is not often used, and sometimes the taper control works a bit too oddly for practical purposes. However, tapering a body part is important when its child uses Propagating Scale. (See *Scaling* under *CR2: Practice* in Chapter 3.)

How to fix: The taper dial is simply a basic channel. You can copy one from any other figure's body part, or build one on your own. (See *The Controls section: level 2 – channels* under *CR2: Theory* in Chapter 3.)

3 All the translation dials will be visible. This means the user can drag any body part around in the document window, which is not a pretty sight. The shin, for example, can be dragged out to the side of the figure, or up to its head, or anywhere. The welds between the shin, thigh, and foot will remain connected, but the leg will definitely be broken.

How to fix: I recommend Ajax's Easy Pose Underground for this one. With EPU, you can select all the body parts and do a mass "change hidden 0 to hidden 1" on them. Otherwise, you need to find the x, y, and z Trans dials in each body part, and change the hidden attribute one at a time, while making sure not to hide the ones you do need (such as in the BODY, the hip, and possibly the eyes).

4 Channels will be in a non-standard order. This means that in Poser the visible dials will be Rotate, Scale, Translate; instead of Scale, Rotate, Translate. Not a big problem, but it may be counter-intuitive to people used to working with standard figures. Internally, the smooth scale and joint/joint/twist channels will be out of order. Again, it does not seem to affect the functionality of the figure, but it may be disconcerting when editing the figure's CR2.

How to fix: In P5, you can drag the dials around and order them in the Poser interface to reposition the rotation dials. Or (in all versions) you can drag the channels around in your CR2 editor, or promote/demote them in Easy Pose Underground. But this is likely to be too time consuming. It would be easier to just avoid this altogether by using the PHI method of character creation.

5 Pro Pack will not weld the thighs to the hip. This means the seams between the thighs and hip will tear. This is a bug that was fixed in P5.

How to fix: Add the welds into the CR2 manually. (See *Welding* under *CR2: Practice* in Chapter 3.)

Finalization

After your first stage of Poserizing, whatever method you are using, the next step will be to do all the JPs, and morphing and such. These stages have their own chapters, but once your figure is nearing its final state there are several areas you will want to cover to clean up everything and save to the final CR2.

Poser 5 materials

P5 assigns a light grey/mid grey/black color set to the diffuse/highlight/ambient color chips for the materials, which is decent, but would not have been my first choice.

Figure 4.27 Here is my default material. The diffuse color is white and the specular is black. This may seem an odd choice for a highlight color, but the dark highlight prevents the shiny plastic look. The ambient is black, of course.

Set your materials to a base white, then save this base material node to your Materials library. Then you will be able to apply it to all your figures.

There are other properties you want to be sure to look at when you set the default material. Change the Transparency Falloff to 0 instead of 0.6, to make trans-mappers happy. Make sure the Reflection_Lite_Multi is on; reflections do not work too well when this is off.

After you apply your default material to all the materials in your figure, make sure you have sensible settings for the different materials. For example, the eyes should *not* have a black

highlight at 70% size (that's .7 on the Highlight_Size entry); they should have small, white highlights. Teeth and gums and other shiny bits should have small, bright highlights. The mouth skin, tongue, and any horns would work well with light, but broader highlights. Just vary the highlight greyscale value and size for each base material.

If you have several varied textures for your figure (or none), you should save the default CR2 without any loaded, so the user can choose which one to apply. If you have only one texture, you may set it up to load with the figure. Plug your texture into the diffuse, specular, and ambient jacks. Include any transparency and reflection settings.

Bumps, gradients, displacements

If you are using a P3/P4 style "BUM" bump map, this is supposed to be plugged into the Gradient Bump jack. This is the Bump that reads the BUMs properly.

The Bump channel is for creating non-perturbed textured surfaces. That is, it behaves as you have come to expect bumps to: they appear to stick out and/or dent in the material, but seen from the side, they are still flat. This is good for skin textures and other subtle effects.

The Displacement works like a bump: it uses a greyscale height map to perturb the surface of the mesh. However, this jack will actually cause the mesh to appear as if it is really sticking out. Bricks and mortar will show indented mortar, even on the edges, and noise-bumped fur will have bits poking out beyond the boundary of the mesh. Use this for such extreme modifications of the model's shape.

Browse through the P3/P4 Materials section for more tips concerning colors, texture maps, transparency and reflections.

P3/4/PP materials

When you first create your figure, Poser will assign some "interesting" random colors to the materials. You will need to set those to be something logical, or plain white if you plan on putting textures on it.

Colors

The main controls are the color swatches across the top. The Object Color is the base color. Note that whatever color you put here it will multiply with the texture map you assign to the material. This is why you should set all the base colors to white, so they do not darken or dull your texture. However, you can get some interesting effects if you use a faint base color under the texture. You can tint your skin bronze or tan or greenish. But that is something for the artist to fiddle with, here we are doing the standard base figure, so white it is.

Sometimes, I use a faint grey or base tint from some materials that should be shadowed, but often aren't. The teeth, tongue, gums, inner mouth ... Often when rendering in Poser, I find

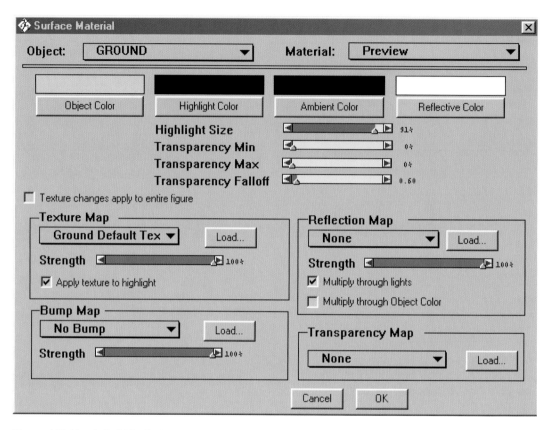

Figure 4.28 Here's the P4/ProPack material editor (Render: Materials). Poser 3 has fewer controls, but the ones it has are the same.

these come out too bright-looking, so I dull the texture map with a pale yellow-brown for the teeth, and fleshy-grey for the other bits.

The nostril material can be set to black, or a very dark brown, to avoid the "glowing nostrils" phenomenon. You can also set pupil materials to black if you like.

When assigning a Highlight Color, do not think of it as a color, think of it as a value assignment for the highlight brightness. White highlights will be very bright, and dark highlights will be subdued. Most people tend to try to assign a lighter version of the base color to the highlights, and this creates Poser's plasticky look. Use darker hues instead, unless you are working with plastic or metal materials.

Once you select a value, you can impart a color to it, to tint the highlights. For the white texture base, though, this should be a grey value.

The Highlight Color interacts with the Highlight Size control. This slider controls, obviously, the size of the highlight. For bright, sharp highlights, shrink the size down to 20–30% or so. For

smoother highlights, turn it up to around 70–90%. If you imagine your material on a sphere, picture how much of the sphere you want your highlight to spread over, and input that value.

If you set the highlight color to 100%, the highlight color will override the base color. If you have an overlying texture map, it will be blended with the color, instead of multiplying and darkening.

Figure 4.29 This is the default ground plane and material with three different pink settings. At the top, the Object Color is set to the pink shown in the background (the Highlight Color and Ambient are set to black). The pebbly brown ground texture multiplies and darkens the pink. In the center, the Object Color is white and the Highlight Color is set to pink, with 100% size highlights. At the bottom, the Highlight Color is set back to black at 50% size, and the Ambient Color is set to pink.

The Ambient Color is the shadow color. Normally, this should stay black. If you use a bright color, your material will be self-illuminating (i.e. glowing). This is good for things like LEDs or glowing eyes. You can use a bright color to tint the glow, or use a greyscale value to underlie the texture map.

For human flesh tones, some people have had luck using a very dark brown for the Ambient Color. This makes the skin tone more lively, but do not make it too bright, or your figures will fail to shadow properly.

The Reflective Color tints the reflection map (if there is one set). For some strange reason, Poser likes to set this to black, which is the worst possible choice for this swatch. If the reflective color is black, and reflections are turned on, your material will be all black. This should be set to white on all materials, even if you do not plan on making them reflective, personally. (You never know, a user might need a chrome tiger or something, and having the Reflection Color pre-set to white is helpful.)

Transparencies

There are three transparency sliders, the Min, Max, and Falloff. The Min and Max are not really the minimum and maximum transparency. Instead, the Min is the edge transparency, and the Max is the main transparency. The Falloff controls how abruptly the edge becomes less transparent. If you are trying to create a glass material, or a translucent balloon, the Min transparency should be less than the Max, and the Falloff to 0.6–1.5 or so. For everything else, especially if you are using a trans map, the Min and Max should both be 100% and the Falloff 0.

The Transparency Map is loaded in the lower right. This should be a greyscale image, and white is opaque. Make sure your black is true black, and your Transparency Max is set to 100%.

Also, when using a trans map, be sure your Highlight Color is set to black, otherwise you will end up with highlights across areas that are supposed to be empty air.

Textures

This is where you load the color texture map for the material(s). When "Texture changes apply to entire figure" is checked, any change you make to one material's textures will be applied to all materials in the figure (but not its props). This includes setting any color, bump, reflection, or trans map to "None," so be careful what you change while this option is on. It is best to turn it on to load a single color and/or bump map, then turn it off to adjust the individual reflection and trans maps.

If you are creating a figure that has several different textures that go with it, you should save it with no textures loaded. If there is only one texture, you can have it load with the figure, or leave it off for the user to load. Make sure, when saving the texture on your figure, that you have it in its final form (JPG for downloads) and in the proper location, so when the user loads the figure, Poser can find all the textures in their proper places.

Bump maps

These also start their life as greyscale maps. It does not matter if you use white as high or black, as the bump map can be set to negative or positive values. Actually, whether the bumps appear to stick out or dent in depends on the lighting situation in the Poser scene. In addition, the CR2 only saves positive values for the bump map, so load it up and set it to 100%.

Poser 3 and 4 will convert the greyscale image to the Poser BUM format, the Pro Pack can use the greyscale image as-is. When creating figures for P3/4, you should include the original greyscale bump map, in case the user wants to edit it. For downloads, the greyscale GIF (or JPG if you must) is smaller than the BUM, and the user can convert them after installation. Pro Pack users are ready to go out of the box, but should be sure their CR2 or MAT Pose files point to the GIF/JPG, not to the BUM.

Reflection maps

Unlike the other types of texture map used in Poser, these do not follow the UV coordinates of an object. They are spherically projected onto your object to fake a sort of distorted environmental reflection deal. They can be greyscale or color maps.

The "Multiply through Lights" and "Multiply through Object Color" should always be turned on; they do not seem to work properly with those turned off, unless you are looking for a very subtle effect. For metallic materials, the Strength should be 100%, but you can create other effects with lower settings. A rainbow reflection map set at 15% or so on a white material can create a pearly sheen, for example.

Rotation names and limits

After the JPs are all set, you should test your limbs' bendability and set limits on the rotations. You should also name the x/y/zRotate dials to their proper names. All this can be done right in Poser.

Select your limb, and test bend it. Note down how far it can go either way before becoming unnatural, or crunching too much, etc. Double-click the dial to enter the Min, Max, and dial name. You can also fiddle with the Sensitivity, which controls how fast the dial turns and how many decimal places it uses. Normally, you can just leave those at the defaults.

The rotation names are usually "Twist," "Side-Side," and "Bend." The collars and shoulders have "Front-Back" instead of "Side-Side," which make sense. The eyes use "Up-Down" instead of "Bend." I also use "Roll" instead of "Twist" and "In-Out" instead of "Side-Side" for mine. If you have wings, you might consider using "Fold" and maybe "Flap" for side-side and bend. You can name them whatever you like, as is appropriate to your particular limb.

When I am doing the Front-Back and Up-Down and In-Out deals on my creatures, I like to change the name to reflect the directions of the dial. For example, on my Norn's right shoulder, it is "Back-Front," because turning the dial in the negative direction moves the arm back. The right eye also uses "Out-In" because the negative Y rotation points the eye outward, and positive points it inward. The left side bits use "Front-Back" and "In-Out" to reflect those dial directions. It is just something that makes the figure easier to pose for the user.

Morph limits

It is standard practice not to set limits on morphs, but for commercial figures, I like to have some reasonable limits on them, just in case the dial goes a little berserk and inputs something like 1001 when the user only meant to turn it to 2.5 or so. See *To limit or not to limit* under *Morphing: Theory* in Chapter 1 for discussion of morph limits.

Initial pose, IK favoring, memorizing

When you create the figure, it is in a zeroed-out pose. Before finalizing it, you should set it up into a default pose, or make it just stand there, instead of hanging there in space. If you are creating an animal, you can put the tail down and the head up, bend the hind legs, angle the paws so they rest on the ground, etc. This expedites the posing process, as it gives the user a base to work with. If they want a creature that is just standing around, they don't have to spend time putting the feet on the floor.

The other reason for posing the figure is the Favored IK Angles. Have you ever turned on a leg IK chain and tried to squat the figure down, and the knee bent backwards and got all twisted? This occurs when the legs are straight at the outset. The IK chain does not know which way to bend the limbs, so it just bends them any-which-way. To get your limbs to bend properly when IK is on, you should bend them slightly (3–5 degrees is plenty) in the direction they are supposed

to bend. Your thigh, for example, should bend forward, and the shin bend back. Then, when the IK is applied, the limb will tend to continue bending towards these favored angles. If you are working with a tail or tentacle that can bend in any direction, you can leave it zeroed.

When you have the initial pose set just right, and your morph targets set up the way you want them (usually all zeroed, by default), you should memorize the figure. This is on the Edit: Memorize: Figure menu. Then save to the library.

When you hit < Ctrl–Shift–F >, the figure snaps back to its memorized state (losing any posing and morphing you applied to it). The memorized state is stored in the initValue in the CR2, and it can be different from the initial pose, which is located in the k 0 entry. (No, the initValue is not the initial value.) What good is this? Well, perhaps you have a set of character morphs that you want to be turned on for your figure (like Stephanie's "Stephanie" set of morphs) when it is first loaded. But, if someone is trying to create new morph targets, having these morphs turned on can cause them problems. So, it would behoove the user to have a memorized state with the morphs zeroed, versus the initial pose, with morphs turned on.

The Favored IK angle works with the initial pose, or with the current state of the limbs when the user turns it on. It is not dependent on the memorized state of the figure.

5

Poser 5 extras

Dynamic hair

Poser 5 introduces strand-based hair that can react to wind force and gravity. If you have worked with strand-based hair in other applications, the controls should be familiar to you. The hair is controlled by Guide Hairs, which are single strands that control a clump of hair around them. Using the Guide Hair, you can control the length, direction, and bend of each lock of hair.

When you design hair (or fur) for your figure, remember that it needs to be grown on a prop, such as a skull cap. You can run your figure into the Hair Room without props on it, and create hair groups directly on the body parts, but this will make it difficult to save the hair to the library. To save dynamic hair as a hair prop, you must save it with its base object. If that base object is your head, for example, the next time you load your hair, you will get the whole head with it.

Another clever feature of the hair is that it will read a texture map from its base prop for its color. So if you select your figure's scalp, spawn a prop, and apply the texture map for the figure to it, you will get matching hair. This is especially useful for fur, where you may want stripes and spots and rosettes and all kinds of variation.

Basic hair operations

Hair groups

The first step in the Hair Room is to create a hair group (or groups). If you have created a group for the hair already, you can use it by typing its name into the "New Hair Group" name dialog

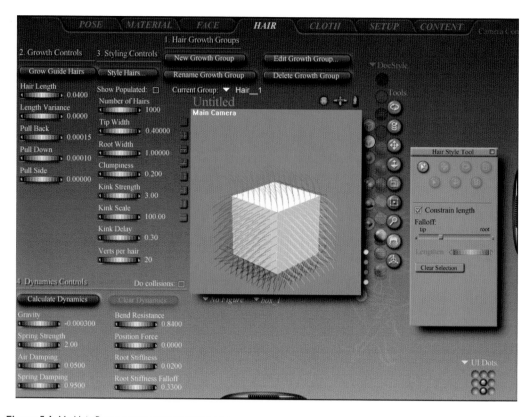

Figure 5.1 My Hair Room setup; customizations vary.

box. So if you selected the strip of scalp polygons down the middle with the grouping tool and named it "mohawk," just type that in where it says "Hair_1."

You can pre-define hair groups on your object if you like, instead of using Poser's grouping tool. To create body parts with groups, use a two-part name consisting of the group name, a space, and then the body part name.

For example, I wanted to define fur groups for the Norn that divided the body fur from the belly fur. So I created "fur1 chest," "fur2 abdomen," "fur3 hip," and "belly1 chest," "belly2 abdomen," and "belly3 hip." Make sure you give each body part a differently named fur group.

You can have multiple hair groups for each object, but you cannot have multiple objects for each hair group. If you are creating a furry creature, you are in for hours of work, because each body part has to have its own hair group, and they cannot all be named "fur." Additionally, you cannot copy hair parameters or save them or apply them in any way, so you will have to write down the parameters you are using for each group and plug those in to subsequent groups.

You will use different groups for different styles of hair. A lion, for example, can have a short fur hair group for the fur, and a long hair group for the mane. Some length variation is possible

within one group, using the Hair Styling tool. So you could create a cheek ruff for a tiger as a separate hair group, or just put all the fur in one group and tweak the ruff hairs' length.

If you want straight versus kinky hair, or hair with different densities, clumpiness, and/or vertex count, you will need different groups for each. You may also want to divide the hair into regions for special effects. For example, if you have hair groups for your creature's back, flanks, and belly, you could raise the clumping of the belly and flanks to simulate wet fur, where your animal has just waded through some water. You could have separate back and belly fur, in case you want to make the spine bristly, and the tummy soft and downy. Also, if you will not be using texture maps to drive the fur color, you will have to divide it by color region.

Guide Hair and hair parameters

Once you have got the group, you need to press the "Grow Guide Hairs" button in section 2. Now you can adjust the overall length of your hair, and the pull back/down/side strength. Note that the side strength is applied symmetrically; that is, hairs on the right side of your object will go to the right and hairs on the left will go to the left. (Unless you use negative values, when they will go the opposite way, but you cannot get all the hairs to go to just *one* side.) Use the pull values sparingly; these are just for the starting direction of the hair growth. You can adjust the gravity in the Dynamics section, and the combing back or to the side via the Hair Styling tool.

You cannot directly control the density of the Guide Hairs. Their placement is somehow calculated based on the mesh density of group they are grown upon. Or perhaps they just use an absolute Poser space measurement to plant them in neat rows.

Go on to Section 3, where you can adjust the clumpiness and kinkiness of your hairs. The most important controls here are the Number of Hairs, where you can specify the population density for each guide hair. If you are doing short fur, you will need a large number.

Also note the vertex count for each hair, which is 20 by default. This is far too many vertices for short stubble hair, so you can lower it. Four is the minimum value. Remember that the vertex count of your hair object will be this number times the number of populated hairs. So, $20 \times 50,000$ is . . . one million! And that's just on one body part, if you are doing fur; multiply that by how many body parts you are doing and . . . you need a bigger computer.

Growing fur

Let us experiment with a fur example. Grab the Poser cat for this test and zoom in on its head with the Face Cam. Jump into the Hair Room and, with the head selected, create a new hair group – name it whatever you want; Hair_1 is fine.

The hair group is created, but it is empty. Grab the Grouping Tool and make sure you select your hair group. Click on Add Material and add the fur material, and also the inner ear material. Do not just Add All, or you will get hairy eyeballs and hairs sprouting off the whiskers.

Once you have that done, hit the "Grow Guide Hairs." Can you see what happens? Well, the default hair settings are a bit too long for a short-haired cat. Adjust the Hair Length, and

remember to lower the Verts per Hair count to 4. The shorter your hair, the less coverage it gives you, so you will have to up the population count (Number of Hairs). You can also raise the root and tip width to give a bit more coverage per hair.

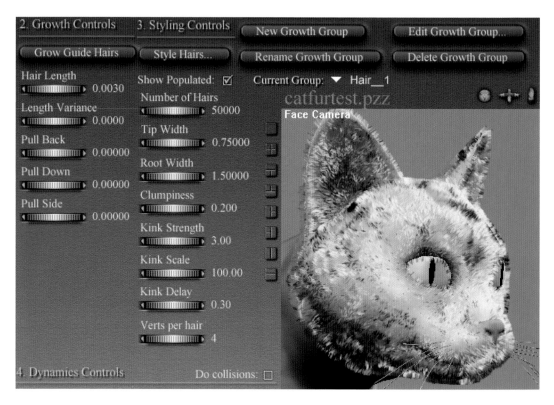

Figure 5.2 Here are the settings for fur on the cat's head. Once you adjust the length of the guide hairs, turn on the "Show Populated." You will notice the hair is pretty sparse and the short lengths don't cover the cat very well. Increase the Number of Hairs until you get a good coverage.

If you want a cheek ruff or tufted ears or something fancy on your cat's head, use the Hair Styling Tool. Turn off the "Show Populated" so you can see what you are doing (and, for lower-end systems, so you can work a little faster). With the Arrow-Plus Hair Styling Tool, you can add guide hair tips to your selection. Selected hair tips will show a yellow dot, but there is a caveat. The yellow dots do not show up in isometric camera views. You can still select them, and de-select them; you just cannot see what you are doing.

Use the front camera to grab some hair tips around the sides of the cat's face, then switch to the Face Cam (or use a dual view) to see what you have got. Use the Arrow-Minus tool to get rid of any hairs you didn't mean to grab.

The manipulation tools in the Hair Styler are the same as for posing the figure, but these apply to the guide hairs. You can use the Translate Tool, for example, to grab hairs and yank them

Figure 5.3 The Hair Styling Tool. The top buttons allow you to select/deselect guide hairs, and manipulate them.

around. The Rotate tool will let you bend hairs, and the Twist tool twists things up and generally makes a mess.

Underneath is a slider from tip to root. This controls the area of effect for your tools, since you cannot actually select the vertices that make up each guide hair. If you want to make your hairs droop down, move the slider about three-quarters of the way to the root and use the Rotate tool on them. If you move the slider near to the tip and rotate the hair the other way, you will start to get a recurve to it. If you just want to change the facing of the hairs, without making them bend, be sure you move the slider all the way to the root end, so you rotate the entire hair. With a little experimentation (on some longer hair) you will get the hang of it.

If you want to change the direction of your hairs by grabbing the ends and moving them, you can use the Translate Tool. If you want the hairs to move, but not change length, check the Constrain Length box. If you want to drag the tips out to make longer hair, then un-check this, obviously.

Then there's the Lengthen dial. Turn this and it will lengthen (or shorten) the hairs you have selected. Turn this to lengthen the cheek ruff hairs on the cat's head, once you select them.

Press the Clear Selection button, and now if you jump to your front view and use the Arrow-Plus tool, you can grab the ear tip hairs. If you're brave, you can then drag upwards with the Translate Tool to lengthen them without seeing what you have selected.

That's all we need to look at for the Hair Room: Hair Group, Grow Hairs, Style hair. The Dynamics (section 4) will mostly be used by the end-user, to apply scene effects like gravity and wind to the hair.

Once you leave the Hair Room, the hairs you have grown become just like any other prop (except, of course, you can always jump back into the Hair Room and edit them). You can apply Magnets and Wave deformers and spawn morph targets for the hair. Remember, just because you can style it, does not mean it cannot have a lengthening or waving morph.

Figure 5.4 Selecting the hairs to give the cat a cheek ruff. Use the Lengthen dial to make them longer than the regular hairs. You can also uncheck the "Constrain Length" box and pull the hairs down with the Translate Tool, which I have also done, to get the ruff hairs to droop a bit.

Figure 5.5 Tufts on the cat ears. They pointed up a little straight when I used the Translate Tool, so I then used the Scale tool to spread them out, which gave them that neat slant. To make the tufts more tufted, subtract one side, then use the Scale tool to squeeze the hair tips together. You can also experiment with the Twist tool on the tufts.

Dynamic hair can be saved to the hair library just like any other hair prop. Remember to include the base prop it is grown on (Poser will remind you). When you re-load the dynamic hair prop, the base should be automatically parented to your figure's head. If you need to move or scale the hair, select the base prop to do so.

Hair materials

Now that your cat has fur (on its head, at any rate), you need to learn the trick of how to get it to use the color of the cat texture map. So, without further ado, on to the Material Room.

The grown hair is now listed under the props; make sure it is selected. All hair is created with a default ugly blond color.

Figure 5.6 The default hair material. Note that it is different from standard material in that it uses a special Hair node, plugged into the Alternate Diffuse jack.

Hair uses a special shading node called "Hair" for obvious reasons. The Hair node is located under Lighting: Special because basically the render engine uses a special algorithm to render all those little strands, and it treats them as a special lighting circumstance. To see just how different this is, try plugging a hair node into the shader for a primitive or your creature's skin and do a render.

The Hair node has four controls. First there are the root and tip colors. The hair will shade from the root to the tip; usually the roots are darker. The specular color chip will control the intensity and color of the highlights. The last control is a number for the root softness. That is an effect that attempts to make the hair less wiry-looking where it meets its parent. If you notice the hairs poking into the scalp like straws, try turning this up.

The Hair node is plugged into the Alternate Diffuse jack, as mentioned before. Do not plug it in anywhere else; it will not work properly. Plugged into the root and tip colors is a noise function, to make the hairs less uniform in color.

Okay, enough preliminaries: how do you plug the cat texture into the cat's fur hair? Simply remove the Noise node (select and delete it) and create a 2D node for the cat map. Plug the cat texture into the root and tip color jacks. Change the colors of the root/tip chips to greyscale values to lose the blonde tint. You can also plug the texture map into the specular color jack.

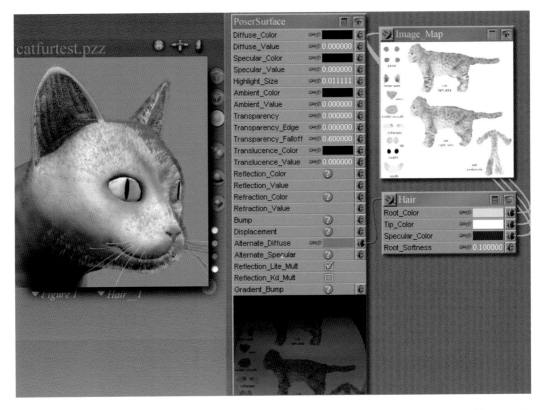

Figure 5.7 The setup for the cat's fur material, and the rendered results using the Poser 4 Render engine. Note that the Alternate Diffuse chip is a dark grey instead of white, and the Hair node root/tip/specular colors are also dulled. This is an effort to avoid glowing hair.

If, while messing with the hair material, your hair turns stark white, do not be alarmed. This is a minor bug, but it will not affect how the hair renders. When you render your hair, you may notice it glowing. In fact, it may glow a lot. This is a side-effect of the Hair node; supposedly they meant to do it that way. There are a few ways to combat the glow.

First, make sure your regular diffuse/specular/ambient color chips, in the base Poser Surface node, are all black. You can also change the diffuse/specular strength to 0. You can make the Hair Node root/tip and specular colors darker grey, but it may be more effective to change the Alternate Diffuse chip to a darker color. Note in the example the Alternate Diffuse is a medium grey. Also note that the render shows a bias towards darker colors on the lit areas of the hair. It's either that, or have the fur under the chin a glowing electric peach color.

Depending on your texture map for your creature, the glow may not be much of a problem. Darker textures have less trouble than lighter textures, for obvious reasons. You will need to do test renders and adjustments for your materials. Also, try both the Poser 4 Renderer and FireFly. The P4 Renderer tends to make the hair look thin and patchy; the FireFly tends to make it look thick and blotchy.

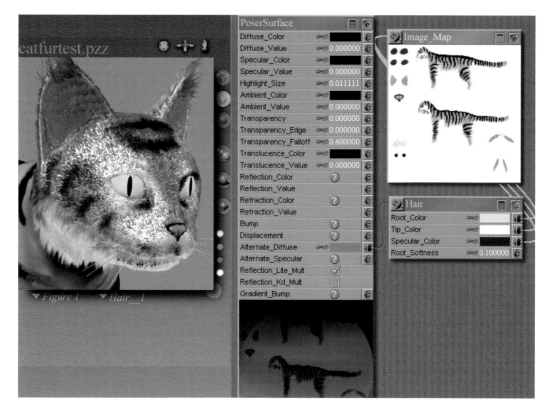

Figure 5.8 An alternate texture for the cat and its hair. This one is rendered with the FireFly renderer. Note how the fur is less thin and patchy than with the Poser 4 renderer.

See below for more help with the Shader Tree materials, and displacement mapping for fur.

Dynamic cloth

Dynamic cloth uses a real-world physics engine and collision detection to realistically drape cloth over objects in your scene. With a few tricks up our sleeve, we can use the simulator to help us model the clothing itself.

Conforming vs dynamic clothing

There are advantages and disadvantages to each type of clothing. Creating a realistic skirt as a conforming figure is a contortionist nightmare for slicing the body parts, whereas for dynamic clothing it is a simple, single piece. Creating a shirt decorated with buttons, stiff collars, and a carnation through the lapel can be a real trial with dynamic cloth. For a long trailing train of a gown, it depends on whether you find it faster or easier to shove the pieces into place by posing them, or if you prefer to let the physics engine calculate where and how it will fall. It also depends on the precision you want. If you want the cloth to clearly define what it is lying over, the dynamic cloth is the way to go.

Conforming clothing is created as a figure, and it must be divided into the various body parts. Dynamic cloth is created as a prop, and it cannot be divided, or the cloth pieces will fall apart during the simulation. It is not possible to make a conforming figure that can be dynamically draped, so you cannot put your conforming body suit on Michael, puff him up with a big beer belly, and expect to use the Cloth Room to have the suit stretch to cover him. (Dynamic clothing does not have this problem.) Similarly, you cannot have a Dynamic cloth that has posable parts. (It can have one manual control and one semi-manual control, as we will see a little further on.)

You could, however, create a composite figure. For example, our starched shirt with buttons and flowers could be created as conforming clothing, and then we could attach a dynamic skirt prop to it to cover the legs. The top would follow the figure's posing as usual, then you would calculate the drape of the skirt.

Dynamic cloth needs to be single-sided polygons that face away from the figure's skin. It also needs to avoid sticking into the figure at any point, or the cloth might "fall through" the figure to the floor. Single-sided polygons are difficult to see (from the back, at least), and it will not be possible to create the insides of sleeves and pant legs, such as on the DAZ Karate Suit.

You also cannot perform other clothing tricks such as having the belt be a solid cylinder that sticks through the figure, or poking belt loops or other decorations through the clothing and possibly into the skin.

Conforming clothing has no such restrictions, of course.

Lastly, dynamic cloth addresses the main niggling issue of conforming clothes: poke-through. Even the most carefully designed conforming clothing can suffer from the underlying figure poking through it during extreme (or even not-so-extreme) poses. Because dynamic cloth uses collision detection, it is much more difficult for the figure to poke through it – although not impossible. If poke-through does occur in dynamic cloth, the Collision Depth, Offset, and Points vs Polys settings must be adjusted to accommodate this. You can see this best by draping the flat cloth plane over a cone with the default settings. By the time the cloth reacts to the cone's side polygons, the cone's point has poked through the cloth.

Dynamic cloth is best for:

* Things that drape or hang down: skirts, dresses, capes, veils, trains, etc.

- Tight clothing where poke-through is a concern, or where the underlying figure is morphed out of shape.
- Baggy clothing that needs to hang and droop due to gravity.

Conforming clothing is best for:

- Things that wrap body parts: shirts, pants, bandoliers, belts, etc.
- Rigid "clothing" such as armor, mech suits, space suits, boots and shoes, etc.
- Loose or moderately tight clothing that should not sag out of shape due to gravity.

Dynamic cloth principles

These are the basic steps for jumping in with dynamic cloth and starting to mess around. First, you need a prop or figure in your scene, and then something to "clothify." A prop and the Square Hi-Res from the P5 props library is fine. In the Pose Room, raise the cloth over the prop.

Figure 5.9 Raise the cloth over the object(s) you want to drape it over, or else nothing interesting will happen. Use Flat or Smooth Lined mode to make sure your cloth is high enough over your object. If it is too close, you will see lines from the underlying object through the cloth. Raise the cloth just enough to get rid of those, and it will be ready to drop.

Now jump to the Cloth Room. For most basic, routine cloth stuff, you can ignore about 90% of the items in here. The basic routine is this:

1 Press the "New Simulation" button. Hit OK for the defaults, because we will be back anyway.
2 Press the "Clothify" button. Select your dynamic cloth item and hit OK.
3 Press the "Collide Against" button, and select the items in the scene you want the cloth to hit. If you have a complex scene, be sparing with this. The more items you choose, the more calculations you will have to wait for.
4 Press the "Simulation Settings" button. Does this look familiar? Yes, the dialogue is identical to the "New Simulation" dialogue. Now we can play around with the settings. For a simple quickie test, you can change the simulation length to 12 or 15 frames.
5 Press "Calculate Simulation" when you are ready to drop the cloth.

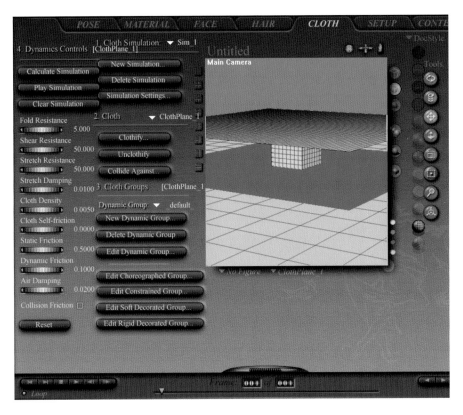

Figure 5.10 My Cloth Room (yours may look different, of course, depending on how you customized it). The important buttons are 1: New Simulation; 2: Clothify; 3: Collide Against; 4: Simulation Settings; and 5: Calculate Simulation.

If you are draping cloth on a figure, you have some extra options. In collision detection, you can use checkboxes to empirically ignore hand, feet, and/or head collisions. In the Simulation Settings, you can use the "Drape from Zero Pose" option.

Cloth groups

Dynamic group – default By default, this is everything. This is "it," the main piece of cloth. This is what you are acting on when you set the Folding and Shearing and Stretching parameters.

You can define any number of dynamic groups, unlike the other types of groups. This is for creating one piece of clothing with different materials, where dynamics can be set differently for each.

Constrained Think of this group as the "parented" group. To use it, you must first define the constrained group, and then set the parent for the cloth prop. If you parent the prop before defining this group, it won't work.

You can indirectly control the constrained group by moving the parent. For example, we can pretend our Square Hi-Res is a handkerchief, and define a clump of points in the center as the constrained group. If we parent the Square to the lIndex3 of our hand, we can pick up the hanky by lifting the hand. The rest of the Square, which is un-choreographed, will respond as normal to gravity and collisions and any wind or whatever we have in our scene.

Figure 5.11 The cloth square can be picked up by its constrained group (red dots), when it is parented to the index fingertip. The constrained group follows the movement of its parent while the rest of the cloth drapes and responds normally to gravity. Load the constrained.pzz file from the CD and play the animation to see it in action.

Candidates for constrained groups are the edges of clothing: collars on shirts, belts/waistlines on pants, and cuffs on the ends of sleeves and pantlegs. If your clothing item covers several body parts, and you are not sure which to set as the clothing parent to get the constrained group to work properly, simply parent the clothing to the hip or the BODY of the figure. This will work fine, even if it appears that the cuffs should be parented to the shins or forearms.

Choreographed The choreographed group will also follow the movements of the cloth prop's parent, but do not confuse this group with the constrained group. These two groups behave the same only as long as the prop itself is not animated. The choreographed group allows you to directly animate the cloth vertices, although in a limited way. These vertices will follow any movement you apply to the prop itself.

For example, to create a towel hanging from my figure's hand, I defined an area on the Square Hi-Res, just as for the hanky example. But instead of parenting it to the figure's hand (which remained still), I keyframed the cloth prop to slide over and up. When the simulation was calculated, the cloth was dragged up into the hand by its choreographed group.

Figure 5.12 The Square Hi-Res prop is positioned on the floor as a towel, and then keyframed to move over and up to the hand. While animating, the entire flat square moves around and does not look like anything. But once the simulation is calculated, the choreographed group are the only vertices that follow the position of the original square. The rest of the cloth responds to gravity, inertia, friction, etc.

Soft decorated Soft decorations are bits of the cloth that stay still on the cloth, but can flop around. Bows, ribbons, belt loops, pockets...these are all soft decorations.

Rigid decorated These are also decorations that are not welded to the main cloth, and are in danger of falling off during simulation. However, these do not bend or flop around or distort in any manner. Things like buttons, buckles, pins, or steel plates are obviously rigid.

Pre-defining cloth groups

Trying to grab all those little buttons on a dress shirt with the Grouping Tool to put in a rigid decorated group can be quite an exercise in patience. Fortunately, we can cheat and pre-group bits of the clothing.

First, the vertex Grouping Tool of the Cloth Room has the same controls as the regular grouping tool. To grab all those buttons, use the "Add Material" button and select the material "button." You did assign a button material to your buttons, didn't you? It's a good idea!

What about your pockets and cuffs and things that use the same material as the rest of the cloth? You can create regular OBJ groups for those. When you import the OBJ, the groups will be made into groups. No surprises there, but these groups are made of polygons and the Cloth Room uses vertex groups, so they have to be converted. Use the "Add Group" button and look in the list for your groups. They'll have a [P] on them to denote that they are polygon groups. Select them to add them to the vertex group. All the vertices of those polygons will be added to the vertex group, so you will not be able to define a single row of points this way, but you can remove the ones you do not want.

Designing and creating dynamic cloth props

Building the mesh

Just as with conforming clothing, dynamic clothes should be built upon the zeroed figure base. Other than that, the standard Poser construction parameters go out the window. Cloth mesh needs to be of high density in order to droop and fold properly. Imagine you have the side of a cardboard box. If you try to bend it to drape over a sphere, you are going to get one or two big folds and that is about it. Now imagine if you score a grid of squares into the cardboard with your x-acto knife. Now the stiff cardboard will collapse and bend at these gridlines, giving you more control. The denser the grid, the smaller and smoother the folds will be. The same thing applies to cloth mesh.

Also, quads are not the best divisions for cloth. If you have played with the Square Hi-Res a lot, you have probably noticed that when you drape it on things, you get a diamond row pattern at the folds. That is where the squares do not fold themselves in half.

Triangles are better, and if you can create those crazy radiating/hexagonal triangles, those will give the most natural folding and bending.

The mesh needs to be single-sided polygons, with no inward facing polygons. Also, it must not intersect the figure mesh, or it will "fall through" during the simulation. If you have decorative bits that poke through the cloth, destined to be decorated groups, that should be okay. Also make sure the cloth does not intersect itself anywhere.

You can create groups and materials for your cloth, but be sure you do not unweld any of the vertices. Ancillary items do not have to be welded on, but plan to create decorated groups for those.

Working with dynamic cloth, you can get away with a few tricks. For example, you could create a cape that is laid out flat and then let Poser drape it on your figure. You could create your skirt or dress (or kilt) as a flat round cloth easy for mapping, and then drop it on your figure's hips. This way you avoid trying to model all those tricky folds and pleats.

After building your flat cloth, drape it on the target figure in the zero pose, and then use that calculated object as your prop. This will save time for the end user, who will not have to do these calculations each time. But do be careful with this if you want your cloth to fit on multiple figures. If you drape your skirt or sarong too closely to Judy's thighs, it might not fit right for Don when you try to put it on him, even if you scale it up to his size.

Sucking cloth onto your figure using the simulator

Here is a trick adapted from high end 3D applications and cloth plug-ins. It uses a shrink-wrap type of principle to get tight, form-fitting clothes without doing much work.

First, you will need to build the basic cloth shape. Load the figure's base OBJ into your modeller and throw some cylinders around the torso and limbs, or do a quickie box-model around the base object. Tuck in the tucked sections and pull out the expanded sections, and make sure the cloth surrounds the body without the underlying skin poking through anywhere. Remember to make your mesh more dense by subdividing before you export it. I have thrown together a quickie shirt for Judy in Lightwave as a demonstration. Load the jdress.obj into Poser. Turn off all the import options. Also, so you can see more clearly what you are doing, jump into the Material room and change the base material color to something you can see. I like purple.

Load any nude Judy; Lo-Res is fine. Zero her out completely by turning off the leg IK, opening the JP window and hitting the "Zero Figure" button, and then making sure the hip and BODY Trans dials are all 0. Make sure the clothing is on her where it belongs, and that her skin is not poking through anywhere. I think her boobs are morphed up, because they always poke through my shirt. Cheat by setting the shirt z Scale up. Adjust the location of the shirt too, if necessary. Fly around and make sure nothing is poking out.

When you are all set, parent the shirt to the BODY. Now, shrink the BODY scale down. How far down depends on how tight you want the clothing to be. We are going to shrink the BODY (and the shirt along with it) down, then puff the figure up inside the clothing to get it the right size, and tight against the skin. If you shrink her down to 50%, the shirt will become very tight, but also be aware that the sleeves and bottom will not stretch out where they belong, and you

Figure 5.13 You can tell how much time I spent modeling this shirt! Put your shapeless clothing on the figure, parent it to the BODY, then shrink the figure down so you can "inflate" it inside the clothing.

will end up with a short-sleeved halter top. No problem with that in itself, but it may not be what you want.

At 90–95%, the sleeves and hem will remain long enough, but she will not fill out the shirt quite as nicely. This could be a problem in the shoulder area on the back, and the stomach area, which are not modelled very closely to the underlying mesh to start with. The sleeve underarm area also will not take on much definition.

Try 75–85% for moderate results.

Figure 5.14 The results of the figure inflation inside the shirt, starting at 50%, 80%, and 95%.

You may need to run the simulation several times to get the right size and tightness you want. Don't worry; as simulations go, this one is pretty easy on the resources. Remember to press the "Clear Simulation" button each time you start one with new parameters.

Now, set the last frame of your animation to 10, jump there, and put the BODY back at 100%. Leave it zeroed out so your clothing will work with the "Drape from Zero Pose" option. Do not touch the clothing. It will grow with the BODY, since it is parented, but the simulation will ignore this once it is clothified.

Speaking of which, now is the time to jump into the Cloth Room and get to work. Create a New Simulation, and set it for 10 frames: 10–15 should be plenty of time to shrink-wrap your clothing onto the figure (or, technically, to inflate-wrap your figure inside the clothing), even when starting at 50% size.

Clothify the cloth, obviously, and set it to collide with the pertinent body parts. The shirt here will hit the hip, abdomen, chest, collars, shoulders, and forearms. It may also hit the buttocks, so you can include those, if you wish.

Lastly, go to the Dynamics (section 4) and turn off the stretch resistance; just set it to 0. This will allow our clothing to stretch over the figure freely. Change the Static and Dynamic friction to 1. These will prevent the cloth from slipping over the figure's skin too easily. We want the cloth to stay in place over the skin, and not shrink down like something washed in hot water. 1 is the maximum input for these slots. It will not help much, but it is an option.

Run the simulation and check out the results. Fly the camera around to check all angles.

You can see there are some trouble areas with the shirt – besides the fact it does not have a realistic collar, hem, or cuffs. There are some weird corners sticking out the sides. These probably would have been better if I had made the hem more rounded, instead of leaving it in its original box shape.

If the lower front is hanging out in a big inverted V in your simulation, it is because you did not set the Static and Dynamic friction to 1. You might try fixing this by lengthening the simulation to give those folds time to settle out, or just by tightening the stomach line in the original model. A Magnet could be slapped on it to fix that at frame one. Or fiddle with the frictional settings. Fiddling with the stretch settings would help as well.

The shirt is not falling onto the clavicles and deltoids very well. This could be tweaked with the Collision Offset and Collision Depth settings in the "Collide Against" dialog box. Lower these numbers to get the cloth closer to the skin.

Also, the sleeves may be shorter than intended, the hemline higher, and the neck wider. You could try adjusting your base model and running it through again. Eventually you will learn to anticipate shrinkage and model your clothing items accordingly. Serge Marck uses a method where the cloth is fitted to the figure in stages, beginning with the future constrained group(s) such as necklines, armbands, etc. Once those are fitted, the cloth is exported in the new, half-finished shape and reimported for another round. The vertices that are finished are placed

Figure 5.15 Check the hemline fit, the underarm fit, the shoulders and collar. This quickie shirt could use still use some improvements in construction and shaping.

in a constrained group, and the rest of the cloth is calculated. See Serge Marck's website for tutorials.

Or, you could export the final simulated cloth and edit that mesh. In fact, this might be a good time to put on those non-stretchy bits like cuffs and collars, and of course all the buttons, bows, and buckles.

Setting up the dynamic cloth prop

Once you have built (and simulated the initial drape, if necessary) the object, set up the different groups. These will be saved with your prop. Run a simulation to make sure everything is working, and your decorations are surviving intact.

When everything is working, add the prop to the props library. You can save it as a smart prop, if you have set the parent, and have pre-defined the constrained group. All the cloth vertex groups and properties are stored in the PP2 (or PPZ).

Shader Tree materials

Poser 5 introduces complex procedural shaders for materials – sometimes a little too complex. If you just want to slap a texture on your figure the way you always have, you might leave P4 or Pro Pack installed to do the material settings in those apps. As you can see in the CR2 dissection in Chapter 3, P5 reads the P4 style materials, and it also translates them into updated P5 materials when you enter the Materials Room.

Of course, there are advantages to using procedural materials. They take up less disk space than those huge, high-res textures, and less rendering memory (after all, they are only mathematical expressions).

You can also mix procedurals with your texture maps, to give the skin tone a shading variation, or an overlying pattern, or use a procedural bump map with your painted texture map. The complexities of all the material nodes and applicates are beyond the scope of this book, but here are some tips and tricks. (Also check the online resources for more tutorials.)

The base "Poser Surface" node

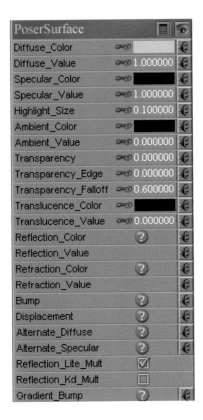

Figure 5.16 The "Poser Surface" base node. These are the minimum settings for every material for an object.

Diffuse_Color This is the base color of the object. If you are using a texture map, this should be white, unless you want to tint the texture. Plug your object texture in here.

Diffuse_Value This is the "strength slider" for the Diffuse Color, where 1 is full strength. If you lower the value, the color is dulled. You can also crank it up past 1, which may be handy if your texture map is looking too dingy, even with a white Diffuse Color.

Specular_Color This is the color of the highlights. This should usually be a dull color, unless you want particularly strong highlights. Plug your object texture in here, unless you do not want the texture to be applied to the highlights.

Specular_Value This is the strength of the highlights; turn it down to make things less glaringly shiny. You can also crank this up if your highlights are not strong enough.

Highlight_Size If you imagine your material on a sphere, this is the percentage of the sphere that the highlight occupies. For example, a tiny, bright highlight may take up less than 10% of the surface of the sphere (.1). A big, diffuse highlight may take up 75 or 80% of the surface (.8). 1 is 100%.

Ambient_Color This is the color of the object in shadow; usually black. You can lighten or warm up your shadows by using a not-quite-black grey or brown. You can also make things glow by setting this to a bright color. Plug your texture in here, if you want to be able to see the texture in the shadows (which only works with non-black Ambient colors.)

Ambient_Value: This is the strength or, actually, luminosity of the shadow color; which is why it is set to 0.

Before Poser 5, the "strength" or "luminosity" of the Diffuse/Specular/Ambient was controlled by the color chip. If you wanted a strong, bright highlight, for example, you would select a bright color, like yellow. If you wanted dull, soft highlights, you would choose a dark color, such as brown or even black. Now you can control this separately from the color with these values (or ignore the values and just use the color chips as you always have before). Think of the Lights' luminosity control. You can set the Light color to be bright yellow, but if you turn the luminosity down, the light color becomes a dull mustard brown. The same idea works here.

Transparency Percentage of transparency of the material, from 0 to 1. (Transparency Max in P4/PPP). Plug your transparency map in here.

Transparency_Edge Percentage of transparency where objects turn away from facing the camera. (Transparency Min in P4/PPP). Think of the side of a glass, where you can see the glass thicken and obscure what is behind it, compared to the front of the glass, where it is clear. Plug your trans map in here, as well.

Transparency_Falloff This controls how quickly the material fades from the Transparency to the Edge Transparency. The default is .6. Be sure you set this to 0 if you are using a trans map.

Translucence_Color This color will appear where light is not shining directly on an object. Think of it as an "Alternate_Ambient" option. (See below for "Alternate" Diffuse and Specular options.)

Translucence_Value The strength of the Translucent color.

Note that the Translucence effect will appear without the Transparency turned up, but if you want to see through the Translucence, you will have to turn Transparency greater than 0.

Reflection_Color This is a tint for the reflections. To use an old-style reflection map, plug in your reflection map, here. If you want your material to reflect the actual scene, you must create a Reflection node (Lighting: Ray Trace: Reflect) and plug it in. If your reflection comes out brighter than the object it is reflecting, change the color chip to a grey value.

For the Reflection node's background, leave it black, or select your current background color or texture. You can also control the quality of the reflection (how precise it is) and the softness. Raise the softness value to have blurred reflections.

Reflection_Value This controls how strong the reflections are. 1 will produce a mirror-like effect; use lower values for faint reflections such as found on polished marble or wood.

Refraction_Color Refraction is an effect, not a color, so this might seem a bit odd. Plug a Lighting: Ray Trace: Refract node in here to activate refraction in your material. It is not necessary to also turn on Transparency (which may also seem odd), but you can experiment with Refraction and Transparency to suit your needs.

Refraction_Value This uses real-world refraction values, so you can use a refraction chart to simulate materials. Air is 1 or no refraction. Raising or lowering the value will result in distorted refractions through your material.

Bump This is for slight perturbations of your surface. Plug in your greyscale bump map here, and use the number that appears to adjust the strength of the bumps. *Note:* do not plug in your P4/P3 BUM files here. (See *Gradient_Bump*, below.)

Displacement: This is for major perturbations of your surface, or things you want to stick out further than a bump map will allow. (See *Bump vs Displacement*, below). Plug in your greyscale bump map here. No, BUM files will not work properly here, either. (See *Gradient_Bump*, below.)

Alternate_Diffuse This is the jack to plug in those alternate lighting nodes, such as velvet, skin, hair, toon shading, clay, etc. When you use an Alternate_Diffuse, remember to turn the regular Diffuse color to black, and/or set its value to 0, to prevent the regular color from overriding the alternate. You can, of course, try to mix them, by using both.

Alternate_Specular This is the jack to plug in the alternate lighting nodes, especially those in the Lighting: Specular category. You can also plug in the velvet, skin, hair, toon, etc. nodes here when you load them as alt-diff nodes. If you leave the regular Specular_Value at 1, the two

speculars will fight and make lots of bright patches on your material. The Alternate seems to override the regular in my experience, so tone it down with a dark color.

Reflection_Lite.Mult: Turning this on will allow your lights to interact with your reflections. Reflections work best with this on.

Reflection_Kd.Mult: What this is trying to say is "Multiply Reflection through Diffuse color." Or, simply, allow the object color to tint the reflections. If you have yellow-colored gold, and want yellow-tinted reflections, turn this on.

Gradient_Bump This is the special node for the P3/P4 BUM bump maps. Plug those in here, or else they will not work properly.

Preview window (not shown): Poser 5 does a sort of fake application of your material to a sphere, to give you an idea of what your material will look like in your scene. If you change the lighting of your scene, this preview will change as well, to show the light colors, and change the locations of the highlights based on the light properties in the current image.

If it seems to take an inordinately long amount of time for Poser to recognize your updates to the materials, try turning off the visual preview, especially of the main node. (Click the eye icon to close it.) Poser tries to update the main preview for each change you do, even if you have not plugged anything into it yet.

You can also close the information section of the node by clicking on the box with line(s) next to the eye icon.

Simply slapping on a texture map

If you do not have P4 or PPP (or do not want to leave it installed) here's how to do the simple texture map on a material.

1 Create a New Node: 2D Textures: Texture map.
2 Click on the texture map name (the first slot) and hit Browse to load your texture. If the texture is already loaded, you can click the drop-down list above the Browse button.
3 Once the texture is loaded, plug it into the Diffuse and Highlight colors. Make sure the diffuse color is white, or whatever you want the base color to be. You can also plug the 2D texture node into the Ambient color. If you are going to leave the Ambient black, this is not necessary.

Plugging in Old BUM bump maps

Load the BUM as a 2D Texture node, as above. But plug it into the jack on the bottom of the Poser Surface palette, where it says "Gradient Bump." This is the special bump jack that reads those weird green Poser BUM files.

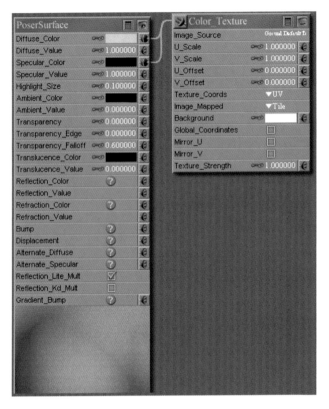

Figure 5.17 The default Ground Plane material shows the typical texture map setup. The 2D texture is plugged into the Diffuse and Specular jacks. Plugging it into the Ambient jack is optional.

If you plug it into the regular Bump (or the Displacement) jack, it may not work correctly.

Bump vs Displacement

The Bump input works the same as you may be used to in Poser or other renderers. The object surface is given "fake" highlights and shadows to simulate perturbations in the surface. Like the nubby skin of an orange, for example. The bumps are only illusory, however. If viewed at an angle, the bumps will not "stick out" from the surface.

Displacement, on the other hand, causes a render-time perturbation of the object mesh. It does not really change the mesh, so you cannot export this phenomenon as an OBJ file. But when seen at an angle, the displacement map will appear to push the skin of the object out past its surface.

Displacement has its own hazards, however. Around each object in the scene is a displacement clipping sheath. If a displacement map pushes the surface out beyond this invisible boundary, the surface is clipped, and you end up with black dots or triangles on your object. You can

control the displacement clipping distance for each object, by editing the Properties. There is also a master slider for this in the Rendering options.

By and large, use bump mapping for subtle texture, such as rough skin, and displacement for bigger things such as warts, scales, mortar between bricks, etc. Also see *Fur* below, for displacement fur.

Noise vs Granite vs Spots

You can plug a Noise node (3D Textures) to create speckled variations for your color or texture. However, if you want to control the size of the dots that make up the noise, the Noise Node does not have such a control. Instead, use the Granite node. When using four steps or less, the Granite dots work just like the Noise dots, but you can control their scale.

Spots can also simulate noise, if you make the spot size very small. This will produce a less-uniform scattering of dots, though at small dot sizes you may not notice.

If you want multi-colored dots, use the Cellular node. See *Iridescence* below.

Skin (human)

There is a special node for creating translucent skin, under Lighting: Special. You can assign a diffuse and highlight color to your skin, and define the depth of the translucent layer with the ETA setting.

Plug your skin texture map into the Skin node diffuse color jack, and set the color chip to white to use your painted texture as the skin color. Select a highlight color that compliments your skin tone.

Add Noise (or Granite) to the skin tone for a more realistic look. Be subtle with this; do not use black and white; use two tones that nearly match your skin tone. If you are using a texture map, plug it into the Granite base color, then plug the Granite into the skin and highlight jacks of the Skin node.

Plug the Skin node into the Alternate Diffuse color, not the standard Diffuse/Specular jacks, or it will not work properly. You can also plug it into the Alternate Specular jack, or use one of the specular nodes there. Make sure you turn the standard Diffuse/Specular settings to black and/or their strength to 0, or the alternate and standard colors will fight and cause unexpected results.

Scales

You can use a Cellular node or a Brick/Tile node for scales. The Brick/Tile will give you regular rows of scales. First, set the brick/tile color to white, and the mortar to black. Make the mortar thicker, especially on the tiles where it is very thin. Then turn up the Softness to blur the square

edges of the bricks/tiles. The Tile node also has the option of using ellipsoid shapes for the tiles; try that also.

The Turbulence will perturb the edges of the bricks/tiles (scales), and make them more organic. Noise will give the scales a roughness.

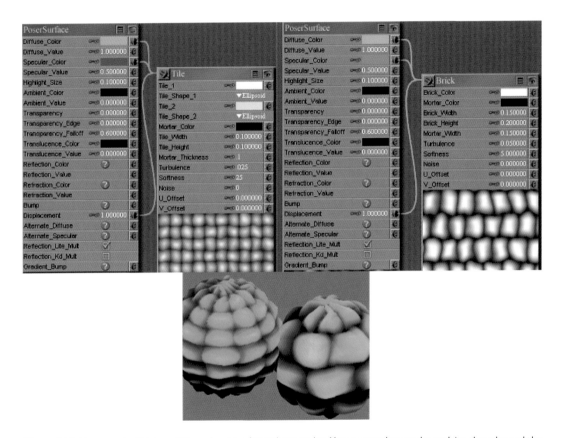

Figure 5.18 Here are the Brick and Tile nodes, transformed into scales. You can use these nodes to drive the color and the Bump/Displacement channels.

The Cellular node will give you more organic scales, stacked together in a random mosaic. The Jitter controls how jumbled they are. At zero, the cells will be perfectly rectangular. The Turbulence will make the dividing lines of the cells more wavy and curved, rather than straight.

There are five shading modes to the scales; try them out. You can have Color 1 at the center and Color 2 at the edges, or vice versa. You can posterize them into two levels of color. You can even do away with the second color altogether. That gives you a flat color. What good is that, you may wonder. Try turning on the "RandomColor" option and see what happens. Pretty! Now turn up the Turbulence to make the colors swirl and melt. Very pretty!

Cellular shaders are not just for cells any more. Have a look at the next section.

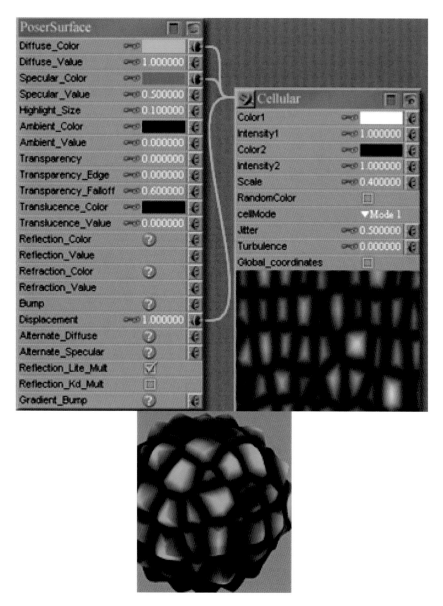

Figure 5.19 The Cellular Node creates good, jumbled scales with very little tweaking.

Iridescence and random colors

The trick to getting random rainbow colors in your material is in the Cellular node. Is that logical? Probably not, but a lot of these tricks are not obvious – that is why this book is called "*Secrets* of Figure Creation". As you saw in the last section, each cell in the Cellular node can be given a random color by turning on the RandomColor. Using Mode 5 (or setting Color 2 to

white) will give us flat colors with no divisions, or you can use a grey color for slight modulation in Mode 4.

Figure 5.20 For iridescence, make the cellular scale very small, and plug the Cellular node into the Specular jack. And here's another trick: turn on "Global Coordinates" for the Cellular node. This will make the material "hold still" while the object passes through it, or, in practical terms, the rainbow colors will appear to shift and sparkle as the object moves.

Fur

For short fur, this might be a great deal easier (for you and the renderer) than growing strand-based hair fur. Plug in a Noise/Granite or even a painted fur bump map into the Displacement jack. You will have to do a render to see the results and how "furry" it looks. If you crank up the Displacement, the noise will shoot hairs out from the object quite some distance. Keep in mind that the displacement will only occur perpendicular to the object surface. You cannot shoot out hairs and then comb them back, for example. Your cat will look as if its tail is plugged in to an electric socket!

Using a strand-y bump map (Eye Candy Fur, for example) will give you the look of combed fur, but remember, it will come out like those little plastic animals that have sculpted fur on them. It will be a solid chunk sticking out, not airy strands.

You can also try the Velvet Node for fur (Lighting: Special). I don't think the Velvet looks much like velvet, myself, without some noise plugged into the colors. But you can plug your texture map into the Velvet jacks to get a velvety sheen on your fur.

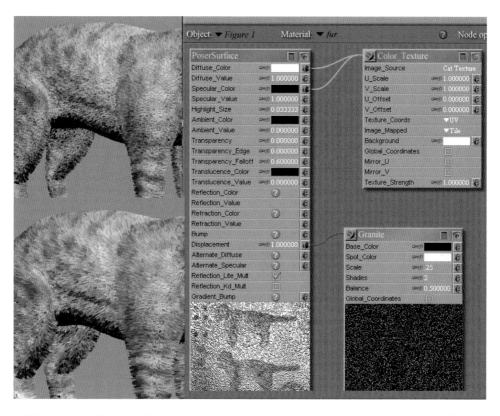

Figure 5.21 I've chosen Granite to drive the displacement mapping, with only two levels, and a small scale. Top – the standard displacement value of 1; bottom – it is cranked up to 2.5. (Remember to turn up the Minimum Displacement Bounds in the render options.)

Figure 5.22 Although the closeup of the displaced fur looks really good, the overall results may not be quite up to par. Here the Granite displacement is set at 1 again. Note how the legs and tail look plugged in, and the head looks all lumpy. The head especially needs a new material assigned to it with a lower displacement setting, if you want to use this method.

Make sure you plug the Velvet node into the Alternate Diffuse jack, not the regular Diffuse jack, or it will not work properly. You can also plug it in to the Alternate Specular jack; I think this gives a nice effect, but standard velvet is not normally plugged in there.

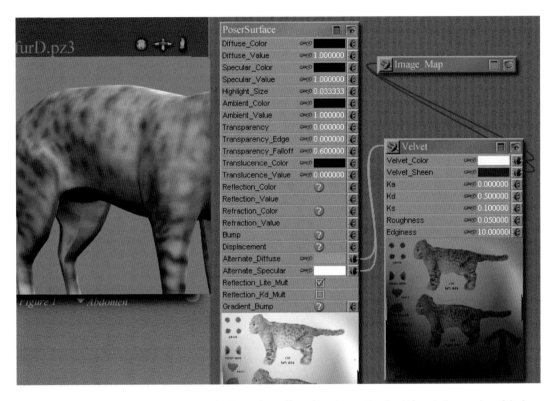

Figure 5.23 Not overly fuzzy fur, but a nice soft velvety sheen. The velvet sheen color should be a darker version of the base color. If you load the Green Velvet that comes with P5 as a base, remember to change the sheen color to a dark grey that isn't green tinted.

You can experiment with mixing nodes for the fur. Velvet with a Granite bump or displacement, for example. You can also try plugging the texture map into the standard Diffuse/Specular jacks and mixing the standard with the alternate. It isn't really designed to work this way, but that's what experimentation is for!

Hair

The Hair node is another special shading mode that plugs into the Alternate Diffuse jack. It is located under Lighting: Special. See *Dynamic hair* above for how to work with Hair materials.

6

Trouble-shooting

Morphs and morphing

Some morph problems are CR2 problems, so do look at that section below as well.

Wrong number of vertices

When you load an OBJ onto your object as a morph target, you get a 'Wrong Number' error.

Causes

It means that the OBJ you are loading has a different number of vertices than the object you are trying to morph with it. Or, basically, that the two objects are not the same thing. This occurs when:

* You are accidentally loading the wrong OBJ, or have selected the wrong body part to load it onto.
* The OBJ you saved as a morph target has more than one body part in it. If you are working on the base OBJ geometry, you need to delete the other body parts you are not using. If you are doing head morphs, remember to delete the eyes out (if they are separate body parts from the head). If you are doing partial or full body morphing, each piece must be exported as a separate OBJ.
* Somehow, a vertex or vertices have been deleted, or welded together; or added, or polygons were subdivided or triangulated. If your modeler triangulates quads automatically, you may not be able to use it for Poser morphing.

How to avoid

Do not add, delete, or weld any vertices in your modeler when you make the morph. Also do not change the polygons by combining or triangulating.

How to fix

If you get a wrong number, try importing the OBJ into Poser to make sure it really is what you think it is. Check for extra body parts in the OBJ, or attached props. Usually this is easy to fix. You can delete off the unwanted parts, or load the OBJ into Compose and save out the component part(s) you want.

Exploding morphs

When you turn the dial, vertices fly off everywhere.

Causes

This occurs when the morph target vertex order is different from the base object.

* Exporting the OBJ from Poser might change the vertex order. This happens a lot when you weld the seams when exporting from Poser, even if you have "As Morph Target" selected.
* Importing the OBJ into your modeler might change the vertex order. Amorphium reverses the vertex order, which is quite easy to fix (import it, export it, re-import it). Lightwave also may change the vertex order if you copy and paste the mesh, or if you do any welding (of seams, for example).
* If you edited the base geometry OBJ and plugged it into its old CR2 and the morphs explode, then something has happened to change the base geometry vertex order. The most likely culprit is welding body part seams. It seems that modelers like to change the order of the edge seams when they are welded.

How to avoid

When you export from Poser, re-load your exported OBJ as a morph target for the original, and make sure nothing happens when you turn the dial. This will test the export for the proper vertex order. Import and export the base OBJ from your modeling app and do the same test. If that test fails, try re-importing and re-exporting the second test base OBJ, to see if your modeler is simply reversing the vertex order. If it still explodes, you have a problem.

How to fix

Exploding morphs may be fixable with UVMapper Pro, which can re-order vertices. You will need the body part you are working on in a separate OBJ file to load as your target for the vertex order. (Make sure *it* has the proper order!)

"But I'm using the *exact same mesh* as I used to on this part, and they *used to* work, but now they explode, and I didn't change *anything*!"

This takes up the most of my time in Poser figure creation: fixing morphs that used to work fine until I edited a part completely unrelated to them.

Causes

Basically, re-welding seams causes vertex orders across the entire figure to change.

Combining meshes in Poser for export (i.e., sticking Griffie forequarters on a Manti-Kitty hindquarters, or importing your figure, deleting the eyes, and saving with new eye props placed within the figure) might change the vertex order. Cutting, copying, pasting different parts of your figure in your modeling app may change the vertex order, or adding/deleting vertices, or creating a new piece might do so also.

How to avoid

Do not do morphs until you have finished (really, *really* finished) editing the mesh. Or at least, don't do many!

How to fix

* Do *not* overwrite your old OBJ files. Try re-doing the combination or edit.
* Re-do all the morphs. Okay, that's *really* not fun, so you can try these next tricks.
* Instead of combining figure parts in Poser or your modeling app, try combining them in Compose. This may cause unwanted seam breaks, however.
* Try exporting from Poser with the Weld Bodypart Seams unchecked, and then importing the OBJ with "Weld Identical Vertices" turned on. Be careful with this option, or you might do something like weld your eyeballs to your eyelids.
* Try using different apps (including Poser) to weld your new body parts onto the old. The best combination seems to be cutting the old parts out in UVMapper Pro, and assembling them in Compose.
* Try re-ordering the offending body part(s) with UVMapper Pro. (However, you will still be stuck with trying to weld the parts back on, and possibly changing the vertex order again.) Alternatively, you could export each finished morph from the Poser figure, and then use the new version of the body part to reorder all the morph vertices. Then load them as MTs on the new version of the figure.

Dud morphs

When you turn the morph dial, nothing happens.

Causes

• You have loaded the base OBJ as a morph target, instead of a modified OBJ, and thus, no vertices are moving.
• You exported a morphed body part from Poser to load onto another figure, with both the "Weld Seams" and "As Morph Target" options selected. When both of these are turned on, Poser exports a non-morphed, non-magneted, non-scaled (i.e. plain base version) of the object. Use "As Morph Target" without "Weld Seams" on.
• You have modified the base mesh and plugged it into a CR2, or you have plugged a new mesh into an existing CR2 for a different figure. If the new base object has differing number of vertices, the old morphs will have no clue how to work upon them. Thus, turning the dial doesn't do anything.

How to avoid

• Do not change the base mesh after morphs are done. If you must, delete the old morph channels from the CR2.
• When exporting from Poser, remember that "Weld Seams" plus "As Morph Target" equals "Zero All Applied Morphs and Deformations."

How to fix

Find the OBJ that is the morph and not the base object. If you exported from Poser with "Weld Seams" and "As Morph Target" on, then export it again without the "Weld Seams."

When you plug a new OBJ into a CR2, delete the morphs that are there from the old figure.

Morphs that work, but fly off

You turn the dial, your nose gets longer all right, but your whole head takes off and goes down the street.

Causes

This occurs when the base OBJ the morphs were built upon is not in the same absolute location as the actual base geometry OBJ, which may result from one of the following actions.

• Exporting a body part from Poser while the figure is posed, or if the figure pose is zeroed, but the hip and BODY translations are not zeroed, and not using the "As Morph Target" option.
• Your modeling app centers the imported OBJ in its workspace, or you move the imported OBJ after importing to better see it.
• You accidentally saved a right side body part morph as a left side, or loaded the wrong side. You can tell, because the morph dial at one will suck your body part to the other side of the body, exactly where its counterpart is.

How to avoid

- Use the base geometry OBJ to do your morphs, rather than exporting from Poser, wherever possible. Turn off any centering/resizing your modeler uses when importing objects, if possible.
- Use Compose or ObjAction Scaler to reposition and/or resize the OBJ before importing into your app if you cannot work with it at the default size and location. Then use Compose/Scaler again to un-reposition and un-resize the morph target.

How to fix

Load the base OBJ and the morph OBJ into your modeler and line them back up by eyeballing them. If you are using the Amorphium Magic Triangle method, it is possible that there was a glitch, and your un-repositioning and un-resizing did not work properly. If you can line up the two Magic Triangles from the base OBJ and the Amorphium export, it will then work properly. (See www.morphworld30.com for tutorials on creating morph targets with Amorphium.)

Morphs that work, but shrink/expand

This is similar to the above problem, but instead of the body part wandering off, it shrivels down or puffs up.

Causes

This is caused by exporting body parts from Poser on a figure that is scaled, or has scaled body parts. Your modeling app resizes the object on import, or you resize it so you can see the blasted thing.

How to avoid

- Use the base geometry OBJ, not an export from Poser. This will solve almost all your problems.
- Use Compose or ObjAction Scaler to resize (and/or reposition) your morph target base to work on, then un-resize the finished morphs.

How to fix

Same as above: you can load it in with the base geometry and eyeball it back into the proper position and size.

Telescoping morphs

When a figure is loaded the morph dials are missing, or only one is there.

Causes

- Did you save the figure to the library after you added the morphs in? That would be a key step.
- Did you load several morphs and leave them all named "Shape 1"? Or name them all the same? If you changed the names later, that does not count. You must give them all unique names when you load them or spawn them. When Poser loads the CR2, it "telescopes" all the morph dials with the same internal names, and only displays one.

How to avoid

- Remember to re-save the figure to the library after you load the morphs on.
- Give them proper names as you load them; do not name them all the same. It does not count if you load them all as "Shape 1" and then change the dial name later.

How to fix

If you forgot to save the figure with the morphs, you will have to load them all over again.

If they telescoped because they all have the same internal name, this can be fixed. *Do not* save over a CR2 that has telescoped its dials; they are still in there, just not displayed. Open the CR2 and edit them so the internal names are all different (preferably matching the external names). See *CR2: Theory* for explanations of the internal and external morph names.

Morph speed

You set the Tracking Scale to .1 so the morph dial would turn faster and not take forever to get to 1. However, when you go to use your figure again, its set back to .000046 or something ridiculous.

Causes

This is a bug in Poser. Poser will reset your morph Tracking Scale settings when it loads the figure.

How to avoid/fix

There really is nothing you can do about this until the bug is fixed.

Full Body and Partial Body morphing

FBM has no effect

You crank the dial, and nothing happens.

Causes

- Cross-talk (pre-P5): If this is not the first/only figure in your scene, the slaved morphs may be confused as to which figure they are supposed to be linked to. See *Cross-talk* under *Morphing: Theory* in Chapter 1 for more information on cross-talk.
- The figure was saved to the Poser library under conditions that changed its figure name or number. This is similar to cross-talk, as the slave dial pointers end up pointing to the wrong master figure.
- No morphs were a non-zero value when the Full Body Morph was spawned. Full Body Morphs do not record scaling or magnet effects, only morph dials. They do not record the settings of other Full Body Morphs.
- The component morph targets have limits set, preventing them from moving below/ above zero, and you are turning the FBM dial the wrong way to see the effect.

How to avoid

See *Cross-talk* under *Morphing: Theory* in Chapter 1 for anti-cross-talk strategies.

Remember to set morphs for an FBM, and not use other FBM dials or magnets.

How to fix

Check the CR2 to see where the slaved morph channels are pointing, and fix it, if necessary.

If there are no slaved morph channels, then somehow you went wrong making the FBM. Try again!

FBM affects things it is not supposed to affect

An example of this sort of problem is when you turn your "abs of steel" dial and the nose grows longer.

Causes

When you spawned the FBM, some other morphs besides the ones you wanted were non-zero. If you are working on someone else's figure, you have to go through all the body parts and make sure the morph dials are all set to zero. Some figures come with pre-set morphs. Michael 2 has a Michael 2 head morph that is at 1 by default. There may be other subtle fixes turned on here and there around the figure. Zeroing the figure with the JP editor will not zero the morph dials. Restoring the figure to its default state will not do so, either, unless it was memorized with them set at zero. If you are working on your own figure, you may still run into this. Remember to turn off morphs when you are done testing them. And if all the morph dials read zero, you may still have a problem. A morph dial may have accidentally been nudged to a tiny value like .18. If you spawn several FBMs with that on, they will start to stack up and become noticeable.

How to avoid

When you are working on your figure, memorize it (Edit: Memorize: Figure) with the morphs zeroed. When you have finished testing your morphs, restore the figure so all the morphs are zeroed out before you start building a new FBM.

If it is someone else's figure, you cannot rely on restoring the figure to zero the morphs; some may have been memorized with particular values. If you go through all the morph lists on all the body parts and they all read zero, you will have to double-click each one and make sure zero is really 0.00.

How to fix

If you do not want to do the FBM over again, you can go into the CR2 and delete the slaving entries in the morph channel you want to un-slave. See *Extended Remote Control* under *CR2: Practice* in Chapter 3 for more information.

Partial Body Morph does not affect other parts

You turn the dial, but only the current part is affected.

Causes

The problem here is cross-talk again. See above.

- You have not slaved the other morph dials to the master dial yet. Or you spelled something wrong/left out a line when you did.
- You changed the internal name of the master morph dial without changing the slave pointers.
- The slaved body parts are in the wrong hierarchical relationship to the master to be immediately affected. (See *Easy Pose* under *CR2: Practice* in Chapter 3 for slaving up and down the hierarchy.)

How to avoid

Do not change the name of the master body part/dials after creating the slaving code.

How to fix

- Check the slaving code and make sure it is all there, and pointing to the right master dial.
- Make sure you have not deleted or re-named the master dial.
- Put the body parts in an IK chain in order to get control going in both directions on the hierarchy. You do not need to turn the IK chain on, just put it in. See the IK section in *Grafting on body parts* under *CR2: Practice* in Chapter 3 or use the P4 Hierarchy Editor to create a new IK chain.

- If you do not want to make an IK chain, or the body parts in question really are not even in one limb that would make sense as an IK chain, you will need to nudge the unresponsive body parts to get them to "wake up" and realize their master dial has been changed.

Magnets

The Magnet is not having any effect

You move the Magnet, you scale it to ridiculous proportions, you twist it around – and yet your object sits there, serene and unaffected.

Causes

- The object has its Bend property turned off.
- The object's Magnet dial is set to 0.
- The object (or the figure it is a part of) is locked.
- The Magnet is not set to affect that object.
- The Mag Zone is not encompassing any points.
- The Mag Zone is set to use a group that it is not encompassing, or an internal group you cannot see, or basically any group(s) you do not mean it to be using. Check the group options of the Zone.
- You set the Zone falloff graph to zero along its entire length, or perhaps deleted all the control points. (Don't!)

How to avoid

- Do not turn off Bend for objects or the Workspace.
- Do not set the Magnet dial to 0.
- Do not lock the body part or figure.
- Do position the Mag Zone while the body part is un-morphed so you can be sure you are positioning it correctly.
- And do be careful when you are editing the Mag Zone groups and falloff graph.

How to fix

Objects will not respond to Magnets if they do not Bend. Select the object, hit <Ctrl–I> and check the Bend property. You can turn it back off once you spawn the morphs. Also make sure the Workspace Bend has not been turned off. This is in the menu Display: Bend Body Parts.

Select the object, find the Magnet dial and make sure to set it to 1.

If you cannot set it to 1 because the object is locked, unlock it (or its figure), and set the Magnet dial to 1.

If you moved a Magnet group from the lToes up to the nose, because you did not want to bother creating a new Magnet for the head, you need add a body part/object for the Magnet to affect. Select the Magnet, hit <Ctrl–I> and "Add Element to Deform."

Turn off the object's morphs to make sure you are not lining the Zone up on vertices that are moved with another morph. Or perhaps another Magnet.

Morph targets spawned from Magnets do not look the same

You set up the Magnet(s) on your object until it looks just right, then spawn a morph target. When the Magnets are removed and the morph target set to 1, it does not come out the way you meant.

Causes

- A morph (or morphs) was turned on when you spawned the morph target. Double check them and set them to zero.
- The Magnets were set up while a Full Body Morph was turned on. This has the same effect, but the body part's morph dials all read zero when you check them, or even if you set them all to zero.

How to avoid

Make sure you are working on the figure where all morphs and FBMs are zeroed.

How to fix

You can turn the morphs/FBMs off and re-spawn the target, if you have not zeroed/deleted the Magnets. If you have, you can fix the messed up morph by setting it to 1, and the morphs you want to subtract to a negative value of their previous value. For example, if the Nose Tip morph was set to −.018, set it to +.018.

Magnet effects appear doubled

You made your nose 3 inches long, but now it looks more like 6 inches.

Causes

- Spawning a morph target and setting it to 1 while the Magnet is still turned on and in place.
- The Magnet is part of a simulation, and its effect was calculated into the simulation.

How to avoid

- Do not turn on the newly spawned morphs if you are going to leave the Magnet on.

- Turn the Magnet off before you run the simulation, unless you need it to position your cloth or hair for the simulation. In which case, just turn it off after you run the simulation.

How to fix

Either turn the Magnet off (set the Magnet dial to 0), reset the Magnet <CTRL–E> back to its zero position, or delete the Magnet if you have finished with it.

Joint parameters

Some of these problems could also be CR2 problems, so do check that section below as well.

Backwards joints

If your limb's child is moving, and its parent is moving, but the limb itself is standing still while the world goes by, this means your JPs are backwards.

Causes

Unfortunately, the cause is unknown. Sometimes Poser just puts them on backwards.

How to avoid

There is really no avoiding this; Poser likes to make the joints facing the wrong way. Usually you can see right away: the green end will be facing the parent and the red end the child.

How to fix

Just turn the JPs around. For the Twist Bar, move the red end towards the parent, and the green end towards the child to turn it around. For the bend Xs, you can grab one red arm and move it towards the next green arm. It will push the green arm ahead of it until they hit the next green arm, so stop before you get there and back the red arm off. By using the arms to push each other, you can get the bend X turned around in about two or three moves.

Sibling rivalry

When you bend the index finger, the knuckles of the middle, ring, pinky, and maybe even the thumb get distorted.

Causes

This usually occurs because you are not using spherical falloff zones where you should. Use them!

How to avoid

Eventually, you will develop a sense of what joints will need spherical falloff zones. Until then, just test the joints without them, and apply them where needed.

How to fix

Turn on "Use Spherical Falloff Zones" in the JP Window, and set the zones up.

Children Affect Their Parents – too much!

This is when rotating the eyes squishes half the face in, opening the jaw collapses the skull, opening the arm of your can-opener figure makes the base melt and curve, etc.

Causes

The problem is that this is how things are supposed to work, but sometimes we do not want them that way.

How to avoid

You cannot avoid this, unless you only make non-bending figures.

How to fix

You have three options, here.

First, you can try using spherical falloff zones to try to limit the extent of the damage.

Or, you can select the parent, and under its options, uncheck Bend. This will cause the parent to be unbending, and nothing the children do will affect it. However, this may not be an optimal solution if you want some children to affect the parent, but not others. Also, not bending will cause the body part's seams to be unwelded, as well.

The other solution is to delete the child(ren)'s affector channels in the CR2. This is relatively simple. Inside the body part's channels branch, there are entries for the JPs of the child(ren). These are clearly labeled with the child's name. You can just delete them, or remark them out (place an asterisk at the start of the line). See the *Affectors* section under *CR2: Practice* in Chapter 3 for more information on the channels and affectors.

No body part selected

You select a body part, but the JP Window says you haven't. Or, it shows the regular JP information *and* says "No Body Part Selected" simultaneously. Or, basically, the JP Window just flips out when you select a certain body part.

Causes

This seems to happen when a body part has too many children. Five seems to be the logical limit (the hands have five children and don't seem to be bothered). My heads typically have nine children: two each of ears, eyes, upper eyelids, lower eyelids, and one jaw. Poser hates my heads! Others seem not to have trouble with body parts with multiple children; it could be because my head is at the end of a limb, with children sticking out at all different angles.

How to avoid

All you can do is not make parts with many children, but this may not really be an option.

Or, upgrade to Poser 5.

How to fix

Do not select that body part while you have the JP Window open. You can select the children and adjust their JPs without a problem. Do all the children's JPs and save the CR2.

From there, you have two options. If some of your part's children are not going to affect it, delete their affector channels (see *Affectors* under *CR2: Practice* in Chapter 3). This might eliminate the problem, but probably not. Deleting the smoothScale entries for the children should. In cases like the head or a hand with multiple children, propagatingScale may be a better choice than Smooth Scaling at any rate (see *Scaling* under *CR2: Practice*). Each smoothScale channel has a slot in the JP Window, and it may not be designed to handle a great number of those. If these options help, just open the figure in Poser again and do the JPs for the head.

If not, make a copy of your CR2 and delete the entries for the part's children, and their affectors in the part. You should be able to edit the JPs for the childless part. Then copy those JPs from the childless CR2 to your usual CR2. (See the *JP Practice: Norn Special Joints* on the CD for more details.)

Parts that bend when they are not supposed to

Bending the neck causes your figure's jaw to open and close with the motion. Even bending the abdomen or hip does, too!

Causes

This happens when you are working with an edited CR2, where the children of a body part have been deleted, but their actor entries and affectors are still left in.

How to avoid

When you delete a body part, make sure you delete its affectors from its parent, at least.

How to fix

Go back and delete those affectors. If you are permanently deleting the whole part, also delete the actor entry, and any addChild, weld statements, and IK chains where it appears.

Missing JP controls

Your body part may only have the twist JP available for you to edit, or not even that.

Causes

This occurs in body parts that have the Curve parameter assigned to them. For some reason, you are not supposed to edit the bend X JPs of a curving part.

If you are working on the base body part (i.e., the hip), there are no twist or bend JPs for it. Only center point, end point, and Smooth Scaling controls.

How to avoid

Do not use curving parts, if you like complete control over your JPs. Many people prefer to use many small parts in a "curving" segment, rather than fewer large parts with a curve parameter, anyway.

How to fix

When Poser converts a figure with curve parameters in a limb, it leaves out the bend X JPs. You can edit the CR2 to put them back in, if you like. Just copy the two Joint* channels from a non-curved limb (with the same rotation orders as your target limb) above the Twist* entry.

For example, if you are inserting JPs into a tail on the ZYX axis, you need to insert JointX and JointY channels above the TwistZ channel. This will make the JPs reappear, but I do not know what effect they will have on the curve parameter. See *Changing rotation orders* and *Grafting on body parts* under *CR2: Practice* in Chapter 3 for instructions on inserting JP channels.

Greyed out JP options

You want to turn on spherical falloff zones, but that option is greyed out. Or you turned them on, but you can't turn them off! Or the Apply Bulges option, etc., etc.

Causes

This is just one of Poser's oddities! I think it is something to do with the focus of the JP Window somehow becoming unfocused.

How to avoid

There is no advice I can offer you, as I don't know what causes it.

How to fix

The most reliable method seems to be this: open the Hierarchy Window; close the Hierarchy Window. If that didn't fix it, try changing the JP you are working on to another one and back. Try changing to another body part and back. Try closing and re-opening the JP Window. If all else fails, restart Poser. Remember to save your figure, first.

Dropping JPs and MatSpheres

When you try to edit JPs, the centers keep dropping to the floor and stay there, no matter what value you enter in the JP Window.

Causes

This happens in non-English versions of Poser, where there is a conflict as to whether a comma or a period should be used as a decimal point.

How to avoid

If you have a non-English version of Poser and want to do JPs, there is really no avoiding this.

How to fix

When the JP Window is open, the decimal numbers are properly displayed with commas for the decimal point. However, if you edit anything within the JP Window, the commas suddenly become void. To edit the JPs you need to change the comma decimals into period decimals. Even if you only change one setting, you must replace the commas in all of them.

CR2 problems

Since this is the heart of the figure, most problems can be expressed as a CR2 problem. Most problems can be fixed with the CR2. Tinkering with the CR2 also causes more problems. If your CR2 problem deals with morphs or conforming clothing, check those trouble-shooting sections as well.

Torn seams

When you bend this body part, holes appear at the seams.

Causes

- Missing weld statements. If you built your figure in the Pro Pack Setup Room, there is a bug whereby the thigh body parts are not automatically welded to the hip.
- The body part has an illegitimate seam adjoining a part that is not its parent.
- The body part has its bend option turned off.
- The workspace has figure bending turned off.
- Vertices at the seam may not match exactly, or Poser does not believe they are supposed to be welded.

How to avoid

- If you are using the Pro Pack, be aware of the thigh seam bug.
- When designing your figure, avoid illegitimate children. (See *Figure creation: Theory* in Chapter 4.)
- Do not turn off Bend if you need the seams to stay welded. Instead, delete the body part's affectors if you do not want it to bend. See *Affectors* under *CR2: Practice* in Chapter 3 for details on those.

How to fix

- Put in the missing weld statements. And/or add extra weld statements, but be aware of the Flying Vertices bug. (See *Welding* under *CR2: Practice* in Chapter 3.)
- Check the object properties for the body part, its parent, and its children, and see if any have the Bend option unchecked. If so, check it.
- Check the Display menu and make sure "Bend Body Parts" is checked. If this somehow gets turned off, you will see seams everywhere.
- Make sure your seam vertices haven't been moved apart while you were editing the mesh. If they appear to be exactly lined up, try welding them together, then splitting them apart again.

Flying vertices

Everything looks fine until you render, and then Poser shoots a triangle point off towards the heavens.

Causes

This is caused by adding weld statements into the CR2. Sometimes they work, sometimes they don't.

How to avoid

Avoid designing your figure with illegitimate children. (See *Figure creation: Theory* in Chapter 4.)

How to fix

Try welding the parts in reverse order. If this doesn't help, you're out of luck.

IK tears off the foot

Turning on IK tears off the foot (or hand, or hoof, etc.); or turning off IK causes the tear.

Causes

This happens when you edit the CR2 to turn off the automatic leg IK chains. When you saved the figure from Poser, IK was on, and the foot was using its Trans dials for positioning. IK was turned off in the CR2, but the foot body part entry still had translations applied to it.

How to avoid

You could edit the foot channels when you edit the IK chain name, but it is really easier to fix than to avoid.

How to fix

After you change the leg IK name, load the figure, turn IK on, then turn it back off. This should reset the foot and its Trans dials. Double check by turning IK back on. Then turn it off and re-save the figure.

A "grafted on" body part does not bend correctly

When you bend a new tail part, it behaves as if the joints are facing backwards (but they are not), the child does not bend, or bends more than it should.

Causes

- Incorrect rotation order.
- Copying a body part entry and not fully editing it, the old parent, the new parent, and any children or orphans.
- Conflict between the end points and centers of parts in a limb.

How to avoid

If you really want to, you can edit the end point coordinates of the new body part to match the center coordinates of the next part right in the CR2. I think it is easier to just get Poser to fix it.

How to fix

Be sure you assign the proper rotation order to your newly inserted body part. If you copied and pasted an existing part, be sure to edit the order of the rotations, along with everything else.

Double- and triple-check the editing on all involved body parts. Does the new parent have the new body part affectors and otherActor pointers? Do the affectors exactly match the new body part's joint/joint/twist entries? Do the new children have their new parent listed in the otherActor entry for their joints? Do their joint/joint/twist entries match those affectors exactly?

The end point of one body part should be located where the center of the next body part is. If you edit the figure in the PPP/P5 Setup Room, you will see any anomalies between the centers and end points by disjointed bones. Simply re-connect one bone end to the next bone start.

If you are using P3/P4, you cannot see this relationship exactly, nor edit it directly, but you can still fix it quite simply. Open the JP Window in Poser, and select the center of the first body part near the affected area (the grafted part's parent, usually). Note the coordinates of the center in the JP Window, then pick the center up and drag it somewhere – it doesn't matter where. Now put it back where it was. You can type in the values it used to have. Then go to the next child in line, and do the same with its center. And then any children that part has. Save the figure.

What does this do? When you move a body part center, Poser knows it is also supposed to move the parent's end point. By doing this little shuffle, you erase the old (incorrect) end point coordinates and get Poser to put in the correct ones.

Geom Swapper with wrong starting geometry

Your swapper starts with the second variation of its geometry, instead of the base geometry.

Causes

This is a victim of the genitals switch. The workspace Genitalia switch will affect which geometry variant shows. It appears to act on whatever alternateGeom it first finds in the hip body part, or any other body part.

How to avoid

Unfortunately, you cannot avoid this, unless you never use Geometry Swapping on a hip. But don't worry about it.

How to fix

There is no way to fix this, and there is no need to. You can still change the geometry freely with the dial, despite the settings of the genital switch.

Incorrect morphs for swapped geometry

When you swap the geometry, the morphs quit working, and/or you can't find the proper morph variants for this version of the geometry.

Causes

This is a minor Poser bug in which the morphs do not automatically change as the geometry is swapped.

How to avoid

There is no way to avoid this – that's just the way it works.

Don't use the same morph names, give each variant a number or a letter. Remember, Poser telescopes morphs with the same name and only reads/uses the first one. The same holds true for morphs on swapping geometry.

How to fix

This cannot be fixed. But, it can be worked around. You just need to grab another object, then switch back to your swapped body part after you change the geometry. Then the proper morphs will appear. You should notify your users in the TXT file or instructions that they will have to do the 'select other part then come back trick' to get the new morphs to appear.

If you used the same names for the morphs on each variant, you will have to edit them to use different internal names. See *Telescoping morphs* above.

Note: Poser 5 just shows all the morphs for all the variants, all the time. That's one way to fix it! You can place these in groups.

Other Poser files

Smart props turn dumb

You saved a prop with a parent, but it does not position itself onto the figure where it belongs when you load it again.

Causes

- Did you remember to say "Yes" when Poser asked you if you wanted to save it as a smart prop?
- Or did you save it as part of a subset? You cannot be smart and part of a subset at the same time.
- Is the figure in your scene the same as the one you originally had the prop parented to? It would help if it had the same body parts for the prop to be parented to.
- Are you sure there *is* a figure in your scene?

How to avoid

- Make sure you save your prop as a smart prop and not as part of a subset.
- Remember to position and parent it to your figure before you go to save it. And when you re-load it, make sure a figure is there for it to attach itself to, and that the figure actually has the body part you want the prop to be parented to. Even if you use human figures, a smart prop saved in the P4NW hand will not appear in the P4NM hand, because of the different sizes and proportions of the figures.

How to fix

Check the PP2 for the parent entry. If it says UNIVERSE, your prop was not "Smartened." Change it to the particular parent you want it to be. (See *Prop files* under *Other Poser library files* in Chapter 3 for details on the parent.)

Also, if you want to save a group of props all Smart-parented, you will have to edit the PP2.

"My prop is smart, but it does not bend"

When you parented the prop, you told it to inherit the bends of the body part. But when you re-load the prop, it is rigid again.

Causes

The joint affector information, which makes the prop bend, is not saved in the PP2 file – not even if you save the prop as a smart prop.

How to avoid

There is no way to avoid it. That's the way it is.

How to fix

The good news is that you can fix this. Either you can re-parent the smart prop and turn on Inherit Bends again after you load it, or you can insert the affectors into the PP2. Be aware that the joint affectors are specific to each figure, so the bending smart prop may behave oddly if you load it onto another figure.

See *Prop files* under *Other Poser library files* in Chapter 3 for details on creating bending props.

"My beard makes me bald!"

When you try to load your beard hair prop, your head hair disappears. And when you re-load the head hair, the beard gets shaved off.

Causes

The props in the Hair library are hard-coded to replace any other HR2 that is already on the figure, rather than adding more hair props.

How to avoid

You can avoid this by saving your beard, and even your hair, as a regular Prop file, smart-parented to the head. With regular props, you can load as many instances as you want.

How to fix

Move your HR2 into a props library and change its extension to PP2.

MOR Poses change the figure's pose

You have an MOR Pose to apply custom morphs to a figure, but it zeroes out your carefully posed figure when you apply it.

Causes

The supposed MOR Pose file has body part rotation information in it. This happens when someone saves the figure, with the "Include Morph Channels in Pose," but then doesn't bother to delete out everything but the pertinent morphs.

How to avoid

MOR Poses *only* have morph information. Remember to always edit them to remove the rotation and scaling information.

How to fix

Edit the PZ2 to remove the scaling and rotation channels from the body parts, and leave only the morph channels.

MAT Pose does not change prop materials

You have set up wonderful MAT Poses for your prop, but when you apply it, nothing happens.

Causes

You cannot apply a MAT Pose to a prop, unless it is parented to a figure. The good news, however, is that you *can* apply a MAT Pose that *is* parented to a figure.

How to avoid

There is nothing you can do about this. It is just the way it is.

How to fix

Parent your prop to a figure. If your prop isn't even remotely supposed to be a body accessory, you can temporarily parent it to a figure while you apply the MAT Pose, or you can create a dummy figure whose sole reason for existence is to have props parented to it so that MAT Poses can be applied to them.

Or, you can turn your prop into a figure – a figure with one body part and no moving limbs, bizarre as that concept is.

MAT Poses add weird materials to the figure

You apply a Victoria MAT pose to your Stephanie-VSkin, and then notice that Stephanie has an Eyeball and Eyeballs material that you are sure she never had before.

Causes

This happens because of code injection. The MAT Pose file has Victoria's Eyeballs material in the figure section (yes, Victoria has Eyeballs, where everybody else just has Eyeball), and that is inserted into the figure when the MAT Pose is applied. This is useless, because that material is not really there and cannot be utilized. It just bulks up your CR2 or PZ3.

How to avoid

When using MAT Poses, use only those created for the specific figure you have loaded.

If you are making MAT Poses, make a separate one for each figure that has different materials.

Note: If you are creating MAT Poses for a multi-figure figure, it may not be possible to avoid this. I noticed when I made MAT Poses for Jelissa's gryphon, the unused eagle materials would appear in the eagle legs, as well as the lion body when I applied them, even though the eagle and lion MAT Poses were separated and applied to each component figure separately.

How to fix

You can delete the extra materials out of the CR2/PZ3.

If you want to convert a MAT Pose from one figure to another, go in and change the material names to match those on the new figure. In the example above, you would change the Eyeballs to Eyeball and Irises to Iris, etc., to change the MAT Pose from a Victoria MAT Pose to a Stephanie MAT Pose.

Figure problems

Remember to check the JP section for trouble with individual body parts and posing. Also check the CR2 section for low-level figure problems.

"Where's my figure?"

You converted my PHI file, or pressed the "New Figure" button in the Hierarchy Window, but you cannot see the figure anywhere.

Causes

This is quite normal. Poser does not automatically load a new figure you create with a PHI, it just creates the figure entry in the New Figures library. Look for your figure there; it will have a blank thumbnail (not even a Grey Shruggy Guy).

How to avoid

This cannot be avoided. It's just the way it is.

How to fix

Just open the New Figures Library and load your figure as normal.

"My figure is invisible!"

You have loaded your figure and you still don't see anything.

Causes

- Your figure geometry is too large and is outside the camera view. Or your figure is too small.
- The group names in your OBJ do not match the body part names in your PHI or CR2 file.
- There is something wrong with the OBJ file geometry, or more likely, the geometry RSR file.
- Poser has run out of memory.

How to avoid

- Before you "Poserize" your figure, import the OBJ file into Poser to make sure it is a decent size, and in the proper location. You can always import your mesh with the "Centered," "Place on Ground," and "Percent of Standard Poser Figure Size" options on, then save it.
- Use PHI Builder or an automated PHI file creation utility that lets you load the OBJ and automatically uses the correct names. Also be sure you are using legal Poser names. (See *Basic mesh structure* under *Figure creation: Theory* in Chapter 4.)

How to fix

First, import your OBJ file and make sure it is not so huge or so tiny that it does not appear anywhere on screen. Turn on the ground shadows; if you see a huge shadow, but no figure; this is a sure sign your object is too huge.

If Poser fails to import your OBJ file, then something is wrong with the format that Poser does not like. (See *Basic mesh structure* under *Figure creation: Theory* for clues with that.)

If the OBJ is fine, try deleting the geometry RSR and try again. Or try restarting your computer.

Check the group names in the OBJ versus the actor names in the CR2. Be especially careful about spelling and capitalization. If the names match, but you are using upper case letters to start your group names, change them to lower case in both the OBJ and the CR2.

If you strongly prefer using different names in the OBJ and CR2, then make sure the geomHandler uses the actual name of the OBJ group, which will be different from the actor name.

"My figure is a ghost!"

The figure loads and is invisible. However, if you wave the mouse over the document window, outlines of body parts appear. All the parts are in the menu. It *seems* the figure is there, but nothing is visible.

Causes

Incredible as it sounds – the problem is too much memory.

How to avoid

Do not get more than 2 gigs of RAM.

How to fix

You need to download a fix from Curious Labs. For Poser 4.0.3 users, download the Poser 4.0.3 Memory Updater. For Pro Pack users, download the Pro Pack Memory Updater.

Invisible parts

Most of the figure is there, but . . .

Causes

* Mis-match between the OBJ group name and the actor name in the CR2.
* Also, if you have saved an OBJ out of Poser that had different names for the actor and OBJ group, the new OBJ is using the actor name, not the old group name.
* The body part is in the CR2, but it either has no entry for its geometry pointer, or it is missing an addChild statement.
* The body part has been turned invisible or set to "off."

How to avoid

Don't use a different name for the group than for the actor, even though, technically, you can.

How to fix

First, if you can select the missing body part, do so and hit <Ctrl–I> to check if it has its "Visible" checkbox un-checked. That would make it invisible. Turn the visibility back on.

Adjust the OBJ group or the actor geomHandler pointer so they match. If you saved the figure with missing parts, Poser probably emptied out the actor entry, so be sure to insert the

storageOffset and geomHandler lines, where applicable. See *Removing embedded geometry* under *CR2: Practice* in Chapter 3 for how to insert the geomHandler information.)

Also check the Figure section of the CR2 for the appropriate addChild statements.

Poser can't find OBJ – "Out of Memory"

When you try to load your figure, Poser tells you it can't find [whatever].obj, and then it tells you that you are out of memory. But you have lots of memory!

Causes

- Your OBJ file isn't where the CR2 says it is.
- The geometry RSR is corrupt.

How to avoid

Again, use PHI Builder or another app that will automatically create correct figureResFile pointers. Or be very meticulous about the path and filename and the figureResFile pointer in the CR2.

How to fix

- Check that the OBJ is in the directory where you think it is. Better yet, check to see it is in the directory where *Poser* thinks it is.
- Check the path in the CR2.
- Check the capitalization as well. Make sure they match.
- If they do match, try deleting the corresponding geometry RSR and start again.

Recorrupting RSRs

Your figure used to work fine, but now when you try to load it up comes "Can't find OBJ," "Out of Memory;" you get invisible figures with only their eyes and hair intact and, to add insult to injury, Poser deletes all the figures in your scene that you had previously loaded. Whatever is happening?

Causes

The geometry RSR has become corrupted. No one knows exactly how or why Poser goes about corrupting RSRs, but it seems it takes fiendish delight in constantly trashing certain ones.

How to avoid

Load the figure (delete the RSR first, if you need to), and after Poser writes a new, good RSR, write-protect it. Note that if you have swapping geometry, you should run through all the geometry iterations before write-protecting the RSR.

How to fix

Delete the geometry RSR and try again. For a permanent fix, write-protect the RSR.

AbNormals – "My figure is inside out!"

When you look at the front, you see the back. And vice versa. However, it renders all right.

Causes

Your figure has inverted normals.

How to avoid

This happens to the best of us, eventually.

How to fix

You can fix this by importing it into Poser with the "Reverse Normals" option turned on, or use your modeler to change the normal facing.

Most of the figure is fine, but some bits are inside out

The figure is mostly fine, but the left ring finger and right thigh are inside out.

Causes

These are also inverted normals, but they cannot be fixed by reversing *all* normals, or the rest of the figure would be backwards. Some modelers invert the normals when you slice the model. Some modelers define the normals by what direction you have drawn the polygon.

How to avoid

If your modeler supports it, make sure all the normals are facing the same way before you export your OBJ.

How to fix

If entire body parts are inside-out, you are in luck. Select the body part, and the grab the Grouping Tool. Make a new group (the name does not matter) and press the "Add All" button. Then press the "Reverse Group Normals" button. Do that on each inside-out body part, then export the fixed figure. (If you are using P3, you will have to use your modeling app to reverse the affected body parts.)

If the inside-out bits are only parts of limbs, or scattered polygons here and there, you have your work cut out for you. You can attempt to fix these with the Grouping Tool.

Start with a New Group that has all the polygons in it (Add All or Add Material), then use the Reverse Normals to turn everything inside out. With the normal polygons backwards and the abNormal polygons facing the camera, you can put them in a new group and flip them around. (See Figures 6.1 and 6.2.)

Figure 6.1 Patchy abNormals on our test subject, the much-abused Poser cat (*left*). Create a New Group named "everything" and Add All. Hit the Reverse Normals button to turn the head inside out (*right*).

Delete all the unused groups, and export your repaired OBJ. (See Chapter 1 for tips on how to get the most out of the Grouping Tool.)

"There are holes in my figure!"

Clear holes, black holes...all your hole problems are addressed here.

Causes

- Do the holes render as if they are filled in? These are reversed normals (see above).
- Do they appear and render as a see-through hole (i.e., you can see the background, or interior of the figure when rendered)? These are holes, obviously.

Figure 6.2 Create a New Group named "fix." Try to select the abNormals that are now facing you (*left*). When you have a batch, press Reverse Normals to flip them, and then Remove All to empty your group and select a new batch of abNormals. When you have got everything turned inside out, re-select the "everything" group and hit Reverse Normals again. If there are still some inverted normals, repeat these steps until you get them all. *Right:* the "fix" group inverted, then "everything" with Reverse Group Normals. You can see the previous holes are now facing the right way. Of course, I seem to have messed up the nose, but I never said this was going to be easy!

- Are they see-through holes that appear at seams when you bend the figure? These are unwelded seams. (See *Torn seams* under *CR2 problems* above).
- Are the holes black? Do they appear black in the preview and black in the render, and stay black no matter what you set the material colors to, or how you shine lights on them? These are polygons in P4 that are sharing the same space. Either you copied and pasted bits of your figure on top of themselves, and did not get rid of the duplicates, or you have two-sided polygons.
- Do the black holes only appear when you render? These are most likely degenerate facets. These usually occur on very thin or pointy parts of Poser objects, but may also appear on broad flat surfaces. They could also be double-sided polygons in P5.
- Do the black holes only appear after you put a material on the object? They might be caused by displacement map clipping in Poser 5.

How to avoid

Inverted normals: See above.

Holes: Preview your model in a shaded mode. That thing you believe is a polygon might actually be four polygons whose sides touch in that shape. Make sure you fill in the polygon.

If you are using P3, make sure you do not have polygons with more than four sides, or these will not appear in Poser. Use dePent if you do not have any app you can use to find n-gons.

Duplicate/two-sided polygons: Delete the duplicates. Do not use two-sided polygons. P3 can handle them, but P5 hates them. P4/PPP can sometimes handle them, and sometimes not. If you need an interior to your object, build one with a slight offset.

Degenerate facets: These can crop up almost anywhere; they cannot be avoided.

Displacement clipping: See Chapter 5 for this one.

How to fix

Holes: Fill them in with your modeler. Run them through dePent.

Duplicate/two-sided: Hopefully your modeler is really good at welding by vertex proximity, and/or it can find and delete overlapping polygons. Or maybe you have a previous version of your OBJ before you ended up with the duplicates.

Degenerate facets: UVMapper can fix these. Load your OBJ and press the <Insert> key on your keyboard. If degenerate facets are found, it will fix them. Save your OBJ as a new file, though, as sometimes fixing degenerate facets ends up deleting polygons.

If you are creating props from imported OBJs, you may find they develop degenerate facets when you re-load them from Poser's prop library. In this case, Poser is truncating the coordinates of the vertices, and those with small differences in position (i.e., the tips of pointy things, or very thin things) will overlap and cause the dreaded Black Spot of Death. You can fix this by having the Prop file use a geometry pointer instead of embedding the prop. (See *PP2 and HR2* under *Other Poser library files* in Chapter 3).

Feet moving when you use the Face Cam

You may notice your figure's feet shuffling around as you move and pose things in the face or hand cameras, even when you are not moving anything on or near the legs.

Causes

This is a bizarre display anomaly. I don't know why it occurs, but it is harmless. Your feet are not actually moving, they just appear to be.

How to avoid

Do not look at your feet while in the face/hand cameras.

How to fix

There isn't anything to fix because it is only an optical illusion. Trust me. If you don't believe me, try rendering the moved foot; you will see that it is right where it belongs.

Model won't texture

You throw an image map on it and it previews fine, but it renders without the texture. Or maybe it doesn't even preview fine.

Causes

The object does not have any UV information.

How to avoid

Always give your object UV coordinates, even if you just want to use plain square texture maps on it.

How to fix

Load the OBJ into UVMapper or your favorite mapping program and give it some UVs. Save the new OBJ. Remember to delete the geometry RSR, if there is one with the OBJ file. You can also try creating UVs with the Grouping Tool.

Poser can't find a file and won't say what it is

When loading a figure you get an error similar to "Can't find [whatever].obj," but it does not say what file it can't find. Everything seems to work fine, though.

Causes

This occurs when Poser "forgets" what a GIF file is. It may also "forget" what a JPG or PCT file is. The reason for this is the uninstallation (or total lack) of QuickTime. If you try to manually load a texture into Poser, and look at the file-type list and don't see a particular type of image file, this is what is going on.

How to avoid

Do not use GIFs, JPGs, or even PCT images for your textures, trans, and bump maps. Use BMP and TIF files only.

How to fix

Either use a 2D app to change the file type of the image, or install QuickTime on your PC.

Fixes to the object don't take

You remapped your object a hundred times, but it still has the same smeared-out pixels, or you filled in holes, welded things shut, put polygons in different groups, but the wretched thing looks exactly the same as always.

Causes

- You re-saved the OBJ file, but didn't delete the geometry RSR that goes with it.
- Your prop is embedded in your PP2 file.
- You used the Grouping Tool on your figure and either embedded geometry in the CR2 (P4) or a new OBJ file was created in your library (PPP/P5).

How to avoid

- Always remember to delete the geometry RSR when you work on your OBJ. Poser reads the RSR if it is there, and does not update it automatically when you change the base OBJ.
- If you imported an OBJ and saved it as a prop, the geometry might have been embedded in the file. Re-import the OBJ and re-save it, or replace the prop geomCustom with a geometry pointer. (See *PP2* under *Other Poser library files* in Chapter 3.)
- Be careful with that Grouping Tool!

How to fix

Delete the geometry RSR. Note: you may have to shut down Poser before you can delete the RSR. If you get "Access Denied", this is the reason.

If your geometry is embedded, export the zeroed out figure, or the zeroed prop as your new OBJ. If Pro Pack or P5 made a new OBJ, it is in the library from whence your figure was loaded. Grab it from there and put it in your Geometry directory, and change the CR2 pointer to point to the correct location.

"When I import my OBJ into PHI Builder, I get a 'Level Skipped' error; but I haven't started editing yet!"

Causes

This happens when you have very long limbs, and/or your PHI Builder Window is not maximized. What happens is that PHI Builder tries to sort your OBJ groups into logical limb chains, but it runs into a word wrap situation. Then the level 7 entry ends up on the next line, with no indentations. And then PHI Builder thinks you tried to place level 7 in the level 1 spot. Unfortunately, you have to fix this before you can go into Tree mode and start organizing your hierarchy.

How to avoid

Either don't use PHI Builder, or don't make very long limbs.

How to fix

This is not difficult. First, maximize the window so you have room to work. Place your cursor at the front of the first wrapped line, and hit the "Increase Level" button (the rightward pointing hand, or on the Text menu, or press F2). If you have room, you should be able to jump the level up to the next level, then decrease it back down where it belongs.

If you do not have enough room (or if the body part does not belong in that limb, anyway), you can just decrease the stray bits' level (F3) until they form a new chain from level 1 or 2 to level whatever. When the OBJ is first imported, it does not really matter where you put the body parts, as they will likely need to be rearranged anyway. The important part is to get into Tree mode, where you can drag things around.

Conforming clothing

"My conformer ... doesn't"

The clothing is hovering out in the air rather than encompassing the figure and/or its body parts when you try to put it on your figure, or the shirt bends to the left, or your bikini top just flies off and falls on the floor.

Causes

- The clothing was not built upon the base OBJ in the correct size, pose and/or location.
- The clothing is not memorized as being zeroed.
- The conformee is the wrong target figure, or has been scaled.
- Important body parts have been left out of the conformer, such as the hip, or the neck where a shirt is concerned.

How to avoid

- Build the clothing on the unaltered base object.
- Zero the conformer and memorize it.
- Only put clothing on figures it was meant to fit on. (You can fiddle with the positioning and scaling of clothing and make it fit on a similar figure, but it will take some work.)
- When you strip a CR2 for a conformer, you must leave in the hip and the hierarchy between the hip and your first actual body part. Also, be sure to keep the phantom children of your body parts to ensure correct bending and conforming.

How to fix

Import the clothing OBJ and the base figure OBJ. Do they line up? If not, fix it.

Load the conformer and hit <Shift–Ctrl–F>. Is the clothing posed? It should not be. Turn off all IK, open the JP Window and hit the "Zero Figure" button. Select the hip and the BODY in turn and make sure all Trans dials are set to 0.000. Now, memorize the figure (Edit: Memorize: Figure). Save it to the library.

Make sure you are putting the clothing on the proper figure. If the figure has been scaled, you need to conform the clothing, and then apply the same scaling to the clothing. This information will not automatically be read from the target figure.

Bits of skin stick out through the clothing

Everything fits okay when you conform the clothing to your figure, but as soon as the figure moves, bits start poking through.

Causes

It is normal for some bits of skin to poke through the clothes at some points, in some poses. Conforming is not a perfect science. Or perhaps you've morphed your figure into an ultra-pumped, beer-belly guy.

How to avoid

You either have to stick to making very bulky winter clothing that covers every body part completely, or just live with it, if the poke-through is minor.

How to fix

Create morphs for your clothing to match the morphs for the target figure. The Tailor will help automate this process.

If patches of skin poke through only when posing, this is something the end-user can deal with. There are several strategies listed below:

- If the clothing completely covers the body part, you can turn the body part invisible. Note: don't do this until you are done posing it, or else you will not be able to grab the invisible parts in the workspace. You could alternately scale the width and depth of the body part down to a little stick figure inside the clothing.
- If the body part is only partially covered, you could try tapering the body part. Shins (or thighs) that stick out of boots work well with this. Arms sticking out of sleeves are another candidate.
- You could also use the grouping tool on the bits of skin that stick out, and apply a new material to them, one that is completely invisible. Remember to set the highlight color to full black for full transparency.
- You can apply a magnet to the clothing to try to pull out bits that are sunk into the skin.

- If you are severely morphing your figure, you could use The Tailor to transfer the morphs from the figure to the clothing item, for a better fit. If you have Poser 5, and your conforming OBJ is dynamic-cloth-compliant, you can use the P5 simulator to fit it. (See *Dynamic cloth* in Chapter 5.)

Conformer gets in a twist

Your conformer conforms mostly fine, but *some*times, in *some* poses, a piece gets all twisted up. Sometimes, the whole torso twists around and falls off.

Causes

The theory is that sometimes there is a conflict between the figure's joints and the conformer's. It may be a lame theory, but that's all we have to go on. Fortunately, it is easy enough to fix.

The torso twist is rumored to be caused by a Divide by Zero.

How to avoid/fix

This twisting weirdness can be eliminated by imparting a slight twist to the conformer's body parts. It has to be very slight, use .001. This should not cause the conformer to fall off the limbs, but it seems to cure the weirdness that occurs in some poses.

Remember, after you set the limb twist to .001, to memorize the figure, and save it to the library.

Don't turn the figure upside down or the torso will twist off the figure. Try rotating the BODY instead of the hip or vice versa. Or try turning your camera upside down instead.

Dynamic hair

Radioactive hair

Help! My figure's hair is glowing!

Causes

The Hair shader node causes this. See the *Dynamic hair* section in Chapter 5 for this one.

Hair turns white

Your figure's hair used to be blond, suddenly it has turned white in the blink of an eye.

Causes

This is a relatively harmless bug in Poser that changes the preview to white. The rendering and actual colour of your hair will not be affected.

How to avoid

Never touch the hair or its materials.

How to fix

To get the (rather ugly) blond default texture back, you can jump back into the Hair Room and fiddle with one of the hair settings. Change the length to something else and then back again, for example. That should reset the hair preview. Check your hair material, if you have changed it, and make sure it has not gone back to being blond.

Can't select Guide Hairs

You click and drag around the hair tips with the Hair Styler's "add" tool, you drag around the whole hair, you drag around the whole head, you bang your mouse and shake your fist, but no matter what you do, no hairs are selected.

Causes

If you are in an isometric (Top, Front, Left/Right) view, the hairs actually *are* selected, but the selection dots are not displayed. I could suggest it was something to do with finite points and infinite view isometric cameras, but, truthfully, I don't know why.

How to avoid

Only select hairs using the conical cameras (Main, Face, Hands, Aux, Posing). Or do a blind selection in an isometric camera and either switch to a conical camera or split your document window so you can see the yellow dots. Or, just select things and move them without playing around with all those dots. For simple manipulations, they are not really necessary.

How to fix

Mere mortals like us cannot fix this.

Offset hair

When you use fast-tracking mode, the hair appears to jump to a different location when everything else turns into a box.

Causes

This is a Poser display bug. The hair actually does remain in the right spot; it just very strange.

How to avoid

Only use full tracking mode.

How to fix

Wait for a patch.

Dynamic cloth

Constrained groups aren't

You tried to staple that loin flap to Don's hip, but it just keeps slipping off and falling on the ground.

Causes

This occurs if you parent the prop before creating the constrained group. It may also occur if you change a choreographed group to a constrained group.

How to avoid

Do not parent the prop until after you have defined its groups. If you have, try re-parenting it after creating the groups.

How to fix

If re-parenting doesn't work, you will need to clear the simulation and start again. Clear the simulation and set the prop's parent to UNIVERSE. Then create a new simulation. You may also need to re-create the groups. If that still doesn't work, try un-clothifying the prop and starting completely from scratch. Remember to set the prop's parent to UNIVERSE before you re-clothify.

Cloth sucks up under the figure

You drape your horse blanket over your horse, but the edges end up clinging to the underside of the belly.

Causes

This can happen when your simulation is not long enough. The cloth has inertia, so when you drop it from a great height, it tends to sweep down and under whatever it is falling on.

How to avoid

You can use longer simulations all the time, but it will probably save time if you only adjust the length when you need to.

How to fix

Open the Simulation Settings and change the length of the simulation by adding more frames, or you can try upping the steps per frame from 2 to 4 or more. Run the simulation again, and your cloth should flop down and under, then rebound and relax back.

Or, you could step through your animation and find a frame where the cloth has fallen far enough, but before it falls too far, and export the cloth from that frame, instead of from the final frame.

Different dynamic groups have the same properties

When you create a new dynamic group, and change the dynamic properties, the same dynamics are applied to all the groups.

Causes

This is a bug; you are supposed to be able to create single clothing items with different dynamics, like a leather harness with silk veils dangling from it.

How to avoid

Plan to use only one type of cloth material for your clothing. Separate different materials (i.e. leather, lace, silk, cotton, canvas) into different clothing props.

How to fix

Hopefully, there will be a P5 patch to fix this.

Cloth falling through

You put your cloth on or above your figure to drape it on, but the simulation just drops it straight through to the floor.

Causes

- Is the cloth poking through any part of the figure? If you are doing a straight drop, make sure you lift it up high enough.
- If the cloth is poking through the side of the torso, or through part of the arm or leg, it won't drape properly.
- Are the cloth polygons facing all one way? If the mesh had an inside part, it will not clothify properly.
- Did you set it to collide with everything you wanted to? If you are dropping things on the head, did you make sure to un-check "Ignore Head Collisions" in the Collisions dialogue?

How to avoid

- Lift your cloth high enough to clear the drop target.
- Make sure the cloth isn't intersecting the target at any point. Build cloth items with enough breathing room between the surface and the figure's skin.
- Build the cloth with single-sided polygons that only face outward. Do not try to make any interior sections of clothing.

How to fix

- Lift the cloth a little more. Use a lined preview mode; if you see the underlying object through the cloth mesh, it isn't high enough.
- Try scaling the cloth prop up a little, to pull it out of the underlying mesh. You can also apply magnets to pull out troublesome bits.
- You need to select the items for the cloth to collide against, of course. Also make sure your head/hand/feet collision object selection has not been overridden by the main collision ignoring options.

Things poking through

The table top pokes through the table cloth, or skin pops out through the cloth, or that veil for your dragon princess is falling through her horns too far, etc.

Causes

This occurs for several collision calculation reasons.

How to avoid

You won't avoid it. Unless you never work with cloth, you will run into this sooner or later.

How to fix

- Simulation Settings: Try other collision detection modes, such as object vertex against cloth polygon. This is particularly useful for those pointy objects that poke through the cloth before it realizes it is hitting the object's polygons.
- Collision Settings: The Collision Offset and Collision Depth will help prevent the cloth from getting too close to the skin (or other object being draped). The Collision Offset determines Poser's "look ahead" time, so it can see that the cloth is approaching a wall and hit the brakes to avoid a messy collision. The higher this is set, the more computations will have to be done.
- The Collision Depth creates a force field around the collision object, causing the cloth to collide with the empty air around the object, instead of waiting to actually hit the surface.

The cloth slices through itself

You have the thing draping down nicely, but when the dangly bits get down there, they all stick through each other.

Causes

This is because the cloth is not calculating collisions against itself.

How to avoid/fix

In the Simulation Settings, check the "Cloth Self Collision" option. Only use this if folds of the cloth will hit each other and pass through, as it eats up more calculation resources and time.

Magnets and morph strength are doubled

At the end of a simulation that involves a morphed or magnetized cloth item, the cloth is warped too far out of shape and does not look right.

Causes

This happens because the Magnet/morph deformations are calculated into the cloth during the simulations. When the simulation is done, the deformation is applied twice: once in the finished simulation, and once again with the Magnet/morph setting.

How to avoid

You cannot avoid it; that's the way it works.

How to fix

Once the simulation is done, either delete the Magnet (if you are *sure* you don't want to re-calculate the simulation), or set the Magnet/morph dial on the cloth to 0.

Simulation stalls

You change one parameter, and a simulation that took 3 minutes is now still going after 20. If you watch the mysterious frame calculation numbers, you may see the decimal numbers cycling through a loop, or perhaps just wandering aimlessly up and down the numbers.

Causes

This means something has gone wrong somewhere to choke the simulation. You should cancel it; it will not get through.

How to avoid

It is not clear what causes this; perhaps two cloth vertices collide and overlap, or the cloth gets folded over in such a manner that the back no longer collides with the objects.

How to fix

Cancel the simulation and fiddle with the settings. If you have changed something, try resetting it to the default value, or changing it a little less. Especially note the collision settings. If you have lowered the Collision Offset and/or Depth (Collide Against button), put those back to 1. If you have turned on several collision options, try using just one or at least fewer (Simulation Settings button).

You may also try upping the number of steps per frame in the Simulation Settings.

Shader Tree material

Radioactive hair

Help! My figure's hair is glowing!

Causes

This is a common problem with P5 dynamic hair and the Hair node shader.

How to avoid

When you change the hair's material from the default, don't mess with any of the standard colour controls. Don't plug the Hair node into any other jack besides the Alternate_Diffuse. And use grey values for the base colours, not white.

How to fix

Set the regular Diffuse/Specular colours to black and their strength to zero. Set the Alternate_Diffuse colour to middle or dark grey. Also experiment with darker tones for the root, tip, and specular colour in the Hair node.

Can't see the texture

I've got these garish red and blue tiles for the base colour, but my document window still shows a flat white object.

Causes

You cannot see procedural textures in the preview mode, only the base colours and any texture maps.

How to avoid

You cannot avoid this; that's the way it works.

How to fix

Just render the scene to see the material on the object. Make the document window in the Material Room very small, and zoom in on part of the figure to get a faster render. Also, turn off shadows and other stuff you are not using.

Black triangles all over

When you render your nice fuzzy sweater, it comes out looking as if someone ran over it with a lawnmower and cut a lot of holes in it.

Causes

Are you using a displacement map? If so, that's your culprit; the strength of your displacement is poking the displaced bits out past the Minimum Displacement bounds, and the renderer is just chopping off the offending bits, leaving black holes.

See also *Figure problems* for more help with black holes when you render.

How to avoid

Use displacement values of 1 or less.

How to fix

This can be fixed in the Render options, by setting a higher Minimum Displacement Bounds number. The default is 0, but because all objects in P5 have a Displacement Bound of 2 to start with, this gives you some leeway in displacing things.

If you want to change the Displacement Bounds of your prop, body part, or figure, you can edit its Properties in Poser. If you want to alter the Displacement Bounds for the whole figure, you could do a search and replace in the CR2. Be sparing with this, higher Displacement Bounds mean more render calculation time. See *The Controls section* under *CR2: Theory* for information on the Displacement Bounds settings for objects.

Showcase

Berengaria and Lionheart (final image, smooth line, and smooth line close up).
Artist: Dave Matthews
© Dave Matthews 2001, 2002

Posable Hairy Spider. The hair is made of a series of overlapping, trans-mapped polygons.
Artist: David Richmond (www.brycetech.com)
© David Richmond 11 December 2002

Posable Honey Bee. The Bee has a conforming "suit" of hairs for extreme close-ups.
Artist: David Richmond (www.brycetech.com)
© David Richmond 11 December 2002

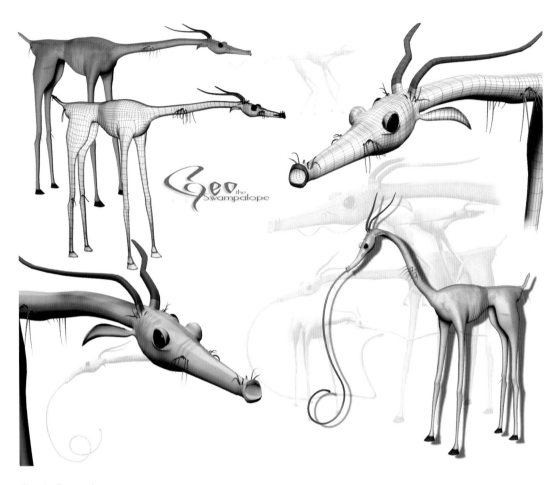

Geo the Swampalope.
Artist: Darren A Thomas of EA Media and Electric Aardvark (ea_media@chartermi.net)
Image and content© EA Media 2002

Gorilla Deluxe
Artist: DAZ Productions (www.daz3d.com)
© DAZ Productions 2002

Michael (above) and Stephanie (opposite). Despite the obviously different shape, both figures use the same mesh.
Artist: DAZ Productions (www.daz3d.com)
© DAZ Productions 2001

Michael (opposite) and Stephanie (above). Despite the obviously different shape, both figures use the same mesh.
Artist: DAZ Productions (www.daz3d.com)
© DAZ Productions 2001

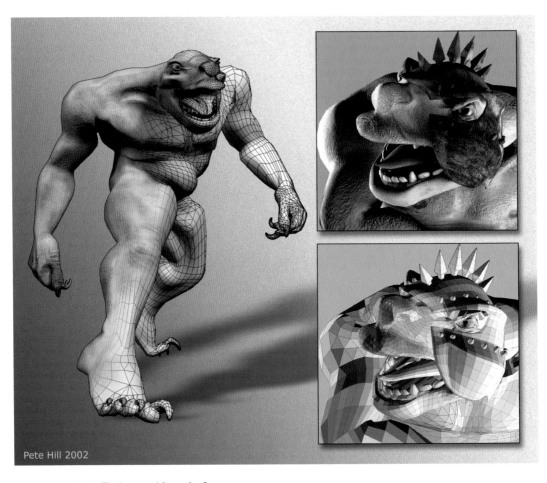

Pete Hill 2002

Curio's Ragbash the Troll: original figure for Poser.
Artist: Pete Hill (www.curiography.com)
© Pete Hill 2002

PETE HILL (CURIO) 2002

Curio's Majestic Dragon: original figure for Poser.
Artist: Pete Hill (www.curiography.com)
© Pete Hill 2002

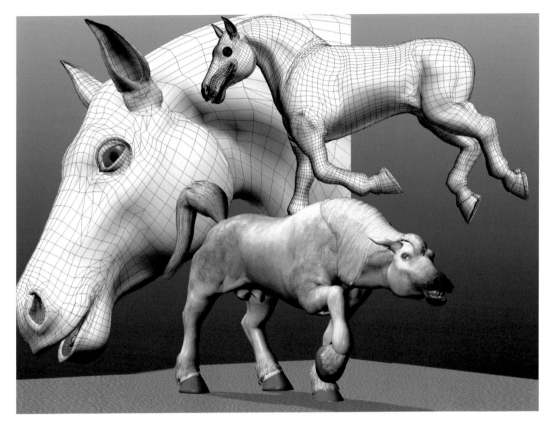

Heavy Horse. The Heavy Horse has conforming manes and fetlocks, and interchangeable posable tails.
Artist: B L Render (www.3dmenagerie.com)
© B L Render and 3D Menagerie 2002

Wee Beasties. Three forequarters, four hindquarters, two pairs of wings, add up to six little critters.
Artist: B L Render (www.3dmenagerie.com)
© B L Render and 3D Menagerie 2002

Nadya: an original human figure for Poser
Artist: Alexander Nesterenko (www.aleknest.da.ru)
© Alexander Nesterenko 2002

"Lucifer the Bat Up Close". Lucifer's fur was scanned from an old coat and assorted plush toys and heavily manipulated in Photoshop.
Artist: Dave Hill (www.aarrgghh.com)
© Dave Hill 2003

A few of DAZ 3D's character head morphs and maps for Victoria 3.
Artist: DAZ Productions (www.daz3d.com)
Image and products © DAZ Productions 2003

A few of DAZ 3D's creature head morphs and maps for Victoria 3.
Artist: DAZ Productions (www.daz3d.com)
Image and products © DAZ Productions 2003

Millennium Dragon.
Artist: DAZ Productions (www.daz3d.com)
© DAZ Productions 2002

Turbo the Wonder Slug.
Artist: Darren A Thomas of EA Media and Electric Aardvark (ea_media@chartermi.net)
© EA Media 2002

Appendix

GetStringRes lookup tables

1024: Body part and object names

Numeric		Alphabetical	
1	Body	5	Abdomen
2	Head	1	Body
3	Neck	96	Body 1
4	Chest	97	Body 2
5	Abdomen	98	Body 3
6	Hip	99	Body 4
7	Left Thigh	100	Body 5
8	Left Shin	4	Chest
9	Left Foot	2	Head
10	Right Thigh	6	Hip
11	Right Shin	103	innerMatSphere
12	Right Foot	21	Jaw
13	Left Shoulder	84	Left Ankle
14	Left Forearm	63	Left Claw 1
15	Left Hand	65	Left Claw 2

1024: Body part and object names (*continued*)

16	Right Shoulder		67	Left Claw 3
17	Right Forearm		19	Left Collar
18	Right Hand		87	Left Ear 1
19	Left Collar		89	Left Ear 2
20	Right Collar		91	Left Ear 3
21	Jaw		101	Left Eye
22	Left Pinky 1		62	Left Finger 1
23	Left Pinky 2		64	Left Finger 2
24	Left Pinky 3		66	Left Finger 3
25	Right Pinky 1		9	Left Foot
26	Right Pinky 2		14	Left Forearm
27	Right Pinky 3		15	Left Hand
28	Left Ring 1		40	Left Index 1
29	Left Ring 2		41	Left Index 2
30	Left Ring 3		42	Left Index 3
31	Right Ring 1		82	Left Leg
32	Right Ring 2		34	Left Mid 1
33	Right Ring 3		35	Left Mid 2
34	Left Mid 1		36	Left Mid 3
35	Left Mid 2		95	Left Pect Fin
36	Left Mid 3		22	Left Pinky 1
37	Right Mid 1		23	Left Pinky 2
38	Right Mid 2		24	Left Pinky 3
39	Right Mid 3		28	Left Ring 1
40	Left Index 1		29	Left Ring 2
41	Left Index 2		30	Left Ring 3
42	Left Index 3		8	Left Shin
43	Right Index 1		13	Left Shoulder
44	Right Index 2		7	Left Thigh
45	Right Index 3		46	Left Thumb 1

1024: Body part and object names (*continued*)

46	Left Thumb 1		47	Left Thumb 2
47	Left Thumb 2		48	Left Thumb 3
48	Left Thumb 3		52	Left Toe
49	Right Thumb 1		70	Left Toe 1
50	Right Thumb 2		71	Left Toe 2
51	Right Thumb 3		76	Left Up Arm
52	Left Toe		78	Left Wrist
53	Right Toe		80	Lower Neck
54	Neck 1		3	Neck
55	Neck 2		54	Neck 1
56	Right Finger 1		55	Neck 2
57	Right Claw 1		105	nullMatSphere
58	Right Finger 2		104	outerMatSphere
59	Right Claw 2		85	Right Ankle
60	Right Finger 3		57	Right Claw 1
61	Right Claw 3		59	Right Claw 2
62	Left Finger 1		61	Right Claw 3
63	Left Claw 1		20	Right Collar
64	Left Finger 2		88	Right Ear 1
65	Left Claw 2		90	Right Ear 2
66	Left Finger 3		92	Right Ear 3
67	Left Claw 3		102	Right Eye
68	Right Toe 1		56	Right Finger 1
69	Right Toe 2		58	Right Finger 2
70	Left Toe 1		60	Right Finger 3
71	Left Toe 2		12	Right Foot
72	Tail 1		17	Right Forearm
73	Tail 2		18	Right Hand
74	Tail 3		43	Right Index 1
75	Tail 4		44	Right Index 2

1024: Body part and object names (*continued*)

76	Left Up Arm	45	Right Index 3
77	Right Up Arm	83	Right Leg
78	Left Wrist	37	Right Mid 1
79	Right Wrist	38	Right Mid 2
80	Lower Neck	39	Right Mid 3
81	Upper Neck	94	Right Pect Fin
82	Left Leg	25	Right Pinky 1
83	Right Leg	26	Right Pinky 2
84	Left Ankle	27	Right Pinky 3
85	Right Ankle	31	Right Ring 1
86	Waist	32	Right Ring 2
87	Left Ear 1	33	Right Ring 3
88	Right Ear 1	11	Right Shin
89	Left Ear 2	16	Right Shoulder
90	Right Ear 2	10	Right Thigh
91	Left Ear 3	49	Right Thumb 1
92	Right Ear 3	50	Right Thumb 2
93	Tail Fins	51	Right Thumb 3
94	Right Pect Fin	53	Right Toe
95	Left Pect Fin	68	Right Toe 1
96	Body 1	69	Right Toe 2
97	Body 2	77	Right Up Arm
98	Body 3	79	Right Wrist
99	Body 4	72	Tail 1
100	Body 5	73	Tail 2
101	Left Eye	74	Tail 3
102	Right Eye	75	Tail 4
103	innerMatSphere	93	Tail Fins
104	outerMatSphere	81	Upper Neck
105	nullMatSphere	86	Waist

1028: Dial and control names

	Numeric		Alphabetical
1	Taper	4	Bend
2	Twist	21	Blue
3	Side-Side	43	BreastSize
4	Bend	51	Curve
5	Scale	52	curve
6	xScale	25	DollyX
7	yScale	26	DollyY
8	zScale	27	DollyZ
9	xRotate	47	Fatness
10	yRotate	15	Focal
11	zRotate	24	Front-Back
12	xTrans	48	Grasp
13	yTrans	20	Green
14	zTrans	42	Hand Type
15	Focal	22	Intensity
16	Pitch	29	Map Size
17	Yaw	44	OriginX
18	Roll	45	OriginY
19	Red	46	OriginZ
20	Green	30	PanX
21	Blue	31	PanY
22	Intensity	16	Pitch
23	Turn	19	Red
24	Front-Back	18	Roll
25	DollyX	5	Scale
26	DollyY	28	Shadow
27	DollyZ	3	Side-Side
28	Shadow	50	Spread

1028: Dial and control names (*continued*)

29	Map Size		1	Taper
30	PanX		49	Thumb Grasp
31	PanY		23	Turn
32	Zoom		2	Twist
33	xTranB		53	Up-Down
34	yTranB		36	xOffset
35	zTranB		39	xOrbit
36	xOffset		9	xRotate
37	yOffset		6	xScale
38	zOffset		33	xTranB
39	xOrbit		12	xTrans
40	yOrbit		17	Yaw
41	zOrbit		37	yOffset
42	Hand Type		40	yOrbit
43	BreastSize		10	yRotate
44	OriginX		7	yScale
45	OriginY		34	yTranB
46	OriginZ		13	yTrans
47	Fatness		38	zOffset
48	Grasp		32	Zoom
49	Thumb Grasp		41	zOrbit
50	Spread		11	zRotate
51	Curve		8	zScale
52	curve		35	zTranB
53	Up-Down		14	zTrans

1029: Texture names

	Numeric			Alphabetical
1	No Bump		17	angelfishmap.tif
2	Male Muscle Bump.bum		18	biz man texture.tif

1029: Texture names (*continued*)

3	Female Muscle Bump.bum	19	biz woman texture.tif	
4	None	20	casual child texture.tif	
5	Male Muscle Texture.tif	21	casual man texture.tif	
6	Female Muscle Texture.tif	22	casual woman texture.tif	
7	Ground Default Texture.tif	23	cat texture.tif	
8	male casual texture.tif	15	child casual texture.tif	
9	female casual texture.tif	24	child hair texture.tif	
10	male nude texture.tif	14	child nude texture. tif	
11	female nude texture.tif	25	dog texture.tif	
12	male business texture.tif	26	dolphin texture.tif	
13	female business texture.tif	13	female business texture.tif	
14	child nude texture.tif	9	female casual texture.tif	
15	child casual texture.tif	27	female hair 1 texture.tif	
16	ground Default Texture.bump	28	female hair 2 texture.tif	
17	angelfishmap.tif	29	female hair 3 texture.tif	
18	biz man texture.tif	30	female hair 4 texture.tif	
19	biz woman texture.tif	31	female hair 5 texture.tif	
20	casual child texture.tif	3	Female Muscle Bump.bum	
21	casual man texture.tif	6	Female Muscle Texture.tif	
22	casual woman texture.tif	11	female nude texture.tif	
23	cat texture.tif	32	frogmap.tif	
24	child hair texture.tif	16	ground Default Texture.bump	
25	dog texture.tif	7	Ground Default Texture.tif	
26	dolphin texture.tif	33	hand texture.tif	
27	female hair 1 texture.tif	34	horse texture.tif	
28	female hair 2 texture.tif	35	lionmap.tif	
29	female hair 3 texture.tif	12	male business texture.tif	
30	female hair 4 texture.tif	8	male casual texture.tif	
31	female hair 5 texture.tif	36	male hair 1 texture.tif	
32	frogmap.tif	37	male hair 2 texture.tif	

1029: Texture names (*continued*)

33	hand texture.tif	38	male hair 3 texture.tif	
34	horse texture.tif	39	male hair 4 texture.tif	
35	lionmap.tif	40	male hair 5 texture.tif	
36	male hair 1 texture.tif	2	Male Muscle Bump.bum	
37	male hair 2 texture.tif	5	Male Muscle Texture.tif	
38	male hair 3 texture.tif	10	male nude texture.tif	
39	male hair 4 texture.tif	1	No Bump	
40	male hair 5 texture.tif	4	None	
41	nude child texture.tif	41	nude child texture.tif	
42	nude man texture.tif	42	nude man texture.tif	
43	nude woman texture.tif	43	nude woman texture.tif	
44	raptor texture.bum	47	p4 man bump.bum	
45	raptor texture.tif	48	p4 man bump.tif	
46	wolfmap.tif	49	p4 man texture.tif	
47	p4 man bump.bum	50	p4 man texture2.tif	
48	p4 man bump.tif	51	p4 woman bump.bum	
49	p4 man texture.tif	52	p4 woman bump.tif	
50	p4 man texture2.tif	53	p4 woman texture.tif	
51	p4 woman bump.bum	54	p4 woman texture2.tif	
52	p4 woman bump.tif	55	p4casboy.tif	
53	p4 woman texture.tif	56	p4casgirl.tif	
54	p4 woman texture2.tif	57	p4infant.tif	
55	p4casboy.tif	58	p4nudboy.tif	
56	p4casgirl.tif	59	p4nudgrl.tif	
57	p4infant.tif	44	raptor texture.bum	
58	p4nudboy.tif	45	raptor texture.tif	
59	p4nudgrl.tif	60	snakelo.tif	
60	snakelo.tif	46	wolfmap.tif	

Glossary

3DS: 3D Studio file format; a 3D mesh.

abNormal: My word for inverted normals; not an industry standard.

addChild: An entry in the CR2 that builds the figure hierarchy; also a name for that section of the CR2.

affectors: Channels within a body part that correspond to the joint settings of its children, which cause the parent to be affected by posing of the child.

Bend X: The visual indicator for the bending joint parameters, consisting of an X with two red arms and two green arms.

black hole: The rendered results of *degenerate polygons*, causing flat blackness where they occur.

Body Handles: Anton Kisiel's name for body parts that control other parts, but are not meant to be rendered themselves. Also *control handles*.

body part: An object in Poser that makes up one moving joint.

BODY: The main section of a Poser figure; it is not of the hierarchy, but encompasses it. It has entries in the CR2, but not in the *PHI* file.

bones: A Poser Pro Pack tool used to define body parts in the Setup Room.

bulge: A joint parameter that causes the mesh to stick out (or in) while the joint bends.

BUM: A special type of bump map created by Poser, which uses red and green channels to store surface slope information.

cascading ERC: A chain of remote control dials where master dials are slaves to other master dials, and thus turning a master-master dial activates several levels of control. See *ERC*.

channel: An entry in the CR2, usually corresponding to a dial in Poser.

character: A collection of any/all of the following: figure, clothing, hair, props, textures, morphs; placed into a CR2 to create a unique character; usually does not entail creating a new figure mesh.

child: A body part that is directly under another (its parent), and one level down in the hierarchy structure.

chopping: Deleting parts of a file to create a new, stripped down file; i.e., chopping a CR2 to contain only animal tail body parts.

choreographed group: Vertices of dynamic cloth that follow the motion of the cloth prop as it is animated, disregarding other effects of the simulation.

CM2: A Camera setting file.

CMZ: Poser 5's compressed CM2 format (Camera files).

code injection: Using a Pose file to insert new settings into a figure. This only works to change information in channels that already exist; it cannot create new channels (with the exception of materials).

collision detection: The ability of a program to calculate whether two virtual 3D surfaces are touching, and the ability to prevent them from passing through each other.

Compose: Jon Wind's utility for OBJ and COB editing.

conforming: A figure, usually clothing, that can be applied to another figure, and follow its movements; or the act of creating a figure that conforms.

constrained group: Vertices of dynamic cloth that stay with the cloth's parent.

control handles: A body part designed to control or bend another part, but is not meant to be an actual body part, nor rendered, itself. Also *Body Handles.*

CR2 Edit(or): John Stallings' utility for editing Poser library files.

CR2 Edit: D. Wilmes' utility for editing Poser library files.

CR2: A Poser Figure file; it contains the joint and morph information, as well as geometry pointers to the figure, material info, props, etc.

cross-talk: Confusion amongst slaved dials when more than one figure is present in a scene. Master dials from one figure affect other figures as well, and master dials on those figures seem to have no effect.

crunching: When vertices on the model collide in a morph, or more often, when a joint is bent. When the green arms of the *Bend X* meet the red arms, crunching occurs.

curve: A parameter inserted in the *PHI* file that defines a body part as "curved." Also, the corresponding dial in Poser that adjusts the curvy-ness of the curved part.

DAZ 3D: A branch of the Zygote 3D model company that specializes in Poser figures and accessories. This group created the new Poser 3 and 4 figures, as well as the animal models that are included in P3 and P4.

degenerate facets: Polygons that render black in Poser, usually occurring at the tips of pointy geometry. May also be caused by double-sided polygons in Poser 4.

DePent: Anthony Appleyard's utility for transforming polygons with more than four sides into constituent triangles/rectangles.

descendants: A body part's child(ren) and their child(ren) and their child(ren)'s child(ren), etc.

Dina: A commercial female figure created by DSI.

Don: The Poser 5 adult male figure.

Dork: Conventional (if unflattering) name for the P4 Nude Male. May also be applied to the P3 Nude Male.

dynamic cloth: Poser 5's new type of draped clothing.

dynamic hair: Poser 5's new type of strand-based hair.

dynamics: A system whereby 3D objects can be affected by calculations based on real-world physics.

EasyPose (EP): A series of remote controlled rotation definitions that allow a curved figure or segment to be smoothly bent, twisted, coiled, etc; developed by Ajax.

ECM: Externally Controlled Morph; see *ERC*.

ERC: Extended Remote Control; the CR2 hack that slaves one dial to another. Developed by Charles Taylor and Robert Whisenant.

Eve: A reworking of the P4NW with new joints and body divisions; different incarnations may include modeled genitalia. Developed by Steve Torino and various others.

exploding morphs: An error in which morph OBJ files have an incorrect vertex order, causing a normally stolid morph to send bits of your mesh in many random directions.

external name: The displayed name of a dial or body part in Poser, which is editable within Poser itself. These may also be defined by a *GetStringRes*.

Face Cam: The face camera; < Ctrl–= > on the keyboard.

FBM: Full Body Morph; a master dial in the *BODY* that controls morph dials on various body parts.

FC2: A Poser facial Pose file, containing only channels for the head.

FCZ: Poser 5's compressed FC2 format (Face/Expression files).

figure: A new mesh built for Poser and jointed, may also include morphs, textures, props, etc. See also *character*.

forceLimits: A CR2 setting to define whether a channel obeys its limits when the Use Limits option is turned off in the Poser workspace. Non-zero values will cause limits to be enforced at all times.

flying vertices: A rendering artifact that occurs sometimes when extra weld statements are included in the CR2.

genital switch: A setting in the Poser figure menu that controls whether male genitalia are displayed or not.

GeomCustom: CR2 code indicating embedded geometry.

Geometries: The main directory where the OBJ mesh files are stored. Pro Pack and Poser 5 may generate geometries within the Libraries directories.

geometry family: A set of different figures created from the same mesh, that has been edited so it is not the *same* mesh. For example, the Millennium children were built from Victoria's mesh, and Stephanie was built from Michael's mesh. Geometry families can share morphs and possibly UV maps.

geometry pointers: Poser file code that points to an external OBJ file for the mesh.

geometry RSR: A Poser-created interpretation of the OBJ file, which it reads instead of the original OBJ, as the RSR is designed to be read faster. These may become corrupted.

Geometry Swapping: Substituting different meshes for objects; decoded and developed by Jeff Howarth and Anton Kisiel. Most notable in the male hip "genital" switch, or Poser 2 figure hands.

GetStringRes: A table of values for common Poser names such as "Head" and "Bend." This allows Poser to be translated into other languages, and name the dials with those native languages, instead of English names.

gimbal lock: A condition occurring when a 3D object is rotated in multiples of 90 degrees, so that one axis overlaps another, and rotation on either axis causes identical rotations.

grandchild(ren): Body part(s) below the child body part in the hierarchy.

grandparent(s): The parent of a body part's parent.

Grey Shruggy Guy: An icon that Poser places on library files that have no corresponding thumbnail files.

Grouper: My alternate name for the Grouping Tool. Note: there is a Poser-to-Bryce utility named "Grouper," which is not referred to in this book.

Grouping Tool: Poser's tool for selecting individual polygons of an object, and assigning them to groups.

growth group: A group in Poser 5 used as the base for growing dynamic hair.

guide hairs: A set of hairs that control a larger group of hairs. When you style a guide hair, the entire lock of hair takes on the new shape.

Hair Styler: The Poser 5 tool for direct editing of dynamic hair length, direction, bend, etc.

Hand Cams: The hand cameras; <CTRL–[> for left hand, <Ctrl–]> for right hand.

HD2: A Poser Hand file, containing hand pose information, which can be applied to either left or right hands.

HDZ: Poser 5's compressed HD2 format (Hand files).

hidden: A CR2 setting to show/hide dials. 0 causes the control dial to be displayed in Poser.

HR2: A Poser Hair prop file, usually containing the hair geometry, morphs, etc. Only one can be loaded on a character at a time.

HRZ: Poser 5's compressed HR2 format (Hair files).

IK chains: A series of limb parts controlled by Inverse Kinematics.

Inherit Bends (of parent): An option in setting the parent of a prop, which causes the prop mesh to be included in the body part's bend zones.

initValue: A CR2 setting that defines the memorized value of a channel.

internal name: The branch name of a channel in the CR2, not displayed within Poser. Also, a body part's branch name. These may not be the same as the *external names* displayed in Poser.

inverse morphs: When a figure is constructed in a non-final state, and then pieces are morphed into their final positions afterward.

inverted normals: Polygons on a model that appear "backwards" or "inside out."

joint parameters (JPs): The internal controls that define how the Poser figure bends.

Judy: The Poser 5 adult female figure.

k: An obscure CR2 setting that defines channel values for keyframes. k 0 is the initial value of the dial when the figure is loaded.

libraries: Categories of different Poser file types, and the location from which they are loaded into Poser, i.e. Figure, Pose, Face/Expression, Hand, etc.

LT2: A Light setting file.

LTZ: Poser 5's compressed LT2 format (Light files).

Mag Base: The base portion of the Magnet object, which defines the center point for the distortion.

Mag Zone: The spherical portion of the Magnet object, which defines the area of effect for the Magnet.

Magnet: Poser's tool for modifying (morphing) meshes.

master dial/channel: A dial, usually without parameters of its own, that effects other channels, i.e. a Full Body Morph (*FBM*) dial.

MAT/MAT Pose file: A Poser file that contains only material assignment data, usually renamed to a PZ2 and stored in the Pose libraries.

MAT-DIV Pose file: A Poser file that uses the body part customMaterial settings to apply special materials in various combinations.

materials: Parts of an object that share the same surface attributes (i.e., skin); also entries and a section in the CR2.

MatSpheres: Joint parameters that define spherical falloff zones for the joints.

Michael/Mike: DAZ 3D's Millennium Man, an advanced add-on figure for Poser.

Millennium Girls: Female child figures created from Victoria's mesh by DAZ 3D. They are in a geometry family and use Victoria's textures and morphs.

mirror paste: This is a manual function: after pasting in Poser, change the $+/-$ value of the yRotate, zRotate, and xTrans dials.

MOR Pose file: A Pose file with all but the pertinent morph information stripped out of it.

morph donor: A CR2 stripped of everything but morphs for one or more body parts, to be used with *Morph Manager* to pass the morphs onto the user's figure.

morph injection: See *code injection*.

Morph Manager: Mr X's utility for copying morph targets from one Poser file to another; also copies props.

morph squeezing/morph squishing: Removing the f lines of an OBJ file so that only vertex data remains. This is useless as a model, but works for loading as a morph target. This method is approved for distributing morphs based on commercial meshes.

morphs/morphing: Changing shape: the vertices of an object are assigned new locations, to change the shape of the mesh.

MTL: An OBJ Material file, that defines material parameters outside the OBJ file itself.

MZ5: Poser 5's compressed Materials format.

Nadya: A commercial female figure created by Alex Nesterenko.

n-gons: Polygons with more than four sides. These should not be present in objects designed for Poser.

node jacks: The input location of a Poser 5 shader node, analogous to an electrical socket.

node plugs: The output control of a Poser 5 shader node, analogous to the plug of an electrical appliance.

node: A component in the Poser 5 material shader.

null figure: A figure designed to eliminate cross-talk in Poser 4 and Pro Pack. It is essentially an empty figure with no geometry.

OBJ: Wavefront OBJ file format; a 3D mesh.

object: A body part or prop within poser.

offset: An arcane setting in the CR2; corruption of this setting may cause PZ3 files to open with stretched "plasticman" figures.

Out of Memory: Poser's general error message, usually caused by an OBJ not being present when a CR2 calls for it, or the corresponding geometry RSR being corrupted.

P2Z: Poser 5's compressed PZ2 format (Pose files).

P4NM: Poser 4 Nude Man.

P4NW: Poser 4 Nude Woman. Known colloquially as "Posette."

P5NM: The Poser 5 Nude Man (Don).

P5NW: The Poser 5 Nude Woman (Judy).

parent: The body part directly above another (child), and one level up in the hierarchy structure. As a verb, used to mean "Set the Parent" of an object.

Partial Pose: A Pose file that affects only part of the body; the rest of the body parts are removed from the file.

PBM: Partial Body Morph.

Penny: The Poser 5 child female figure.

pentagons: Five-sided polygons. Only three- and four-sided polygons should be used in Poser objects.

PHI Builder: A PHI file creator/editor by Roy Riggs.

PHI Factory: A PHI file creator/editor by Bushi.

PHI: A text file delineating the hierarchy of a Poser figure to be created, using the P3 PHI method of figure creation.

pixel smearing/pixel stretching: A problem with textures when the UVMapping of an object causes some of the polygons to be viewed edge-on. The broad polygon is reduced to a flat line, and the texture thus "smears" one pixel across the polygon.

PNG: An image format, used by Pro Pack and Poser 5 for library thumbnails.

Point At: A property that can be assigned to a Poser object, to align its twist axis to face towards the target. Also a dial in an object with this property turned on, to control the strength of the pointing.

polarity: The $+/-$ value of a number. Polarity is "reversed" on certain values to perform a *symmetrical paste*.

posable prop: A Poser figure that is not a living being, but rather an inanimate object, such as a chain, a coffin, a Lamborghini. Mentally, they are considered props, but technically, as CR2 files, they are figures.

Poser Bones: My own term for body parts that are completely encompassed by their parents, used as internal mesh deformers. See *control handles*.

Poser RSR: A file named "poser.rsr". This file occasionally becomes corrupted; it should be set to read-only and/or backed up to avoid having to re-install Poser.

Posette: Conventional nickname for the P4 Nude Woman. May also be applied to the P3 Nude Woman.

PP2: A Poser Prop file. Usually it contains the prop geometry, as well as any morphs, material information, etc.

PPP: The Poser Pro Pack, an application with more tools and a different setup than Poser 4, including a new method for creating figures, and Python script capabilities.

PPZ: Poser 5's compressed PP2 format (Prop files).

Propagating Scale (P-Scale): A special scaling condition in which all a body part's descendants are scaled with it.

Python: A scripting language, used by Pro Pack and Poser 5. Plug-ins and macros can be created using Python scripting.

PZ2: A Poser Pose file, usually containing only the channels for body parts (but not the full *BODY*).

PZ3: A Poser Scene file, containing figures and props, as well as lights and camera info.

PZZ: Poser 5's compressed PZ3 format (Scene files).

RCM: Remote Controlled Morph; see *ERC*.

reverse polarity: Changing the $+/-$ value of a number, usually to create a mirror of the object. See *symmetrical paste*.

rigid decorated group: Vertices of dynamic cloth that hold their position over the underlying cloth, and do not deform during the simulation.

root node: The basic component of all Poser 5 material shaders.

rotation order: The rotation axes assigned to body parts; the standard order is Twist, Side-Side, Bend.

RSR: A Poser file extension for various file types; see *geometry RSR, Poser RSR, thumbnail RSR*.

Runtime: The main Poser directory where files are stored. Poser cannot read anything above the Runtime directory, although Poser 5 can use multiple Runtimes.

seams: The edges of body parts where they meet their parent/child(ren).

Shader Tree: Poser 5's new material properties and controls.

Side Cams: The left and right cameras. < Ctrl–; > for left, < Ctrl–' > for right.

simulation: Calculations for gravity and dynamics for Poser 5 dynamic hair and dynamic cloth.

Simulator: The Poser 5 Cloth Room, where cloth simulations are run.

slave code: The code that defines how one dial is slaved to a master.

slave dial/channel: A dial/channel that is controlled by another.

Smooth Scaling: Poser's default body part scaling, which attempts to keep a smooth continuity between scaled and un-scaled parts. See also *Propagating Scale*.

smooz/smoox/smooy: Joint parameter smoothing zones, as named in the CR2.

soft decorated group: Vertices of dynamic cloth that bend and stretch, but hold their position over the underlying objects.

Stephanie: A Millennium Woman by DAZ 3D. Created from Michael's mesh, she can share his morphs, but proportioned like Victoria, she can wear her clothing.

symmetrical paste: A procedure whereby one object is copied, and then its information pasted to another. Then the second object's xTrans, yRotate, and zRotate are reversed in polarity.

Symmetry: A Poser command that copies a pose (and, optionally, joint parameters) from one side of the body to the other. The Arm/Leg Symmetry only affects the common Poser Arm/Leg body part names, but the Full Symmetry will copy to/from any body parts that have the same name, but with a leading "r" or "l."

thighLength: An arcane setting in the PZ2.

thumbnail RSR: A Poser-generated thumbnail preview of a library item in Poser 3 and 4.

trans map: A greyscale image that defines opacity (white) and transparency (black).

trans-mapped: An object, usually very simple, that derives a more complex shape from a transparency map. Most often used in hair.

Twist Bar: The visual indicator for the Twist joint parameter, consisting of a white line with red and green T ends.

twisty/twistx/twistz: Twist joint parameter entries as they are named in the CR2.

UVMapper/UVMapper Pro: Steve Cox's utility for creating UVMaps for OBJ files.

UVs/UVMaps: Coordinate information for meshes that lays them out in 2D space, for painting textures.

UVS: A file created by UVMapper with encoded UVMapping, group and/or material information.

Victoria/Vicky: DAZ 3D's Millennium Woman, an advanced add-on figure for Poser.

weld statements: Entries in the CR2 that prevent figure seams from ripping; also a name for this section of the CR2.

Will: The Poser 5 child male figure.

Wrong Number (of vertices): An error in which an OBJ loaded as a morph target is incorrect for that object.

Y-up: A 3D universe orientation in which positive Y values are "up." Poser's universe is Y-up (Z is forward/backward). Other 3D apps use a Z-up universe.

Z-up: A 3D universe orientation in which positive Z values are "up." The Y axis is used for forward/back.

Index

Italic page numbers refer to illustrations/tables.

AbNormals, 217–18, *218*, *219*, 263
AddChild, 60, 98, 263
Adding affectors, 90–1
AddToMenu [1/0], 44
Advanced figure design, 125–39
Affectors, 89–91, 263
AllowsBending [1/0], 61
Alternate_Diffuse, 182, 190
Alternate_Specular, 182–3
Alternate Diffuse chip, 167, 168, *168*
Alternate Pose files, 75–9
AlternateGeom, 45, 109–10
Ambient_Value, 181
Ambient Color, 157, 181
Amorphium, 10
"And Anything Else We Can Think Of" Pose, 78–9
Antelope Expansion Pack, 4
Anti-gravity, 133–4
Apply Bulges option, 35
Armor, suits of, 148–9

BackfaceCull [0/1], 47
Backwards joints, 201
Base objects, 11
Basic body parts, 42–8, *42*
[BASIC ENTRIES], *49*
Basic mesh structure, 114–17
Bat, *249*
Bend X joint controls, 33–5, *34*, *35*, 91, 263

Bend [1/0], 43
Bending:
 see also Affectors; Conforming
 figure design, 117
 grafted on body parts, 207–8
 not required, 203–4
 props, 71–3
 smart props don't, 210–11
Berengaria and Lionheart, *237*
Black holes, 218, 219, 263
Black triangles all over, 232–3
BODY, 263
Body Handles, 21, 130–1, 263
Body parts:
 channels, affectors, 89–91
 chopping (deleting), 99–100
 controls section, 42–8, *42*
 definition, 263
 grafting on, 94–9
 names, 255–8
 new in Controls section, 96–7
 new in Figure section, 98–9
 new in Geometry section, 95–6
 selecting, 203
Body-typing, 14
Bones, 263
'Branches' of library files, 38
Brick node, 185–6, *186*
Buffer zone body parts, 125–8, *126*, *127*

Bulge, 35, 263
BUM bump maps, 183, 263
Bump, 155, 182, 184–5, *186*
Bump maps, 65, 158, 183, 263
BumpStrength [decimal percentage], 64

CanonType [number], 62
Can't find file, 221
Can't find OBJ, 216
Cascading ERC, 104–5, *105*, 263
CastsShadow [1/0], 44
Categories, morphing, 13–14
CATP *see* Children Affect Their Parents
Cellular node, 185–8, *187*, *188*
Center and end point joint controls, 31–5
Changing rotation types, 94
Channels, 38, *49*, 52–9, 89–91, 264
[CHANNELS], 45
Character, 4, *251*, 264
Child, 97, 264
Child/parent relationships, 30, 37
Children Affect Their Parents (CATP), 30, 37, 119,
 128, 202
Chopping (deleting), 81–2, 90, 99–100, 264
Choreographed group, 173–4, *174*, 264
Cloth falling through, 228–9
Cloth Room, 171–5, *172*, *173*, 178
Clothifying, 171, *172*
Clothing:
 choreographed group, 173–4, *174*
 cloth groups, 172–5
 conforming, 139–42, 223–5
 conforming vs. dynamic, 170–1
 constrained group, 172–3, *173*, 227
 design, 139–50
 different dynamic groups have same properties,
 228
 dresses, 142–7, *143*, *144*, *145*, *146*, *147*
 dynamic, 169–79, 227–31
 dynamic group (default), 172, 228
 poke-through, 170–1, 176
 pre-defined cloth groups, 175
 rigid decorations, 175
 slices through itself, 230
 soft decorations, 175
 sucks up under figure, 227–8
CM2, 264
CMZ, 264
Code injection, 264
Collision detection, 170, 171, 264
Colors, 155–7, *157*

Combining figures, 100
Compose (John Wind), 11, 264
Conforming, 62, 101, 264
 clothing, 139–42, 147–50, 170–1, 223–5
ConformingTarget [body part], 45
Constrained groups, 172–3, *173*, 227, 264
Construction lines, 117
Construction morphs, 12
Control handles, 130–1, 264
Control names, 259–60
Controls section, 42–8, *42*, 48–52, 96–7
Correlations, 111–13
CR2:
 Editing program, 20, 21, 264
 flying vertices, 207
 Geom Swapper with wrong starting geometry,
 208–9
 IK tears off, 207
 incorrect morphs for swapped geometry, 209
 practice, 79–113
 problems, 206–9
 sections (top level), 38–9
 theory, 38
 torn seams, 206
Create Perspective UVs, 26
Creating the mesh, 2
Creating morphs, 3
Creature head morphs, *251*
Cross-talk:
 definition, 264
 dial names, 16–17
 Extended Remote Control, 17
 morphing, 14–17
 Universal Null, 16
Crunching, 264
Curio's Majestic Dragon, *245*
Curio's Ragbash the Troll, *244*
Curve, 264
CustomMaterial [0/#], 46–7

DAZ 3D, 264, 270
DAZ Productions, 241–3, 250–2
DefaultPick [bodypart], 61
Defining the hierarchy, 2
Deformations, doubled, 230
Degenerate facets, 265
Deleting, 81–2, 90, 99–100
DeltaAddDelta control ratio, 105–9
DePent, 265
Descendants, 265
Dials:

changing dial orders, 81
Full Body Morphs, 13
groups, 82–3
hands, 84
locking/hiding/deleting, 81–2
master dial, 101
names, 16–17, 259–60
SpiralSide/SpiralSide, 103
Diffuse_Color, 181
Diffuse_Value, 181
Dina, 265
Displacement, 47–8, 155, 182, 184–5, *186*, *189*
DisplayMode [mode], 46, 62–3
DisplayOn[1/0], 61
DisplayOrigin [0/1], 46
Don (P5NM), 265, 269
Dork (P4NM), 265, 268
Dots, 185
Double-sided polygons, 115
Doubled deformations, 230
Doubled effects, Magnets, 200–1
Dragon, *245*, *252*
Dresses, 142–7, *143*, *144*, *145*, *146*, *147*
Dropping joint parameters, 205
Dud morphs, 193–4
Dynamic cloth, 169–79, 227–31, 265
Dynamic clothing, 170–5
Dynamic group (default), 172
Dynamic hair, 161–9, 225–7, 265
DynamicsLock [0/1], 43–4

Ears, 18
EasyPose (EP), 16, 17, 103–9, 265
Editing joints, 99
Egyptians clothing set, 143–7, *146*, *147*
Embedded geometry, removing, 80–1
'Empty' geometry, 112
End point, 31–5, 45–6
Enhanced Remote Control, 17
EP *see* EasyPose
ERC *see* Extended Remote Control
Eve, 265
Expanding morphs, 195
Exploding morphs, 192–3, 265
Exporting, 11, 20–1
Expression morphs, function, 12
Extended Remote Control (ERC), 17, 101–2, 265
External name, 265
Extras:
 dynamic cloth, 169–79
 dynamic hair, 161–9

Shader Tree materials, 180–90
Eyes, 18

Face Cam, 220, 265
Faces, 73, 74
Facilitating movement, 127–8
Falloff graphs, Mag Zone, 22–5, *23*, *24*, *25*
FBM *see* Full Body Morphs
FC2 Pose files, 73, 74, 265
FCZ format, 265
Feet, 207, 220
Figure creation:
 advanced, 125–39
 basic mesh structure, 114–17
 character creation comparison, 4
 combining figures, 100
 geometry families, 124–5
 hierarchy method, 151–2
 holes in figures, 218–20, *219*
 inside out figures, 217–18
 intermediate mesh design, 117–25
 materials, 153–8, *154*, *156*
 parts information, *59*
 practice, 151–60
 problems, 213–23
 Setup Room method, 152–3
 theory, 114–51, 265
Figure section, 60–8, 98–9
FigureResFile pointers, 39–40
FigureType[1318/number], 61
File, Poser can't find, 221
File ['""/file name], 68
Finalization, 153
Find files, Poser can't, 221
Firefly renderer, 169, *169*
Fix morphs, function, 12–13
Fixes to the object don't take, 222
Flying off morphs, 194–5
Flying vertices, 207, 265
Footwear, 148
ForceLimits [0/non-0], 50, 265
Full Body Morphs (FBM), 13, 196–8, 265
Fur *see* Hair and fur

Genital switch, 109, 266
Geo the Swampalope, *240*
Geom Swapper, 113, 208–9, 266
GeomChan, 53, 110
GeomCustom, *42*, 80–1, 266
Geometry families, 12, 124–5, 266
Geometry RSR, 266

Geometry section, 41–52, 95–6
Geometry Swapping, 109–13, 266
GeomHandler, 110
GeomHandlerGeom, 41, 81
GetStringRes lookup tables, 255–62, 266
Ghost figures, 215
Gimbal lock, 266
Global Coordinates, *188*
Gorilla Deluxe, *241*
Gradient_Bump, 183
Gradients, 155
Grafting on, 94–9, 207–8
Grandchildren, 266
Grandparents, 266
Granite, 185, *189*, 190
Grasp dials, 84
Gravity, 133–4
Grey Shruggy Guy, 266
Greyed out JP options, 205
Grouping Tool, 25–9, *27*, 266
Groups:
 cloth groups, 172–5
 constrained groups not working, 227
 dial groups, 82–3
 different dynamic groups have same properties,
 228
 growth group, 266
 hair groups, 161–3
 naming, 115–16
 nodes in channels branch, 52
Growing fur, 163–6, *166*
Growth group, 266
Guide Hairs, 163, *164*, 226, 266

Hair and fur:
 Alternate_Diffuse jack, 190
 basic operations, 161–6
 beard loading causes hair to disappear, 211
 dynamic, 161–9, 225–7
 figure creation, *135*, 137–8, *139*
 fur cape, 91
 groups, 161–3
 growing, 163–6, *166*
 Guide Hairs, 163, *164*, 226, 266
 materials, 166–9, *167*
 offset, 226–7
 parameters, 163
 Poser 5 extras, 188, *189*, 190
 radioactive, 225
 rendering, 169, *169*
 turns white, 225–6

Hair node, 167, 168, *168*
Hair Room, *162*, 165
Hair Styling Tool, 163, 164, *165*, 266
Hairy Spider, *238*
Hands, 73, 74–5, 84, 85, *85*, 266
HD2 files, 73, 74–5, 266
HDZ files, 266
Head, morphing practice, 19, *19*, 20, *20*
Heavy Horse, *246*
Hidden [0/1], 44, 50, 266
Hide/Show Pose files, 78
Hiding dials, 44, 50, 81–2, 266
Hierarchy, 2, 151–2
Highlight_Size, 181
Highlight Color, 156–7, *157*
Hill, Dave, 249
Hill, Pete, 244, 245
'Hill' style falloff zone, 24, *24*, *25*
History of Poser, 1
Holes in figure, 218–20, *219*
Honey Bee, *239*
Horses, 17–18, *18*, *246*
How to use this book, 5–6
Howarth, Jeff, 109
HR2 prop files, 73–4, 267
Human skin, 185, 224–5

IK, 98, 159–60, 207, 267
Importing objects, 222–3
IncludeInDepthCue [1/0], 44
Inflation of figure, 176–9, *177*, *178*
Inherit Bends, 71, 267
Initial pose, 159–60
InitValue [value], 50, 267
InkyChain [name], 60–1
InkyParent [parent], 45
Inside out figures, 217–18
Interchangeability, 122–4
Intermediate mesh design, 117–25
Internal name, 267
InterpStyleLocked [0/1], 51
Inverse mapping, 131–2
Inverse morphing, 131–2, *132*, *133*, 267
Inverted normals, 267
Invisible figures, 214, 215
Invisible parts, 215–16
Iridescence, 187–8, *188*

Joint controls, 31–6, *32*, *34*, 35, *35*
Joint parameters:
 backwards joints, 201

bending not required, 203–4
definition, 267
dropping, 205
greyed out options, 205
joint controls, 31–6
Joint Parameters Window, 30
MatSphere Zones, 35–6, *36*
missing controls, 204
no body part selected, 203
practice, 36–7
setting, 2
sibling rivalry, 201–2
theory, 30–6
trouble-shooting, 201–5
Joint[axis] joint[axis], 57–8
Joints, editing, 99
Judy (P5NW), 267, 269

K setting, 267
KaColor, 63
KdColor, 63
Keys, 51
Kisiel, Anton, 109, 112
 Egyptians clothing set, 143–7, *146*, *147*
 Geometry Swapping, 109, 112
 Long Flowing Fantasy Beard, 130
 Michael's Fantasy Beard, *130*
KsColor, 63
KsIngore Texture [0/1], 64–5

Lemurtek's Second Nature series, 4
'Level Skipped' error, 222–3
Levels:
 level 1, 42–8, 60–3
 level 2, 48–52, 63–6
 level 3, 66–8
Library files:
 affectors, 89–91
 channels branch, 52–9
 chopping, 99–100
 conforming, 101
 Controls section, 42–8
 CR2, 38–9, 79–113
 definition, 266
 dial operations, 81–4
 Easy Pose, 103–9
 Extended Remote Control, 101–2
 Figure section, 60–8
 figureResFile pointers, 39–40
 geometry section, 41–2
 Geometry Swapping, 109–13

grafting on body parts, 94–9
plugging in new OBJ file, 79–80
Pose files, 73–9
prop files, 69–73
removing embedded geometry, 80–1
rotation, 91–4
scaling, 84–7
scene files, 68–9
version section, 40–1
welding, 88
Limb angles, 118–19, *120*, *121*
Limits, 13, 14, 159
Lines, 115
LinkParms, 102
LinkWeight, 99
Lionheart, *237*
Location, 116–17
Lock/Unlock Pose files, 78
Locked [0/1], 47
Locking dials, 81–2
Long Flowing Fantasy Beard, 130
LT2 files, 267
LTZ files, 267
Lucifer the Bat Up Close, *249*

Mag Base, 22, 267
Mag Zone, 22–5, *23*, *24*, 25–9, *25*, 267
Magnets, 112
 doubled effects, 200–1
 spawned targets, 200
 strength doubled, 230–1
 theory, 21–5, 267
 trouble-shooting, 199–201
Malis, Jon, 4
Marck, Serge, 178, 179
Master dials, 15, 16, 101, 267
MAT Pose, 75, 212–13, 267
MAT-DIV Pose files, 76–7, 267
Material [name], 62
Materials:
 definition, 267
 figure creation, 153–8, *154*, *156*
 hair, 166–9, *167*
 MAT Pose doesn't change prop materials, 212
 Shader Tree, 180–90, 231–2
MatSphere Zones, 35–6, *36*
MatSpheres, 205, 267
Matthews, Dave, 237
Max [value], 50
Memorizing, 159–60
Memory out, 216, 268

Mesh, 2, 114–25, 175–6
Meta-balls, 19, *19*
Michael/Mike, *242*, 267
Michael's Fantasy Beard, *130*
Millennium Dragon, *252*
Millennium Girls, 268
Millennium Null, 15, 16
Min [value], 50
Mirror paste, 268
MOR Pose files, 77–8, 211–12, 268
Morph Manager, 268
MorphPutty, 48
Morphs:
 categories, 13–14
 creation, 3
 cross-talk, 14–17
 definition, 268
 dud morphs, 193–4
 exploding, 192–3
 flying off, 194–5
 Grouping Tool, 26–9
 head, 19, *19*, 20, *20*
 horse, 17–18, *18*
 incorrect for swapped geometry, 209
 inverse morphs, 131–2, *132*, *133*
 limits, 159
 Magnets, 21–5, 29
 ordering vertices, 9, 10–11, *10*
 practice, 17–21
 preserving morphs, 20–1, *21*
 props vs posable props, 151
 shrinking/expanding, 195
 speed, 196
 squishing/squeezing, 268
 strength doubled, 230–1
 swan, 18–19, *19*
 telescoping, 195–6
 theory, 9–17
 trouble-shooting, 191–9
 types, 12–13
Mouth, horse, 18, *18*
Movement, 125–7, *126*, *127*
MTL files, 268
My Hair Room setup, *162*
MZ5 format, 268

N-gons, 115, 268
Nadya, *248*, 268
Name [name], 50, 60
Name "[name]", 67
Name [name/GetStringRes], 43

Names:
 dial names, 16–17, 259–60
 GetStringRes lookup tables, 255–62
 groups, 115–16
Nesterenko, Alexander, 248
New body parts, 95–9
New Figures, problems, 213
No Body Part Selected, 203
Node jacks, 268
Node plugs, 268
NodeInput "[name]", 67
Node [NO*NODE/"name"], 68
Nodes:
 Cellular node, 185–6, 187–8, *187*, *188*
 definition, 38, 268
 Hair node, 167, 168, *168*
 Noise node, 185
 "Poser Surface" base node, *180*
 root node, 270
 shading nodes, 167, 168, *168*
 Spots node, 185
 Tile node, 185–6, *186*
 Velvet Node, 188, 190
Node "[type]" "[name]", 67
Noise node, 185
NonInkyParent [parent], 45
NsExponent [percentage number], 64
Null figure, 268
Null Loader, 15–16

OBJ, 79–80, 119–22, *122*, *123*, 216, 268
ObjAction Scaler (Maz), 11
Object color, 155, *157*
Object names, 255–8
ObjFile pointers, 110
Offset, 55–6, 58–9, 226–7, 268
On [Off], 43
Orders:
 changing dial orders, 81
 rotation, 91–4, 118–19, *120*, *121*
 vertices, 9, *10*
Orientation [angles], 46
OrigFigureType [1318/number], 62
Origin [coordinates], 46
Out of Memory message, 268

P2Z format, 268
P4NM (Nude Man/Dork), 265, 268
P4NW (Nude Woman), 268, 269
P5NM (Don), 265, 269
P5NW (Judy), 267, 269

Parameters, hair, 163
Parent, 97, 269
Parent [parent], 44
Parm[R/G/B][NO*PARM/?], 68
Partial Body Morphs (PBM), 13, 196–7, 198–9, 269
Partial Pose, 269
Partially conforming clothing, 149–50
PBM *see* Partial Body Morphs
Penny, 269
Pentagons, 269
Phantom Parts, 141
PHI Builder, 222–3, 269
PHI factory, 269
Pistons, pointing, 134, 136–7, *136*, *137*
Pitfalls to avoid, 4–5
Pixel smearing/stretching, 269
Plain dial, *49*
Plugging in new OBJ file, 79–80
PNG format, 269
Pointing things, 132–8, *134*, *135*, *136*, *139*, 269
Poke-through, 170–1, 176, 224–5, 229–30
Polarity, 268, 269
Popeye-Arm morphs, 13
Pos [x y coordinates], 67
Posable Hairy Spider, *238*
Posable Honey Bee, *239*
Posable props, 150–1, 269
Pose files, 74–9
Poser 3/4 materials, 63–6, 155–8
Poser 5 extras, 161–90
Poser 5 materials, 153–5, *154*
Poser Bones, 21, 130–1, 269
Poser Pro Pack (PPP), 152–3, *156*, 269
Poser RSR, 269
"Poser Surface" base node, *180*
Poser version features, 6, 7
Poses, 211–12
Posette (P4NW), 268, 269
PP2 prop files, 69–73, 269
PPP *see* Poser Pro Pack
PPZ format, 269
Practice:
 figure creation, 151–60
 joint parameters, 36–7
 Magnet Zone, 29
 Magnet Zone Grouping Tool, 26–7
 morphing, 17–21
Pre-built static meshes, 5
Pre-defined cloth groups, 175
Preserving morphs, 20–1, *216*
PresetMaterial [name], 62

Preview window, 183
Pro Pack, 152–3, *156*, 269
Procedural shaders, 180–90
Propagating Scale, 56, 84–7, *85*, *87*, 270
Props:
 clothing, 170, 171, *171*
 design, 150–1
 dynamic cloth, 175–9
 files, bending props, 71–3
 MAT Pose does not change materials, 212
 PP2 files, 69–73
 prop set vs posable prop, 150
 smart props don't bend, 210–11
 smart props turn dumb, 210
 subsets, 70
 swapping, 113
 vs conforming clothing, 147–50
Putting it all together, 3
Python, 270
PZ2 Pose files, 73–4, 270
PZ3 files, 17, 270
PZZ format, 270

Quads, 114

Radioactive hair, 225
Ragbash the Troll, *244*
Rainbow colours, 187–8, *188*
Random colors, 187–8, *188*
Recorrupting RSRs, 216
Reflection_Color, 182
Reflection_Kd.Mult, 183
Reflection_Lite.Mult, 183
Reflection_Value, 182
Reflection maps, 158
ReflectionColor [RGBS], 66
ReflectionMap [NO_MAP/texture file], 65
ReflectionStrength [number], 66
Reflective Color, 157
ReflectThruKd, 65
ReflectThruLights, 65
Refraction_Color, 182
Refraction_Value, 182
Remote control *see* Extended Remote Control
Removing embedded geometry, 80–1
Render, B.L., 246, 247
Rendering hair, 169, *169*
Reordering vertices, 10–11
Reverse Normals button, 218, 219, *219*
Reverse polarity, 270
Reverse-Hierarchy Affectors (RHA), 143–7

Richmond, David, 238, 239
Rigid decorations, 175, 270
Root [body part], 60, 270
Root node, 270
Rotate[axis] [axis]rot, 58
Rotation names/limits, 159
Rotation orders, 91–4, 118–19, *120*, *121*, 270
Rotation types, changing, 94
RSRs, 216, 266, 269, 270, 271
Runtime, 270

S-curves, 108
Saving Magnets, 29
Scale, 11, 56, 84–7, *87*, 185–6, *186*, *187*
Scene files, 68–9
Seams, 270
Setup Room method, 152–3
Shader Tree, 66–8, 180–90, 231–2, 270
Shading nodes, 167, 168, *168*
ShadingRate [value], 48
Shins, 142, *144*, *145*, 146, 147
Showcase, 237–53
ShowPreview [1/0], 67
Shrinking morphs, 195
Sibling rivalry, 201–2
Side Cams, 270
Simulation, 231, 270
Simulator, 176–9, *177*, *179*
Sitting problem, 142–3
Size, 11, 116–17
Skin, 185, 224–5
Slave code, 101–2, 270
Slave dials, 15, 16, 270
[slaveEntries] (set of five, optional), 51–2
Slaving paths, 104–5, *105*
Slicing, 2, 230
Slug, *253*
Smart props, 70
Smooth Scaling, 54–5, 84, 86, 270
SmoothPolys [1/0], 48
Smooz/smoox/smooy, 270
Soft body revolution, 143–7
Soft decorations, 175, 270
Spawned targets, 200
Specular_Color, 181
Specular_Value, 181
Speed, morphs, 196
Spider, *238*
SpiralBend, 103
Spirals, 108–9
SpiralSide, 103

Splitting the mesh, 2
Splitting the OBJ, 119–22, *122*, *123*
Spots node, 185
Spread dials, 84
Square Hi-Res, 171, 173, 174, *174*
Stalling, simulations, 231
Stand-Alone morph, function, 13
Stephanie, *243*, 270
Strength doubled, Magnets, 230–1
Stumpy, 4–5, *5*
Sucking cloth onto figure, 176–9, *177*, *179*
Suits of armor, 148–9
Surface materials, 153–8, *154*, *156*
Swampalope, *240*
Swan, morphing practice, 18–19, *19*
Swapping, 111–13
Symmetrical paste, 271
Symmetry, 271

Tag numbers, 112
Taper[axis] Taper, 54
TargetGeom [name], 53
Targets, spawned not looking same, 200
Taylor, Charles, 15, 17
Telescoping morphs, 195–6
TExpo [number], 64
Texture, 3, 158
 can't see, 232
 maps, 65, 183, *184*
 model won't texture, 221
 names, 260–2
 textureColor [111S], 64
 textureMap [NO_MAP/texture file], 65
ThighLength, 271
Thighs, 142, *143*, *144*, 146, 271
Thomas, Darren A., 240, 253
Thumb grasp dials, 84
Thumbnail RSR, 271
Tile node, 185–6, *186*
TMax [decimal percentage], 64
TMin [decimal percentage], 64
Torn seams, 206
TrackingScale [value], 51
Translate[axis] [axis]tran, 59
Translucence_Color, 182
Translucence_Value, 182
Transparencies, 157–8, 181
Transparency_Edge, 181
Transparency_Falloff, 181
Transparency maps, 65, 271
Triangles, 114

Troll, *244*

Trouble-shooting:

 beard loading causes hair to disappear, 211

 black triangles all over, 232–3

 can't see textures, 232

 conforming clothing, 223–5

 CR2 problems, 206–9

 dynamic cloth, 227–31

 dynamic hair, 225–7

 figure inside out, 217–18

 figure problems, 213–23

 joint parameters, 201–5

 Magnets, 199–201

 MAT Pose adds weird materials to figure, 212–13

 MOR Poses change figure's pose, 211–12

 morphs, 191–9

 Shader Tree material, 231–3

 simulation stalls, 231

 smart props don't bend, 210–11

 smart props turn dumb, 210

Turbo the Wonder Slug, *253*

Twist Bar, 32–3, *32*, *33*, 93, 271

Twist/joint/joint[axis] [child]_twist/joint/joint[axis], 54

TwistAft dial, 105, 106–7

Twist[axis] twist[axis], 58

Twisted conformer pieces, 225

Twisty/twistx/twistz, 271

Universal Null, cross-talk curtailment, 16

UVMapper Pro, 10–11, 271

UVMapping, 3, 125, 271

UVS file, 271

Value [RGBS], 67–8

ValueParm, 53, 101, 102, 103, 104

Velvet Node, 188, 190

Versatility, 122–4

Version section, 40–1

Vertices, 9, *10*, 22, 191–2, 207

Victoria/Vicky 3, *250*, *251*, 271

VisibleInReflections [1/0], 47

VisibleInRender [1/0], 47

Waves, 109

Webbed wings/fingers/toes, 130–1

Wee Beasties, *247*

Weld [child]; [parent], 61

Welding, 88, 98, 271

Whisenant, Robert, 15, 17

White hair/fur, 225–6

Will, 271

Windows, 30

Workflow basic steps, 1

Wrong Number (of vertices), 271

Y-up orientation, 271

Z axis vector, 12

Z-up orientation, 271

Also available from Focal Press ...

Essential CG Lighting Techniques
Darren Brooker

- Get all you need to know about CG lighting from one easy to use volume
- Put into practice the theories learned with the detailed tutorials and free demo software provided
- Learn both the art and the science of lighting CG environments

Illustrated throughout in full color, this comprehensive text not only looks at the technical and theoretical aspects of becoming skilled at using the light tools available in 3D software, but also provides invaluable tutorials so you can explore these techniques in-depth.

Lighting is a core CG skill that makes or breaks a 3D environment. Providing all you need to master this vital aspect of CG, this comprehensive guide looks at the key concepts that can be applied in any 3D package.

Every ounce of theory is backed up with practical tutorials, using the free demo version of 3ds max supplied on the accompanying CD-ROM. The tutorials deal with the fundamentals of lighting and as such are easily transferable to any other major 3D software package. The free CD also includes all the files needed to complete the tutorials step-by-step, as well as demo versions of Dark Tree Textures, Deep Paint 3D and Cinelook, acclaimed applications that every lighting artist should be aware of.

If you are new to CG lighting, are thinking of specializing in this area, or want to brush up on your existing lighting skills, then this book will provide you with a one-stop master class so you too can achieve professional looking results.

October 2002 • 246 x 189mm • 384pp • 400 colour illustrations • Paperback with CD-Rom
ISBN 0 240 51689 3

Also available from Focal Press ...

Flash MX Games
ActionScript for Artists
Nik Lever

- Benefit from the experience of a successful games designer whose Flash sites regularly get 10,000+ hits per day
- Explained by an artist for artists so you can easily see how Flash ActionScript can work for your own games development
- Includes lots of sample games you can adapt for your own use with the files on the free CD-Rom

Learn the professional skills you need to make the best use of Flash for creating interactive animation and producing exciting, dynamic Internet content. Nik Lever, writing as an artist for artists, takes you through the entire process from creating the art and animation for games in Flash, to adding the interactivity using Flash's ActionScripting language. He also provides valuable extra coverage of how Flash integrates with Director 8.5 Shockwave studio and C++.

As a designer using Flash you will see how you can apply your creative skills to the many stages of game production and produce your own interactive games with this versatile package. As an animator you will be able to add interactive functionality to your own animation and produce a game. As a web developer you will see how to make the best use of the sophisticated development environment Flash offers for the production of both artwork and code to create low bandwidth, animated web content that sells!

The free CD-Rom includes all the code and files you need to try out each tutorial from the book so you can see exactly how each game was created. Learn from the many different types of games provided as examples, from simple quizzes to platform-based games. High score tables and multi-player games using sockets, vital to higher level online games, are also covered in detail to ensure you have the complete skill set needed to succeed in this competitive arena.

December 2002 • 246 x 189mm • 456pp • 226 illustrations • Paperback with CD-Rom
ISBN 0 240 51903 5

Also available from Focal Press ...

Producing Animation
Catherine Winder and Zahra Dowlatabadi

- Complete guide to identifying, pitching, selling, developing and producing an animated show

- Includes a detailed description and flow charts of the production process for traditional (2D) and 3D CGI

'This is a bridge book between the fiscal and creative forces of animation... It ought to be required reading in animation schools for students and teachers, to show how much there is to learn and is needed to do to bring out the best in animation.'
TAISzine

'While there's a useful library of books covering the tools, techniques and aesthetics of animation, until now there's been scant coverage of the highly refined skill sets needed to produce animation...'
Kit Laybourne, Head of Animation at Oxygen Media and author of The Animation Book

'Producing an animated film is a mind boggling confluence of art, business, frustration, and elation. This book is a veritable treasure of information and inspiration on one of the toughest, most rewarding jobs in the film industry.'
Don Hahn, Producer (Beauty and the Beast, The Lion King, Atlantis: The Lost Empire)

'*Producing Animation* is an indispensable book for anyone working or thinking of working in animation. Covering features, direct-to-video and television - so few [producers] have experience in all mediums, it provides comprehensive information on the nuts and bolts of the business.'
Bonnie Arnold, Producer (Tarzan, Toy Story)

June 2001 • 324pp • 234 x 180 mm • 60 line illustrations • Paperback
ISBN: 0 240 80412 0

Also available from Focal Press ...

How to Cheat in Photoshop
The art of creating photorealistic montages
Steve Caplin

- Full color, high quality illustrations show you what you can achieve.
- Many of the original Photoshop files are provided on the free CD so you can try out the techniques
- Real world examples demonstrate how to put each technique into practice

Learn from a professional illustrator how best to make Photoshop work for you. Each section is divided into double page spreads on illustrative techniques, giving you bite size chunks with all you need to know in a highly visual, approachable format.

The beauty of this book is the way Steve Caplin shows you step-by-step how to work from the problem to the solution in creating photorealistic images, from the viewpoint of the illustrator who has been commissioned to create a job. This is both a technical guide and an artistic inspiration, packed full with new ideas that you will be dying to try!

June 2002 • 246 x 189mm • 500 colour photographs • Paperback with CD-Rom
ISBN 0 240 51702 4

Focal Press

www.focalpress.com
Join Focal Press on-line
As a member you will enjoy the following benefits:

- an email bulletin with **information on new books**

- a regular **Focal Press Newsletter**:
 - featuring a selection of new titles
 - keeps you informed of **special offers, discounts and freebies**
 - alerts you to **Focal Press news and events** such as author signings and seminars

- complete access to **free content** and reference material on the focalpress site, such as the focalXtra articles and commentary from our authors

- a **Sneak Preview** of selected titles (sample chapters) *before* they publish

- a chance to have your say on our **discussion boards** and **review books** for other Focal readers

Focal Club Members are invited to give us feedback on our products and services.
Email: worldmarketing@focalpress.com – we want to hear your views!

Membership is **FREE**. To join, visit our website and register. If you require any further information regarding the on-line club please contact:

Lucy Lomas-Walker
Email: l.lomas@elsevier.com
Tel: +44 (0) 1865 314438
Fax: +44 (0)1865 314572
Address: Focal Press, Linacre House,
Jordan Hill, Oxford, UK, OX2 8DP

Catalogue
For information on all Focal Press titles, our full catalogue is available online at www.focalpress.com and all titles can be purchased here via secure online ordering, or contact us for a free printed version:

USA
Email: christine.degon@bhusa.com
Tel: +1 781 904 2607 T

Europe and rest of world
Email: j.blackford@elsevier.com
Tel: +44 (0)1865 314220

Potential authors
If you have an idea for a book, please get in touch:

USA
editors@focalpress.com

Europe and rest of world
focal.press@elsevier.com